Digital Color Correction

Digital Color Correction

by Pete Rivard

THOMSON

™

DELMAR LEARNING

Australia Canada Mexico Singapore Spain United Kingdom United States

THOMSON

DELMAR LEARNING

Digital Color Correction
Pete Rivard

Vice President, Technology and Trades ABU:
David Garza

Director of Learning Solutions:
Sandy Clark

Senior Acquisitions Editor:
James Gish

Product Manager:
Jaimie Weiss

Marketing Director:
David Garza

Channel Manager:
William Lawrensen

Marketing Coordinator:
Mark Pierro

Production Director:
Mary Ellen Black

Senior Production Manager:
Larry Main

Senior Production Editor:
Tom Stover

Editorial Assistant:
Niamh Matthews

Cover Design
Dan Masucci

Cover Image
Pete Rivard

Library of Congress Cataloging-in-Publication Data:
Rivard, Pete.
 Digital color correction / Pete Rivard.
 p. cm.
 ISBN 1-4018-9663-4 (alk. paper)
 1. Color photography—digital techniques. 2. Image processing—Digital techniques. I. Title.
 TR267.R58 2006
 006.6—dc22 2005036070

NOTICE TO THE READER

Table of Contents

Introduction vii

Preface ix

Chapter 1
The Four Characteristics of Appealing Images 1
It's Hip to Be Square 2
The Color Specialist 5
Roadblocks to the Optimal Image 7
Rivard's Pyramid 9
Defining the Optimal Image 10
The Four Characteristics 10
The Farnsworth-Munsell 100 Hue Test 12
Summary 14
Review 14

Chapter 2
Contrast 15
Color Spaces 18
How Is Contrast Controlled? 20
Measuring Light 21
Summary 32
Review 32

Chapter 3
Balance 33
Balance Defined 34
The Causes of Color Cast 36
RGB Balance 38
L*a*b* Balance 38
Gray Balance in Practice 43
Summary 46
Review 46

Chapter 4
Sharpness and Detail 47
Pixels 48
Edge Definition 55
Grain 55
Unsharp Mask 56
DPI and LPI 61
Summary 64
Review 64

Chapter 5
Believable Colors 65
Color Alterations and Corrections 68
Color Attributes 69
Describing Color 71
Communicating Color 76
Wanted and Unwanted Components 77
Skin Tones 78
The Expanded Gamut 80
Summary 83
Review 83

Chapter 6
Image Evaluation 85
The Evaluation Checklist 88
Summary 100
Review 100

Chapter 7
The Plan of Attack 101
Reviewing the Image Evaluation 103
Correcting the Poor Image 107
Summary 112
Review 112

Chapter 8
Masked and Invisible 113
Anatomy of a Mask 114
A Masking Scenario 121
Summary 126
Review 127

Chapter 9
Tool Work 129
Recognizing a Need for Tool Work 132
Tool Work Considerations 135
The Brush Tip 136
Color Correction Using Tool Work 137
Summary 141
Review 141

Chapter 10
Special Treatments 143
Duotones 144
Sepiatones 146
Euro Grays 148
Drop Shadows 149
Summary 156
Review 156

Chapter 11
Color Correction vs. Color
Management 157
Color Management 101 159
UCR and GCR 163
Color Management in Practice
 166
The Contract Proof 168
Summary 172
Review 172

Glossary 173

Index 183

Introduction

Imagine yourself employed in the publishing industry. You're a color reproduction specialist. You're paid to produce eye-catching, appealing, color images for print and the Web. You work in a creative, collaborative atmosphere with designers, layout specialists, typographers, and printers. In your particular fantasy, maybe you're the designer, the layout specialist, the typographer, and the color guru, all rolled into one, and in this blossoming era of digital print, possibly the press operator as well. What a cool job! Scary. But cool.

You're presented with the cover image for next week's issue. A digital photo. Okay, let's fire up that baby in Photoshop and have a look. Whoa! Who the heck took this shot? Quite the mediocre, unappealing image, as cover photos go. This image has to pop! It has to sizzle! Get cracking!

"Let's see. What does this image need?"

It helps that you know the core characteristics of all appealing images. Right? You need to determine what's lacking in this cover shot. There are reasons why the colors are flat and the model appears ill. You need to figure out what needs to be done and how best to go about it. By the way, there are eighteen more digital photos from this same "photographer" ("The camera store guy said I just point and shoot!"), all need to be evaluated and fixed by the end of your shift today. Three need the backgrounds dropped and shadows added. The writer wants that "old-time, Matthew Brady sepia look" on one. Let's go! Let's go! Let's go!

Right about now, your imagined occupation is losing some of its coolness.

"Nineteen images analyzed *and* corrected in one shift! What? Do they think I have some kind of system? Three outlined, with drop shadows! Those drop shadows I did for the computer products last issue looked okay. The one for the auto ad came out pretty crappy. Those Chrysler dealers were *not* happy. Like I'm some sort of artist? Maybe there's a slam-dunk drop shadow filter on the Internet. Sepias? How do I do that with CMYK inks?"

If these or similar thoughts are assailing your fantasy of a career in color reproduction, this book is for you. It is possible to get all of the above-mentioned work, and more, done in one shift. It is not only possible, it is necessary to understand the reasons why some images look great, and others don't. It

is possible to employ a systematic approach to quickly and accurately evaluate images and carry out needed improvements. Appealing images are not only visually superior to unappealing images, they are *measurably* superior as well.

I came to write this book after years of waiting for someone else to. I teach at a private, two-year technical college in Minnesota. As the Principal Instructor in Digital Imaging, it is my responsibility, every year, to receive a dozen or two young sons and daughters of toil and turn them into competent color technicians. For the most part, these young folks don't have a day in the trade. Many aren't sure they're college material. They are visually oriented, interested in drawing, color, photography, painting, and design. Since they prefer regular meals to starvation and regular paychecks to poverty, they tend to expect employment in their chosen profession on graduation (if not sooner) as part of the package. And we deliver. Our placement rate of program graduates hovers at or near 100% annually, even in soft-market cycles. Our graduates land operator level jobs at some of the most prominent prepress houses, printers, creative agencies, corporate in-plants, and photo studios in the area.

My background is production and prepress. I come from the real world of print production and that's where my students go. Few of us indeed spend our careers painstakingly crafting superb photomontages and killer portfolio pieces. We work under deadline pressures and with mediocre originals, as often as not. We're usually presented with a big pile of *what* needs to be done, *when* it needs doing (it's always urgent), and our job is to determine *how*, posthaste, and with great dispatch. We need to be both *effective* and *efficient*. The book I was after would describe exactly what it is that makes a printed image grab one's attention and hold it. It would enumerate and prioritize the characteristics of an appealing image. It would present a system for image analysis and correction.

So I combed the publishers' catalogs annually, searching for a book that was software version-proof, cross-disciplinary, cross-platform, and core knowledge-laden on the subject of color imaging and color correction. Never found it. On one of my periodic tirades on the subject, I must have said something like, "If I have to write the danged thing myself..." to a Thomson Delmar Learning book rep, and the next thing I know, there's a contract overnighted to my house.

Shoot! Now I have to deliver! Much like the stressed out color specialist at the beginning of this preface. So, let's go! Let's go! Let's go! By the end of this book, we'll both be superstars.

Preface

Few days in our lives go by when we don't interact with published color images. If one were to simply log every instance during a given day that involved viewing a printed photographic color image, whether that image was in a newspaper, magazine, poster, label or package, billing statement, or side of a bus or truck, the tally would truly be an eye-opener. Add to that all of the static color images we encounter on Web pages. Additionally, color ink flies off the shelves at discount stores everywhere as more and more of us print the images we shoot on our digital cameras.

Some of these color images look great. Some, well, could use a little help. Why don't they all look great? Don't our computers take care of that somehow?

This book is intended for anyone who is now, or will soon be, responsible for the outcome of published color images. This general classification includes graphic designers, prepress technicians, digital artists, photographers, and Web designers. It is designed as a classroom textbook, intended for the two-year and four-year college student pursuing any of the various graphic communications or digital art careers. This book is also for the continuing education market, serving the worker in the printing or publishing industry who is shouldering added responsibilities or preparing for opportunities that include color image editing. This book certainly can be used by anyone who is interested in the subject matter for personal use, which now includes anyone who owns a consumer digital camera and cares to know how to evaluate their captured images and carry out the required tweaks that ensure the best possible printed outcome.

Emerging Trends

These are exciting times for those involved in any of the various areas of graphic communications. Delivering the right message to the right person as effectively and coherently as possible includes much of the information being presented in the form of color images. Technology has not replaced color printing. In fact, modern technology is driving color printing. Why is more paper and more colorant (ink, toner, etc.) being consumed by more organizations than ever before if

print is, as so many claim and apparently want to believe, dead?

Color printing is becoming increasingly decentralized. Corporate in-plants are growing. Color printers are becoming the ubiquitous appliance in our home offices and dens. Digital service bureaus are appearing everywhere. Technologies are converging, and with them, job descriptions. The once clear lines between designer and printer are dissolving. It is not only possible, it is becoming commonplace for the same person to take a job from design all the way through to print. It happens every day in your local Insty Prints.

Databases are spilling over with color images that need to be repurposed and republished on demand. What runs in today's newspaper is on yesterday's Web page and will be needed for next week's ad campaign. The deadline is tomorrow morning, if not later today.

One result of technological convergence and tight expectations is the replacement of the professional color retoucher, digital or otherwise, to whom we entrusted the responsibility of all our color editing needs, with whoever isn't busy at the moment that can do this work. The same person who was doing layout and typesetting yesterday and running the wide format inkjet printer the day before has to be the Photoshop ninja today.

The more efficient and effective they are, the sooner they can complete the color editing work in front of them and get on to something else.

Background of This Text

I wrote this book because no one else would. I teach students, aged 19 to 59, digital image editing. Most are educating themselves to compete for industry jobs. Many are already employed and are sharpening their skills to remain

competitive. Because software and related color imaging technology evolve so rapidly, it is necessary to master the transferable color skills that survive from software version to version, and from offset press to flexographic press to digital printer. These same skills come in very handy for optimizing the digital photographs accruing in the family digital photo album.

I never found the exact book that mapped itself nicely to the skill set that I needed to pass on. This is it. The knowledge contained here, though framed with Photoshop examples, recognizes that not everyone can afford Adobe Photoshop. Last year I discovered an extraordinary open source software called the GNU Image Manipulation Program (GIMP). The GIMP is free, first of all, and though it isn't Photoshop's equal, it has all of the features that are required by the serious amateur or interested family photographer, and much more. It also gives the impoverished student (or school district, for that matter) one more educational tool, one more outlet for hands on experience. It's amazing how much capability the GIMP features, far surpassing the usual software bundled in the consumer digital camera package. This book refers to the GIMP as another illustration of the subject matter, of how certain of this book's ideas are addressed elsewhere than in Photoshop.

The knowledge in this text was acquired over decades of experience in the graphic communications industry. I've worked in the color reproduction arena in production positions, management, technical support, field training, and now formal technical college instruction. There is no tallying up the color scans, color corrected images, dot etched film, color proofs, analyzed press sheets, International Color Consortium (ICC) profiles, and digital photographs that I have produced in the past 25 years. I've had the

good fortune to work with and learn from some outstanding photographers, scanner operators, color retouchers, prepress technicians, press operators, and process control experts. I've produced work for offset printing, gravure, flexography, and every variety of digital print.

Every statement in this book, every exercise, every morsel of information has been thoroughly tested, tried before, personally experienced, taught repeatedly, and proved out.

The walls in my college's Graphics and Printing Technologies program are filled with plaques. Our trophy case is crammed. Every plaque and trophy is industry recognition of the quality of the student work coming out of our program. Technical education's goal is demonstrable competence in the chosen occupation. More than eighty of our students have demonstrated competence on the national level in the past 6 years, and the number increases annually. All of our graduates get hired. The same information that they have absorbed, year after year, is in this book.

Anyone with basic computer skills, an inclination toward the visual, and an appreciation of color and color images will find useful information here. The student pursuing a career in graphic design, prepress, digital imaging, photography, or printing will find the entire text useful in their career preparation.

Textbook Organization

This book is organized to impart the bedrock knowledge that supports all color imaging activities. Namely, why do images that look great, look great? Why do they print well?

The book begins with simple concepts and techniques and works its way through intermediate-level information and editing strategies and finishes with an introduction to the advanced knowledge areas of color management and contract proofing.

Chapters 1 through 5 define the basic characteristics of appealing images and the normal strategies for ensuring that those characteristics are accounted for. The next two chapters, Chapters 6 and 7, guide the reader through image evaluation and overall correction strategies. Chapter 8 deals with localized editing through masking and targeted color adjustments. Chapter 9 discusses the uses of very localized editing with brush tools. Chapter 10 enumerates common special color treatments such as duotones, sepiatones, and Euro grays, and covers the concept of drop shadow creation, a necessary skill for color image technicians. Chapter 11 focuses on the topic of color management and the relationship between the color correction process and the color managed process for optimal image reproduction.

A glossary of terms common to this book and the color reproduction industry at large is included. There is an appendix of additional resources useful to the color specialist, including books, Web sites, and software. Also included is a CD with all of the images required for the exercises in this book, several color control elements with instructions for use for the evaluation of printed data, PDF files of the Image Evaluation Checklist and other useful charts, and a number of white papers that support some of the topics covered in this text.

Features

The following list provides some of the salient features of the text:

- Objectives that clearly state the learning goals of each chapter
- Clear and concise explanations showing how to prioritize color correction options,

from simple to difficult, and from least to most likely to succeed

- Directions on how to measure color proofing and printing to evaluate compliance with industry and in-house standards
- Before-and-after images showing how flaws in images can be detected and corrected
- Step-by-step strategies for efficient image correction, helping readers make sense of the many processes involved in working with digital images
- Review questions reinforcing the material presented in each chapter

Resources

This guide on CD was developed to assist instructors in planning and implementing their instructional programs. It includes sample syllabi for using this book in either an 11- or 15-week semester. It also provides chapter review questions and answers, exercises, PDF documents, PowerPoint slides highlighting the main topics, and additional instructor resources.

ISBN: 141801432X

About the Author

Pete Rivard has racked up 25 years in the Graphic Communications industry with production and management experience in offset, gravure, flexography, and digital print. For the past 11 years, Rivard has concentrated on workforce education, first as International Paper's Upper Midwest Regional Technical Support and Training Specialist and the past 6 years as Principal Instructor-Digital Imaging at Dunwoody College of Technology in Minneapolis, Minnesota.

Rivard was named the Julian Andersen Outstanding Graphics Instructor of the Year in 2002. The Electronic Document Systems Foundation (EDSF) awarded his program the 2004 Excellence in Post-Secondary Education Award. The Harper Corporation recognized the program as Flexographic College of the Year in 2002 and 2003. In the past 6 years, Dunwoody students have won over eighty regional and national awards for printing excellence. Rivard is devoted to the task of program recruitment and industry awareness among high school students, and travels the length and breadth of Minnesota and neighboring states talking up graphics and printing careers. His articles on the subject can be found at www.ondemandjournal.com.

Pete Rivard is actively involved with The Printing Industry of Minnesota, Xplor International, and the Flexographic Technical Association, and supports the work of the IPA and the PODi whenever he is able.

Acknowledgments

The author would like to thank the photographers whose work graces this book: Joe Esker, Harold "Stoney" Stone, Teresa Aldridge, and Marylou Rivard. I'm also indebted to the crack editorial team at Thomson Delmar Learning, particularly Jaimie Wetzel, Jim Gish, and Niamh Matthews. This book is strongly inspired by my colleagues Joe Tuccitto, Stoney Stone, Megan Garner, Jeff Keljik, and the other Dunwoody instructors laboring on their own books.

No one becomes expert on any subject without benefiting from the knowledge and experience of others. I would like to thank everyone who ever taught me anything on the subject of color. In particular, I have learned much of value from Manny Cameratta, Donna Morris, Mark Jones, Bob Greer, Ken Ives, David Valentine, Rick Haring, Brian Holmberg, Mike Billstein, Amy Cullinan, Bob Gilmore, Tom Holzinger, Greg Schaffner, Joe Stafford, Brad Christian, Ken Smith, Cal Dahl, Roy Bohnen, Timmreck, John Jaquinde, Keith

Gilbert, and Dave Kline, and especially the aforementioned Joe Tuccitto and Stoney Stone.

Thanks also for the generous support of Esko-Graphics, Kodak Polychrome Graphics, the Harper Corporation, X-Rite, Gretag-Macbeth, Chromaticity, Xerox, QDS, Latran, Mark-Andy, Xsys Ink Systems, DuPont, 3M, Heidelberg, the Foundation, Rimage, 4Site, CGS, and Creo in delivering best in-class education to the next generation of color reproduction technicians. Thanks to Noel Ward for giving me space and opportunity on ondemandjournal.com to sharpen my writing skills and Frank Romano for general inspiration and some good conversation. And thanks to Thomson Delmar's local book rep, Charlene Drill, for talking me into the whole thing.

Thomson Delmar Learning and the author are indebted to the following reviewers for their valuable suggestions and expertise:

Patricia Bruner
Coordinator, Graphic Arts Technology
 Department
Harper College
Palatine, Illinois

John Craft
Graphic Arts & Imaging Technology
 Department
Appalachian State University
Boone, North Carolina

Mark Millstein
Design Department
University of Massachusetts-Dartmouth
North Dartmouth, Massachusetts

Steve Suffoletto
College of Imaging Arts and Sciences
Rochester Institute of Technology
Rochester, New York

Thanks to Bela Fleck and the Flecktones for providing the background music for many hours of writing and supporting image work. I blame all missed deadlines on Tiger Woods.

Pete Rivard
2006

Questions and Feedback

Thomson Delmar Learning and the author welcome your questions and feedback. If you have suggestions that you think others would benefit from, please let us know and we will try to include them in the next edition.

To send us your questions and/or feedback, you can contact the publisher at:

Thomson Delmar Learning
Executive Woods
5 Maxwell Drive
Clifton Park, NY 12065
Attn: Media Arts & Design Team
800-998-7498

Or the author at:

Pete Rivard
Principal Instructor—Digital Imaging
Dunwoody College of Technology
818 Dunwoody Blvd
Minneapolis, MN 55403
privard@dunwoody.edu
612-381-8214

This book is dedicated to Marylou and Ethan, who picked up the slack around the house while I toiled away at this work. Also to Matt and Carrie, who supported me in spirit from a safe distance.

1

The Four Characteristics of Appealing Images

Chapter Learning Objectives

- Understand that all appealing printed photographic images share common characteristics
- Be able to list these four common characteristics in their proper order
- Recognize the roadblocks that prevent color reproduction professionals from a shared acceptance of these common characteristics

The color reproduction specialist, the photographer, the graphic designer, the prepress technician, and the press operator all stand squarely at the intersection of art and science—a place where visual impact can be quantified and numbers turned into colors. The bedrock knowledge, or color wisdom if you like, acquired by those who work at this intersection of art and science is transferable from occupation to occupation and software version to software version.

The importance of transferable knowledge is greater than ever today, when software versions last a year, at best. New color devices come on the market monthly. Employers know this. No one is more concerned about the abilities of the workforce to adjust to changing technology than the folks who sign the paychecks. Employers look for talent who can transform their knowledge on a regular basis, multitask, and learn on the fly.

It is entirely plausible that a color technician might work on color images in Adobe Photoshop on a Macintosh in the design or prepress department at his workplace only to come home and sharpen the family digital photos using the GNU Image Manipulation Program (GIMP) on a PC.

There are those who complain about the "craft" in the color reproduction trade being eliminated by the computer. The informed worker in this color field realizes that the craft, which is capturing images and then reproducing them on paper (and other substrates) with ink (and other colorants), is the same. Only the tools change and evolve. The worker in this color arena needs to change and evolve with the tools. The best way to do this is to understand and take guidance from those core realities that do not change. The features that support a successful color image do not change with technology. These features, and how we arrive at them using current technology, are the subject of this book.

It's Hip to Be Square

This book is about digital imaging. So, in effect, it is a book about pixels. Pixels, as most of you are already aware, are those tiny squares that have some sort of color to them which make up a digital image. The more of them there are in a digital image, the more we have to work with and the more satisfying our results will be. You have to zoom well into a displayed file just to see them (Fig. 1-1).

Artists have been creating the illusion of painted, or even semi-realistic, images out of colored, square tiles for millennia (Fig. 1-2). These mosaics have been dug out of the ash at Pompeii. They appear among the remains of the ancient world, when artisans were once employed to compose mosaics based on scenes of contemporary belief or everyday life for patrons of the arts to wander by or walk upon. Thousands of little ceramic squares of various color values were organized and arranged to trick the eye and brain into instant recognition of a coherent image.

The beadwork of the Native Americans and others takes advantage of this same approach. In this case, beads of different hues are lined up and organized along tightly packed parallel strings to form distinct logo-like graphics (Fig. 1-3), some examples of which are complex enough to form a

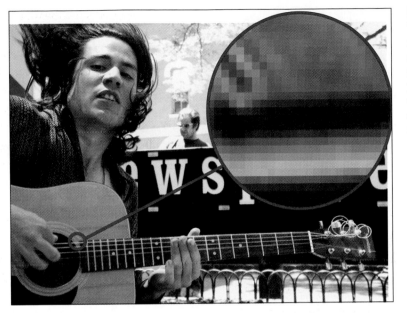

Figure 1-1
The magnified view from the detail area shows individualized pixels. There are 90,000 pixels constructing the details in every square inch of this particular image.

narrative. Those who practice needlepoint in essence do the same basic thing; they form images from adjacent single-colored stitches, each stitch in its own way a pixel of color information, like mosaic tiles.

Our task is to master the control of pixel creation, conversion, and output in order to produce realistic photographic images and special effects on demand. We need to go beyond the concept of pixels themselves and consider some of the same subject matters with which artists and photographers have always contended. What are the realities of producing successful images, whether we use oil paints, pastel chalks, or computer-generated pixels? How do we attract and

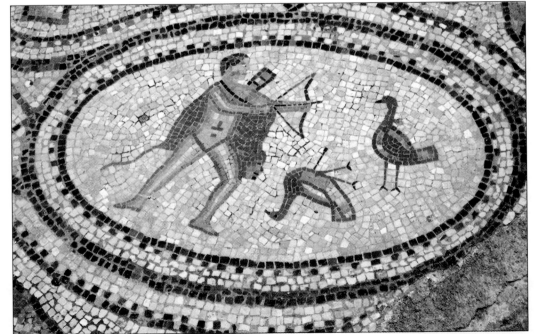

Figure 1-2
This ancient Roman mosaic from Morocco is an example of an image constructed from small colored tiles, much like the modern digital image.

Figure 1-3
Monochrome (single-colored) beads on the hand drum are mixed and arranged to produce logo-like graphics.

hold the attention of the viewer? What is it that makes certain images striking and others hardly worth noticing?

The path to becoming a color specialist, an imaging ninja, begins with understanding what makes up an image that is appealing, striking, three-dimensional, evocative, and even moving. Knowing how to carry out an adjustment in Photoshop or the GIMP is of no use unless you also understand why you are adjusting the image in the first place.

Figure 1-4
The color specialist may be called on to do a variety of tasks.

The Color Specialist

Let's call our worker in the color reproduction industry a **color specialist**. The color specialist works in that inexact space between the capture of the original subject or scene and the destined output of that original, in whatever designed form it has been placed. We call that working space *inexact* because there are so many variations, so many possibilities of activity, between the original photograph and the published piece (Fig. 1-4).

The following is an example of a very simple color workflow (a **workflow** is a set of numbered steps that are organized to accomplish a task) (Fig. 1-5):

1. Shoot a digital photograph.
2. Upload the resulting digital image to a computer.
3. Print the image to a color printer.

The following is an example of a complex color workflow (Fig. 1-6):

1. Shoot several digital photographs.
2. Scan several more originals (prints, watercolors, 35 mm negatives) provided by the customer.
3. Silhouette and remove the backgrounds of several of these images, adding black drop shadows.
4. Assemble all images in a page layout application into a four-page brochure.

5. Convert one copy of the brochure to PDF, color managed for a specific production press, and print that PDF to a color managed proofing device for customer approval.
6. Show the color proof to the customer and mark up all required changes and corrections.
7. Carry out all the color corrections and changes that the customer asks for.
8. Print a color proof of the corrected file for customer approval.
9. Show that second proof to the customer.
10. Convert one copy of the finished, customer-approved piece to HTML and forward to the Web design department for incorporation into a Website.
11. Forward a second copy of the approved piece as a PDF file to the output department for ripping to digital color plates.
12. Show up at pressside after the plates have been mounted on press and the press inked up to compare and approve printed sheets to the customer-approved color proof.

Two workflows. One has three steps; one has twelve. The first is easy to understand. The second may be completely bewildering to anyone but an experienced professional. Both workflows happen every day, all over

Figure 1-5
A visual of our simple workflow.

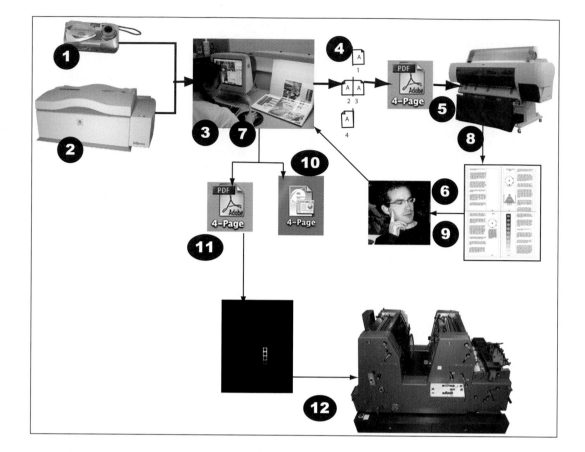

the world. And every variety and combination of different workflows occurs between our two examples. The color specialist will be involved in several variations of workflows no matter where he works. The truth of the matter is, the workflows that one becomes familiar and comfortable with will change annually as software versions are tweaked and color devices become outmoded and replaced. That is why we call the color specialist's indigenous habitat an inexact space.

An array of originals, from 35 mm negatives to digital photos to watercolors, arrives every day and becomes part of digital documents targeted to an ever-expanding array of output devices: wide format inkjets, offset presses, digital presses, computer-to-plate, flexography, the Web, CD, and DVD (Fig. 1-7). The duties of the color specialist may include scanning, file translation, color correction, retouching, digital janitorial work (dust, scratch, and hair removal), color special effects, color proofing, device calibration and characterization, and image measurement and evaluation.

In some cases, the photographer and the color specialist are the same person. And, with increasing frequency, caused by the growth in digital printing, the roles of the color specialist and the press operator are combined into one person. Maybe that person is you.

Tying together all these task categories is the big picture. What exactly is our job? Simply stated, our job is to deliver images that are in an optimal state to the output device, be it a press, ink jet printer, or computer display. By optimal, we mean an image that can't arguably be improved, given its particular destination; it can only be changed with further work. How can we

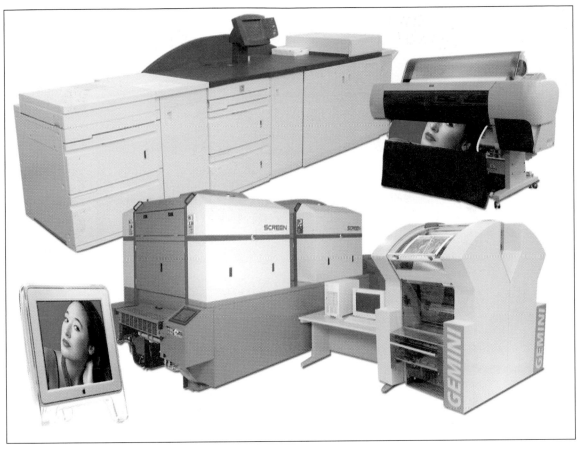

Figure 1-7
A few of the many different color publishing devices that the color specialist might interact with.

possibly know when an image can no longer be improved? We're going to spend the remainder of this book learning just that.

Roadblocks to the Optimal Image

Let's begin by briefly considering the common roadblocks that prevent many images from ever reaching an optimized condition. One of the issues has to do with language and terminology. *What do terms such as "contrast" and "snappy color" actually mean?* What are clients asking for when they say an image needs more "pizzazz"? How does one increase "pizzazz"? By the end of this book, you will be able to translate virtually any slang into a corrective strategy that produces what is asked for. If you choose to report to your customer that you increased the "pizzazz" by 17%, that's your business.

And what's all this talk about "color management"? Is that the same as "color correction"? Does that mean that color correction is becoming managed by software and making the process totally automated? Is there going to be any need for color specialists in the next 4 or 5 years? There have been several technological breakthroughs in the past two decades that were supposed to render people who do what we do obsolete. Yet, every day, people wave around immensely disappointing printed samples and ask, "How could this have happened?" See Figure 1-8.

Everyone sees color differently. I'm not convinced. Data collected by years of testing

Figure 1-8
A pile of fine books on the subject of color. The one that actually defines why certain images look good and others don't is the one you're holding.

a variety of people at my college using the Farnsworth-Munsell 100 Hue Test indicates that the average member of the human species seems to see color in a remarkably similar fashion to most other members of the human species. Differences between any two given test takers in our database tend to be incremental, rather than gross. Only those individuals afflicted with severe hue discrimination issues seem to see color radically differently from the average person. This "everyone sees color differently" is used every day to shore up the position that there is no way to predict how one's client is going to react to the quality of an image.

Color is entirely subjective. Nonsense. This is the companion excuse to the "everyone sees color differently" claim used by those who perhaps have misinterpreted or exaggerated whatever they've read on the psychology and cultural aspects of color. Although good taste is not universal, and certainly cultural differences do exist regarding how different peoples interpret color, nearly everyone can come to some form of agreement over the relative appeal, or lack thereof, of a given printed image. If color were entirely subjective, every pressrun would dissolve into strife, as no one would have any idea of the preferences of, or ever reach agreement with, anyone else (Fig. 1-9).

Put a beautifully reproduced image next to a poor or even mediocre version of the same image, and the vast majority who are asked to choose between the two will select the same image. Let's consider an example:

Have a look at Figure 1-10A.tif and Figure 1-10B.tif. Now, make a snap judgment of the one you prefer. Did you pick Figure 1-10B? Good. You just passed the first level of certification as a color specialist. If you prefer Figure 1-10A, sell this book to a friend and consult a career counselor.

How do we get past this gumbo of slang terminology, overreliance on technology, and

Figure 1-9
See? These folks aren't fistfighting. They're reaching an agreement of the quality of the printed piece.

Rivard's Pyramid

Rivard's Pyramid represents this text's philosophy on image adjustments in a single, all-encompassing model. As we progress through the book, we will return to Rivard's Pyramid frequently to reference where we are in relation to this model in order to classify the manner of adjustment chosen, to understand how much time is going to be required, and whether there is much inherent risk in our given approach. And by risk, we mean doing as much or more damage to the image as we are improving it.

The bottom line is that all image adjustment should be as unobtrusive as possible. We don't want to call attention to the fact that we've edited or altered the image in any way. We want to leave no trace behind. Just like a camper in a wilderness park, we don't want to litter or leave any manner of evidence that we were there in the first place.

As we look at Rivard's Pyramid, the lower we are on the pyramid, the closer to safe ground we are. Adjustments near the bottom are overall in nature, very natural looking, and with a high degree of success, as a rule. As we climb toward the peak, we are on increasingly risky footing, with an increasing possibility of failure, and a much higher level of skill needed. Time required increases as we climb, and with it, expense. There is a color version of Rivard's Pyramid in the color plate center section, as well as on the accompanying CD.

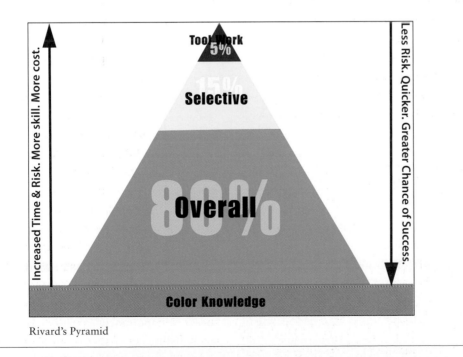

Rivard's Pyramid

well-regarded misunderstandings? Is there an underlying framework of sound knowledge and sound habits that contributes to the successful reproduction of color? I hold that there is. This book attempts to present this knowledge and these habits in an organized fashion.

Defining the Optimal Image

There are particular and precise characteristics to any appealing color image. These characteristics, or attributes, are ordered in a certain fashion. Some have greater influence over the success of a color reproduction than others, or at least need to be attended to in a certain order, so that the adjustment of one attribute doesn't undo or distort the results of another adjustment.

Color specialists armed with this knowledge are effective and efficient, thus productive. By *efficient*, we mean using time wisely to maximize effort. By *effective*, we mean getting something of worth accomplished. So, *productivity* becomes the art of accomplishing much of value in as short a time as possible. Color specialists become effective when their color adjustments are directed with a high degree of useful information, resulting in intelligent decisions that yield satisfactory results. They become efficient as the practice of any system yields speed through repetition. Also, the systematic, step-by-step approach reduces the chance of forgetting to do something important, what Catholic grade school teachers call "sins of omission," caused by sloppy, haphazard habits.

Depression-era, cowboy philosopher Will Rogers once said, "Everybody's ignorant. Just on different subjects." That's as true today as it was 80 years ago. Let's define once and for all what constitutes an optimal image and reduce the general level of ignorance in this color reproduction trade of ours.

The Four Characteristics

This book is based on the central concept that there are four core characteristics to any optimal color image. On the accompanying CD is a classroom exercise that is useful in getting groups of people, students or seminar attendees for example, to discover these core features for themselves. To save time, I'll come right out and identify them.

Here they are, folks! Please welcome the four characteristics!

1. **Contrast**
2. **Balance (or gray balance)**
3. **Sharpness and detail**
4. **Believable colors**

Each of these characteristics is covered in its own chapter. They are all crucial to the success of a color image. And they are interconnected. Change one, and you affect all.

Contrast has to do with the visual, and measurable, difference between the light and dark areas in an image. **Balance**, or gray balance, has to do with the image being free of any particular color bias, such as would be created by looking at the image through tinted glasses or filters. **Sharpness and detail** has to do with the image looking properly focused with well-represented details and transitions. **Believable colors** are those colors that print as we would expect them to, based on our own visual experience and memory. These colors are properly saturated (or rich), have the right shape and hue, and relate naturally to other tones in the image.

Why this particular order? Over time, experience in scanning, color correcting, evaluating images, and evaluating press-runs tend to sort out these attributes in order of importance. There simply is no use in adjusting gray balance before the overall contrast has been set, as overall balance can be skewed slightly out of true by contrast moves. Similarly, adjustments in overall

sharpness, normally accomplished via **Unsharp Mask** filtering, can again be accentuated or minimized by Contrast adjustments. Generally, when Contrast, Balance, and Sharpness are properly set, there is little or no color correction needed. So it would be damaging to adjust individual colors first and then rebalance or change contrast to the image.

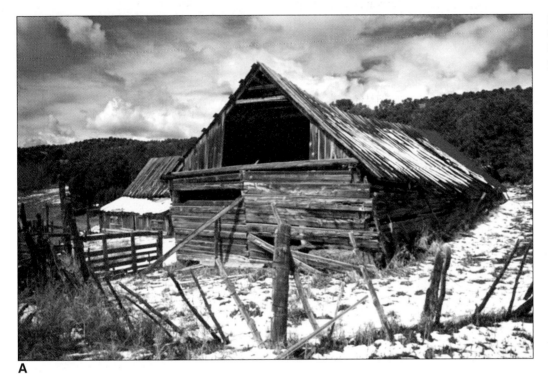

A

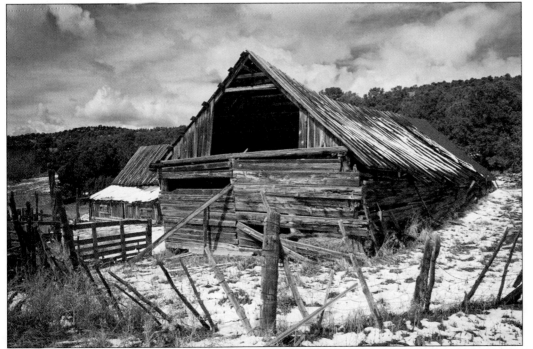

B

Figure 1-10
Compare image A with image B. Which one do you prefer? Why?

Let's look again at Figure 1-10A.tif and Figure 1-10B.tif with a more informed sensibility. There are four demonstrable reasons why Figure 1-10A is inferior to Figure 1-10B, and those reasons are a failure of Figure 1-10A in each of our four categories.

Figure 1-10A flunks the Contrast category as it shows simply too much contrast. The highlight, or whiter, areas are blown out, or devoid of detail. The shadow areas are plugged, meaning they are oversaturated, and so also lack detail. Figure 1-10A flunks the Balance category, as the entire image looks too pinkish, or reddish. Every area of this image shows an unnaturally reddish-pink cast. Figure 1-10A flunks the Sharpness and Detail category, as it is blurred and out of focus. Finally, Figure 1-10A flunks the Believable Colors category as the combination of exaggerated contrast, reddish cast, and blurred detail conspire to skew the picture's colors off in terms of saturation, hue, and shape.

Figure 1-10B, on the other hand, sails smoothly through all four categorical evaluations. The Contrast is properly set, showing highlight and shadow detail and an agreeable transition of tonal values throughout. The Balance is properly set, resulting in gray items in the original scene, such as the weathered wooden fence posts, barn timbers, and roof, appearing as balanced neutrals. The image evinces pleasing Sharpness and Detail, as it is clearly in focus and replete with fine detailing. Finally, the colors in the browns of the barn, the trees in the background hills, and the blues of the sky show an appealing combination of saturation, hue, and detail.

Each of the above-mentioned core attributes will be covered in depth in its own chapter. We will see that each of these four attributes can be evaluated visually and numerically. Once evaluated, the given numbers, when compared against the optimal numbers achievable, will yield the exact direction and amount of adjustment needed to reach an optimized state.

The Farnsworth-Munsell 100 Hue Test

The single critical need for any color specialist is accurate hue discrimination ability. A person who expects to make a color evaluative career in the graphics, printing, and publishing trade has to be able to see color well. One will occasionally hear anecdotes regarding "color blind" people working "strictly by the numbers" who are awesome color correction technicians. I take those tales with a large grain of salt. Ours is a visual occupation. Those encumbered with a color deficiency toward red or green or severe color blindness are at a huge disadvantage when evaluating images.

Sound hue discrimination is a measurable and demonstrable ability. An extremely accurate test, and one that we use on all students in Dunwoody's Graphics and Printing Technologies program, is the Farnsworth-Munsell 100 Hue Test (Fig. 1-11). (The test name is somewhat boastful, as there are actually 85 chips.) Nonetheless, this visual evaluation delivers a complete analysis of someone's hue discrimination abilities, complete with a computed result that is graphed, enumerated, classified by the categories of Superior, Average, and Poor, with further details (Fig. 1-12).

The test is given in a timed condition under industry standard, 5000 Kelvin lighting. There are four boxes, or "sticks," to the test, each containing 20 or so colored moveable chips arranged between two fixed chips, one on each end of the box. The chips vary by hue only, having equal saturation

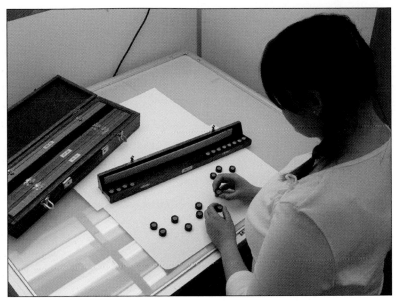

Figure 1-11
This person is taking the 100 Hue Test to evaluate her ability to recognize small changes in hue.

and brightness values, and they don't vary by hue very much. The job of the test taker is to rearrange a completely mixed up array of chips into an orderly, smooth transition, progressing from the first fixed chip to the last.

Each chip is numbered beneath, so the test giver has only to close the box lid and flip the chips upside down to view and score the results. Each box takes the test taker one-quarter of the way around the color circle.

The lower you score on the 100 Hue Test, the better (like golf). A perfect score on the 100 Hue Test is 0. This score results in a perfect circle on the graph in the center of a dozen or so concentric rings. As errors in the chip placement are encountered, the perfect circle begins to show bumps and flares away from the center which becomes more pronounced as the severity of the test taker's color vision woes increase.

Figure 1-12
Three samples of 100 Hue Test results from people of varying hue discrimination ability.

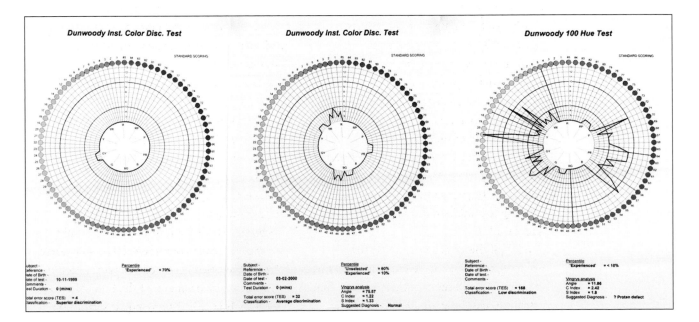

My own experience is that anyone who scores in the Superior range (0–16) is a slam-dunk candidate for color evaluation responsibilities. In fact, those who score on the higher end of the Average designation (say, 17–32) also seem to have no trouble with color reproduction tasks. As the score increases, so does the likelihood that the individual in question will feature a weak hue area, which will create problems with their abilities to notice and carry out needed corrections in that color zone.

Chapter 1 Summary

Advances in technology drive hardware and software development at such a rapid pace that it is difficult, if not impossible, to become comfortable with any color system before it is outmoded and replaced. It is more important than ever to grasp the transferable knowledge and skills related to color image editing and reproduction in order to flourish amid the tumult. There are four characteristics to appealing images:

contrast, balance, sharpness and detail, and believable colors. Understanding this group of core attributes and generalized techniques for evaluation and correction of these attributes provides a framework upon which to base any new technology.

Chapter 1 Review

1. Why do we say that the color specialist stands squarely at the intersection of art and science?
2. Contrast an example of transferable knowledge with an example of software-specific knowledge.
3. Name three color-related misconceptions commonly encountered in discussions related to image reproduction.
4. Identify the four characteristics of an appealing printed photographic image.
5. Give two reasons why any color professional should have his hue discrimination ability evaluated via the Farnsworth-Munsell 100 Hue Test.

2

Contrast

Chapter Learning Objectives

- Understand what people mean when they use the term "contrast," visually and numerically
- Grasp the meaning of the phrase "dynamic range"
- Grasp the meaning of the phrase "tone distribution"
- Learn how to manipulate the end points and the three pivot points of the gradation curve to best control the contrast in an image

The human eye is not a reliable color measurement device. It is not given to us to view a particular color on a computer monitor, for instance, and compute the exact red, green, and blue values that combine to make up that color. Many of us who have been at this line of work for years can hazard a close guess, but none of us will hit the exact values every time, or even most of the time.

In fact, it is debatable whether we would notice the difference between two colors, side by side on our color display, where a single digit has been shifted in one of the red (R), green (G), or blue (B) values. A brown swatch made up of 85R, 60G, and 30B will appear identical to most of us to an adjacent swatch composed of 85R, 59G, and 30B. Only those gifted with the most refined hue discrimination might notice a slight variation between the two, and then only because the two swatches are right next to each other. The further apart the two swatches are moved, the more difficult it becomes to notice that meager variation. If we view those two swatches separately, then it becomes virtually impossible to detect any difference.

Enter the notion of contrast. We human beings are programmed to notice variation. Our eyes are drawn to difference. We are wired to ignore sameness and focus on difference. When we say that an object "stands out," we are stating that that object is not the same as what it is near. The phrase "stands out" even has a positive connotation. The word *outstanding* carries a best-in-class meaning. A person or experience is *outstanding* when she or it is not the "same as it ever was."

That noticeable differentiation is exactly what we mean when we use the term contrast in the color reproduction trade. Contrast means difference and variation in the visual information that makes up an image. The more difference there is in an image, the more our eyes will be drawn to it (Fig. 2-1).

The hardcover edition of *Webster's Encyclopedic Unabridged Dictionary of the English Language*, which can be used to enhance vocabulary and tone forearm muscles, defines contrast as, among other things, "opposition or juxtaposition of different forms, lines, or colors in a work of art to intensify each element's properties and produce a more dynamic expressiveness." Beautiful. Difference generates intensity and dynamics.

Webster's further defines contrast as "the relative difference between light and dark areas of a print or negative." This is closer

Figure 2-1
The white scarf in this image contrasts starkly with the other tones.

to home for those of us of the graphics persuasion. The difference between lighter and darker tones in an image, whether grayscale or color tones, provides contrast. Control the differentiation between light and dark tones, and you control contrast.

Generally, people prefer more contrast to less. Again, we are programmed to notice variation. The more contrast in an image, the more difference there is. Is it possible to have too much contrast? You bet. Bad things happen when contrast is overdone (Fig. 2-2). So how do we know when we have as much contrast as the image will take before those bad things happen? And exactly what bad things are we referring to?

Perhaps the best place to begin is to discuss the visual evidence of a sound image with regard to contrast. A hypothetical image with optimal contrast features clean whites and saturated, bright primary colors, rich shadows, and drawing and shape in colors and neutrals. Good contrast tends to help

photographic images appear less two-dimensional and more vibrant. Viewers will remark that the image "pops" or "looks snappy." It "jumps off the page." Not because there is any untoward gaudiness or unrealistic intensity to the image, but precisely because there is a believable feel to the image. It looks real.

As we lose contrast, the image quickly becomes less vibrant and appealing. Whites begin to appear dirty and gray. Colors lose saturation and also tend to "gray up." The more contrast we lose, the less difference there is between the lighter and darker tones. Images begin to appear "flat" and look "blah." Viewers begin to use terms like "muddy" and "foggy" to describe what they are seeing. Generally, images with too little contrast leave the viewer with a dissatisfied "aftertaste."

Conversely, images with too much contrast tend to alarm or disturb us visually. Highlights and whites are "blown

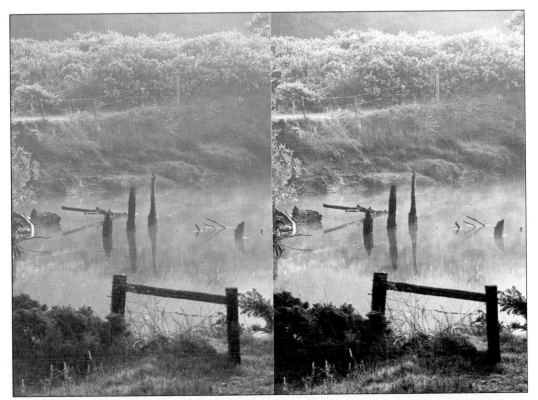

Figure 2-2
In this comparison, the image on the right suffers from too much contrast, and the misty mood of the scene is damaged by oversaturation of colors and harsh breaks in some of the transitions, such as the surface of the pond.

Figure 2-3
In this collage, the center image has more contrast than the image on the left, and less than the image on the right. The effects of too little or too much contrast, even on a grayscale image, are evident.

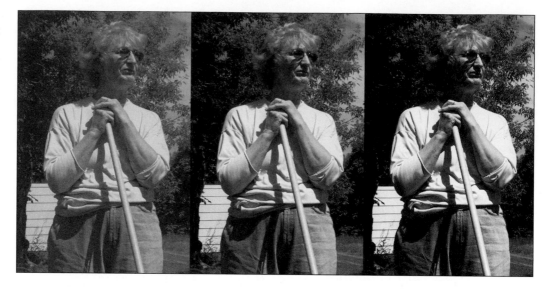

out" (reduced to a shapeless white paper value); colors are gaudy, oversaturated, and two-dimensional; definition is lost; and differentiation is grossly exaggerated (Fig. 2-3). Posterization occurs, which is severe differentiation between adjacent colors, resulting in the reduction of smooth gradients to crude, banded steps of colors or tints.

To be sure, not every image requires the same contrast treatment. The picture of the pond has that misty, early morning quality that can only be reproduced in print by constraining contrast. We need to prevent the colors from oversaturating and brightening because of an overly clean highlight adjustment.

Color Spaces

People have been striving to order the manner in which the colors that we can see can be diagramed since Isaac Newton. Newton was one of the first to organize a color circle, in an attempt to fuse geometric concepts with the visible spectrum. Color scientists, and indeed the entire color reproduction industry, now work to perfect three-dimensional models, known as color gamuts (Fig. 2-4), of achievable colors.

There are dozens of excellent texts of which I am aware that delve deep into the history and science of color and are well worth the read. This book is not one of them. On color as a subject in and of itself, and a fine companion text to this book, I highly recommend Steven Bleicher's *Contemporary Color: Theory and Use*. Though we need to be informed and confident about our knowledge of the subject of color, we don't need to be a color scientist or a fine artist to succeed as a color specialist. We color specialists are neither

Figure 2-4
RGB color gamut.

Figure 2-5
The digital camera and the computer display operate in RGB space.

pure scientists nor artists, normally. We are technicians of the visual realm.

However, one concept that must be grasped is the idea of **color spaces**. Color spaces are the three-dimensional models in which are found all the available colors resulting from the mix of particular red, green, and blue values, or cyan, magenta, yellow, and black colorants. For example, many digital cameras capture images and translate the captured data to the sRGB color space, which means that every color and neutral value in the original scene gets translated to a color or neutral that is available in the sRGB color space. Larger RGB spaces than sRGB exist, such as Adobe RGB, but for whatever reasons, many consumer level cameras use the sRGB.

A color reproduction specialist must be, at a minimum, competent in the interpretation and use of the RGB, CMYK, and CIELAB (LAB) color spaces as well as the Grayscale mode, from which we make duotones, tritones, and the like.

RGB, or Red Green Blue, space is known as the additive color space because the combination, or addition, of these three fully saturated transmitted colors create white light. The RGB color model is the color space of digital cameras, scanners, televisions, computer displays, and a few color output devices (Fig. 2-5). For the most part, it is useful to consider the RGB color space as an input and editing space. Images are captured as RGB data and best edited as RGB data.

CMYK, or Cyan Magenta Yellow blacK (the K actually stands for Key separation, for reasons lost in the misty past of color

Figure 2-6
Compare the size and shape of this CMYK color space (the gold squares) to the RGB space (the blue squares) in the center section.

reproduction), is known as the subtractive color space because white is created by subtracting these colors from their substrate. The three subtractive primaries cyan, magenta, and yellow combine at their most saturated values to form a near black. Because of light reflection and absorption imperfections, this combination of subtractive primaries tends to result in a brown, rather than black color. So neutral black ink is added to the mix to provide for the full transition of no color (white) to all colors (dark black). CMYK is the color space of proofing devices, color copiers, and printing presses.

LAB, or L*a*b*, space is the backbone of the color management process. Earlier, I mentioned that color management is the organized control of the entire color publishing process. LAB space is used as the transitional space that allows software programs to remap color values from RGB to CMYK or from one CMYK color space to another. LAB space acts as a color hub through which color values pass as they are translated, or remapped (Fig. 2-7). My own color correction experience persuaded me that more color alteration, particularly the outright change of a product from one hue to another, is best accomplished in LAB;

we'll cover how that's done in Chapter 5, Believable Colors.

LAB is interesting in that it diagrams all possible visible colors along three axes. Each axis ends in a perfectly saturated color, or gray value. The L* axis goes from pure white at the top to darkest black at the bottom. The a* axis goes from red to green, and the b* axis goes from yellow to blue. Where each color axis crosses the L axis is the perfect balance of the desaturated opposing colors, thereby creating a neutral, or gray condition. One way of thinking of LAB is viewing it as almost a six color space: RGBYWK.

How Is Contrast Controlled?

In my view, there are two components that, in collaboration, control Contrast. The first is **Dynamic Range**. The second is **Tone Distribution**. Many in the color reproduction trade think of Contrast and Dynamic Range as the same thing or as two different things. Both are misconceptions. There is a simple demonstration of the error of such thinking, but first, some definitions are needed.

Dynamic Range

Dynamic Range is the measured difference between the lightest and darkest information in an image. Generally, we want as much difference between the lightest and darkest data in the image as possible. The more difference there is between these two **end points** of lightest information, or **highlight**, and darkest information, or **shadow**, the more room there is to construct the rest of the image.

If Dynamic Range is the measured difference, just how do we measure it? Computing the Dynamic Range is simply a matter of subtracting the lowest value from the highest value.

Figure 2-7
LAB color space.

L White

+b
Yellow

-a
Green

+a
Red

-b
Blue

Black

The resulting difference is the Dynamic Range. Where we get those values depends on where in the process we are.

When scanning, the scanner acts as a densitometer. We can use the scanner to read the lightest and darkest values in an image. Some scanners will automatically find those values for us. In any case, we can leave them as is, or adjust them as needed.

When viewing color images on a computer display, the software used, generally Photoshop or a competitive product, will allow us to use our cursor as a roving densitometer and take readings of the highlight and shadow values.

For printed images, we use either a densitometer or a spectrophotometer to read the lightest and darkest values in the image.

In the case of your average printed grayscale image, the lightest possible value is the paper itself with no ink impressed on, and into, it. The darkest value is an area of solid black ink coverage where no paper is visible. Expressed as dot percentage, white paper is 0% K (black) and solid coverage is 100% K. Again, expressed as a difference in dot percentages, the dynamic range is 100 (100% K − 0% K = 100%).

There are a number of reasons why it is damaging to the image to feature either a 0% lightest value (highlight) or a 100% darkest value (shadow) in a printed grayscale image. For now, understand that as the highlight value increases to any value greater than 0%, 1%, or 2% for instance, or the shadow value decreases to any value less than 100%, the dynamic range of the printed grayscale image decreases.

If I measure these two values, white paper and 100% black, with a densitometer (assuming a coated sheet), the paper might measure 0.05 and the 100% black might measure 1.65 or so. Without knowing anything else regarding what these numbers mean, we can still subtract the lighter value from the darker value and arrive at a dynamic range of 1.60, expressed as density.

Measuring Light

Process control and quality assurance experts alike insist that if any part of a process can't be measured, then it can't be controlled. If we wish to control our process, we *must* measure it. This basic rule applies to any process, such as baking recipes, steel manufacturing, or producing music in a studio. The act of controlling any imaging process related to graphics production is the act of measuring light.

Let's start with the fact that, without light, we are unable to see. Anything that we do see, therefore, has some level of light associated with it, whether that light is transmitted from a source such as a light bulb, or is reflected from an object that we are viewing. Essentially, three light measuring devices in the graphics world are crucial in conducting our business of color image reproduction. These three devices are the **densitometer**, the **colorimeter**, and the **spectrophotometer** (Fig. 2-8). In most cases, the densitometer and the spectrophotometer are used to measure printed matter, such as color prints, proofs, and press sheets. Certain types of densitometers are used to measure transparent products, such as positive or negative film separations or color slide film. The colorimeter is generally used to measure light emitted from a computer display.

Any densitometer or spectrophotometer emits a known quantity of light at a certain color temperature (which assures that the light emitted is neutral and balanced, free of color bias) and then measures the amount of light that reflects off the surface of the measured area into the device's optics, or is allowed to pass through a transparent

Figure 2-8
Clockwise from left:
GretagMacbeth
Spectroscan; X-Rite
DTP92 colorimeter
(attached to laptop
monitor); X-Rite
361T transmission
densitometer; X-Rite 528
Spectrodensitometer;
X-Rite DTP41
strip-reading
spectrophotometer.

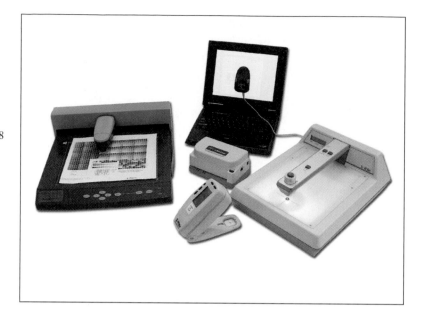

medium into the optics. The difference, or deviation, between the original emitted light and the measured returned light is translated into a value of density. This density value ranges from 0.00 (which is essentially clear air, blocking no light) to 6.00 (which is absolute darkness, allowing no light to penetrate or return to the optics).

Reflective densitometers, and certain types of transmission densitometers, are rigged with red, green, and blue filters that quantify the color components of the analyzed light. The information reported to the device's software by the red, green, and blue filters is often inverted to complementary density values of cyan, magenta, and yellow. This process allows the color specialist to judge the quality of a color print, proof, or press sheet, and even to use the measured information to calibrate a specific output device, and to print consistently from day to day and job to job.

A spectrophotometer is equipped with a prismatic grid in place of the red, green, and blue filters that permits much more sophisticated color analysis than the densitometer. The results of the light analyzed through the prismatic grid are

reported back, not as density, but as values which are plotted on three different axes: the L* axis, a* axis, and b* axis. The L* axis represents luminosity, which is the amount of light analyzed; the a* axis describes the relative red or green component of the color; and the b* axis describes the relative yellow or blue component of the color. These three values of L*, a*, and b*, or LAB, when added together, can describe any color visible to humans.

The colorimeter, rather than emitting light, reads transmitted light from a source, usually a color monitor, again using red, green, and blue filters. The results of repeated readings of different color values flashed into the colorimeter optics by the monitor are organized into a monitor profile, which is used in the color management process.

The two dominant vendors of color measurement solutions are GretagMacbeth and X-Rite. Both vendors provide measurement devices and related software solutions for processing data, supporting device calibration procedures, and color device characterization, or color profiling. These devices used to be priced out of reach of not only the consumer and serious

Figure 2-9
Reading the density of a
100% black ink patch
on a printed sheet.

hobbyist, but the small to medium prepress house or printer as well. Now they are more affordable; and some devices will not only provide densitometric, colorimetric, and spectrophotographic data, but can also serve as light meters.

If I print a grayscale image with a highlight of 3% and shadow value of 97%, the dynamic range, expressed as a dot percentage, is 94. One would expect this image to appear less satisfying than one with a dynamic range of 100. That's not necessarily the case.

For displayed images on a monitor or printed images, there are additional influences to dynamic range. On the computer monitor, brightness and contrast controls affect apparent dynamic range. On the printed page, the brightness of the paper and the quality of the ink affect dynamic range. Bleached and coated papers are brighter and whiter than uncoated and unbleached stocks (Fig. 2-10). The paper that this book is printed on is brighter than the newspaper substrate that arrived on your doorstep this morning (unless my editor pulled a fast one at production time).

Ink densities vary due to their pigment (the color itself) to carrier (the fluid the pigment floats within) ratio *and* the choices

the press operator makes to control ink film thickness, which is exactly what it sounds like: the depth of the ink layer above the surface of the paper (Fig. 2-9).

In the RGB, or Red Green Blue color space, the extreme values represent two conditions: Lights OFF and Lights ON. The integer 0 equals Lights OFF. Pitch Black. The number 255 represents Lights ON. White

Figure 2-10
Look at the differences among these various paper grades in terms of density. Paper has a tremendous impact on dynamic range, and therefore the quality of the image printed on it.

light. High noon. Any number between these two values represents some transitional value between black and white. Each of the RGB channels features this 0 to 255 range. When all three channels are 0, what is displayed on a computer monitor is the same value as if that monitor had never been powered up at all. When all three channels feature 255, that represents the display's White Point, or maximum Lights ON condition.

Given these end points of 0 and 255, some very quick math tells us that the greatest possible Dynamic Range value of a digital file in any of the three RGB channels is 255.

255 (highest possible value) −0 (lowest possible value) = 255 (Dynamic Range)

A normal RGB channel for an image intended for print may well feature a highest value of 245 and a lowest value of 10, resulting in a Dynamic Range of 235. In this second case, the image has a smaller Dynamic Range than the maximum possible of 255. Again, this does not necessarily mean that the image with a Dynamic Range of 235 has less contrast than an image with a Dynamic Range of 255.

The following three examples share the exact dynamic range, in terms of percentage and density (Fig. 2-11). All three images of our hillbilly street musician share a highlight of 0% K and a shadow of 100% K. Because they appear on the same page, there is little reason why they should not measure identically when put to the densitometer. They clearly are not identical images. Why not? Well, let's see, since they are printed with black ink only, they will not have balance or color issues. The sharpness settings were the same. What does that leave? Contrast. But we know that the dynamic range of all three is identical. What's the problem here?

Tone Distribution

The problem is the differences in distribution of visual information, or *tone*, between the two end points. The first example lacks any information other than 0% and 100% pixels. There's no tone to distribute. This type of image is known as a *bitmap*, or *one-bit* image, as a single bit of computer data describes the only values in the image: 0 and 100. The grayscale images are not identical. Though they have plenty of pixels that are neither white nor black, but some shade of gray in between, these tones in each image have been distributed differently to demonstrate that dynamic range and tone distribution combine to create the appearance of contrast.

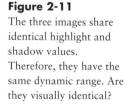

Figure 2-11
The three images share identical highlight and shadow values. Therefore, they have the same dynamic range. Are they visually identical?

Quartertone
Midtone
Three Quartertone

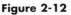

Figure 2-12
The pivot points on an RGB and a CMYK gradation curve are shown.

Tone Distribution is the controlled assignment of all intermediary values between the two end points that make up Dynamic Range. The greater the Dynamic Range, the more tonal values we have to distribute. The importance of controlling Tone Distribution cannot be overstated. This combination of End Point settings, which establish the dynamic range, and tone distribution adjustments, which complete the contrast needs of an image, are the critical skills that, once mastered, can take care of about 75%–80% of all color corrections. So how do we do that?

There are three important *pivot points* between the end points of Highlight and Shadow (Fig. 2-12). These three pivot points control tone compression. Adjusting these pivot points is a matter of raising or lowering their default values. The most important is the **midtone** (MT), which is the halfway point between the highlight and shadow. In a grayscale image, the MT is the 50% dot. In an RGB file, the MT is 128, halfway between 0 and 255. The assignment of the MT value in an image controls the overall lightness or darkness of the scene and has a significant effect on color hue and overall cast. The further away from the highlight the MT is placed, which is a matter of shifting the 50% value to areas whose original value are higher than 50%, the

more an image will lighten. The closer to the highlight the MT is placed, the darker the image will appear.

The other two pivot points are **quartertone** (1Q) and **three-quartertone** (3Q). The quartertone pivot point is 25% (192 in RGB), or roughly halfway between the highlight and the midtone. The 1Q controls shape and detail in lighter tones and brightness in colors. The 3Q, centered at the 75% (64 in RGB) value, controls shape and detail in the darker, or shadow areas.

And now, back to our hillbilly street musician. Which of the three is the optimal image? Not the bitmap, as that grossly oversimplifies the scene's detail. The first one, right? Trick question; none of the above are optimal.

Here we get to the matter of proper end point adjustment, which controls the dynamic range component of contrast. All three of the above images share a highlight value of 0% K. Yet all three are visually different in the light areas of the scene. That being the case, we begin to understand that 0% is an unreliable highlight value. With a 0% highlight, there's no telling how much light area detail we've sacrificed. Our image features drop offs and holes wherever the percentage value is 0%. Because ink is a liquid and tends to spread on contact with the substrate, the difference between 0% and

1% in the digital file can end up as the difference between 0% and 2%–3% and higher when printed. The worst-case scenario is that all highlight detail is blown out and the scene's contrast is exaggerated.

Again, because ink is a liquid and tends to spread, or gain, on contact with paper, setting the shadow end point to 100% is inadvisable. Here's the deal: a 99% dot is likely under the best conditions to gain, or grow, to the same 100% value. We have reduced the number of discreet values in our shadow end. In effect, we are allowing our shadow end to plug, or reduce, the shadow detail to a featureless solid area.

What is one to do? It's logical to begin by making sure our highlight dot doesn't drop below 1%, right? That way we should avoid any holes in the image as we start our tone reproduction with a known value. Better make it 2%–3%, as the normal variation in most color reproduction workflows can't be controlled tightly enough to guarantee that a 1% dot will survive all the steps from digital file to press sheet.

The darkest pixels in a digital grayscale file are best constrained to about 97%. That way, if the 97% dot grows to a solid value,

the 96% dot will probably only grow to a 99% and thus we preserve differentiation in the extreme shadow end.

Once these end points are set, they should be regarded as nails pounded into a board—immovable. All further adjustments are best carried out via the pivot points, beginning with the midtone and moving from there to the quartertones.

Setting End Points

Most scanner software applications feature the ability to precisely define what the RGB values of the highlight and shadow will be (Fig. 2-13). Sometimes the two end points are defined as White Point and Black Point. Many scanners allow the operator to scan to a CMYK file and adjust CMYK percentages, although the scanner is actually capturing RGB data and doing a software conversion to CMYK.

I highly recommend scanning in RGB and then using Photoshop or, in professional graphics houses, your raster image processor (RIP), to control an RGB to CMYK conversion. This gives you a larger color space to work in (RGB has a much larger color gamut than CMYK) and allows you to

Figure 2-13

The software controlling the Creo EverSmart scanner features an End Points palette with multiple adjustments for density and cast reduction as well as dynamic RGB density values wherever the cursor is directed on the image.

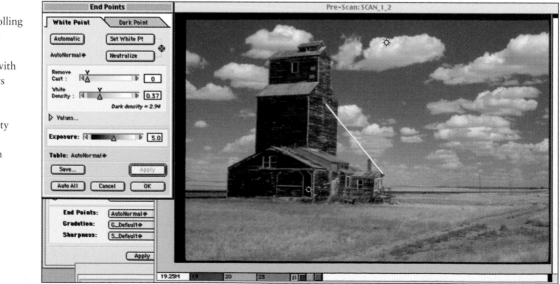

defer your CMYK conversion to the last minute when you have made certain which device the image will be printed to. Those who convert the RGB data to CMYK early in the process and carry out all adjustments in CMYK, throw away useful data, which can never be restored. One can't go back from CMYK's small space to a restored, larger RGB space. Also, lower resolution JPEGs and GIFs are easily produced from the original high resolution RGB scan for Web graphics.

Some scanner software applications will analyze a quick preview of the image and choose your end points for you; the higher end scanners can act as their own densitometers. If not, then the scanner operator chooses the end points. Always choose points inside the image itself, as opposed to making the scanner glass your highlight and the transparency frame or other nonimage black as your shadow. By doing this, you reserve the entire available dynamic range of the RGB color space for image data only.

You'll want to refrain from setting 0 RGB as your shadow and 255 RGB as your highlight. Setting your shadow at 0 is a guarantee of plugging the shadow end and sacrificing detail. Setting your highlight at 255 guarantees blowing your highlight detail out to white paper, again losing precious highlight value and harming shape and drawing throughout the image. Sound target values for the shadow end begin around 8 to 10 RGB, with 240 to 245 representing an RGB highlight that will convert to usable CMYK percentages.

If someone else has provided the TIFF, JPEG, or EPS file, whether from a scanned original or a digital camera shot, the end points still need to be checked and adjusted if needed. Like many other color specialists, I prefer, and suggest, using Levels in Photoshop to secure end points (Fig. 2-14).

One benefit of using Levels to set the dynamic range is that this palette also features a histogram, a type of distributional graph that shows how many samples at each gray tonal value the image features. This histogram is useful in judging where the image will best benefit from later Tone Distribution alterations. Photoshop CS now has a histogram palette that can be continually displayed and shows how the tonal values are affected by any edits. In addition, the GNU Image Manipulation Program (GIMP) shows the histogram as a background in the Curves palette.

One often encounters images where many white and near-white values are scattered about, making it difficult to judge visually which is the brightest and time consuming to examine each one via the Info Palette and cursor. Likewise the shadow end, where there's just no judging visually which of several different areas is the darkest black.

One of my students passed on a clever technique that he had picked up surfing through various Photoshop Websites. Somebody discovered using the Threshold option to precisely locate highlight and shadow settings (Fig. 2-15). This same Threshold technique is also easily accomplished using the GIMP. Choosing this option converts your RGB or CMYK TIFF to a bitmap (black and white only) image. Do not save this mode change! It is only of temporary value. Moving the provided slider

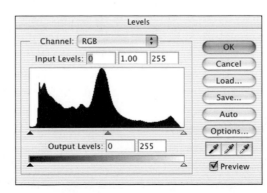

Figure 2-14
The Levels palette provides for a quick visual of how the image's data is distributed between highlight and shadow, and sliders for adjusting those two end points, as well as the midtone. Note the Input Levels and Output Levels sliders.

Figure 2-15
The upper inset shows a Photoshop Threshold adjustment with the slider moved well right to tease out the image's highlight location, which is the last remaining white patch. In the lower inset, the Threshold slider is moved left, burning out all detail except the extreme shadow, shown as a black patch.

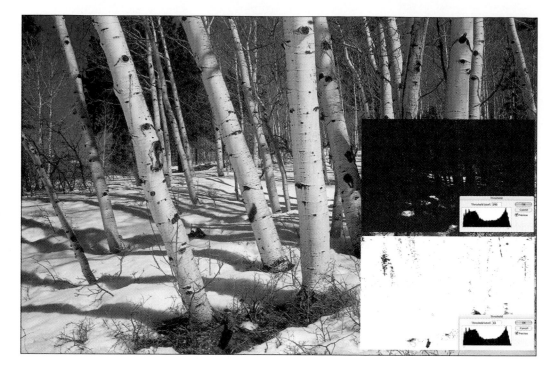

control to the left blasts out all detail to white in a gradual progression to the extreme shadow value in the image. So the last black detail is your shadow. Likewise, moving the slider to the right blackens all values gradually to the extreme highlight, which is the last white information left before the entire image goes black. As you get a good visual fix on each end point, Shift-Select the end points with the Eyedropper tool to fix its values in your Info Palette, simply cancel out of the Threshold palette and your image returns to its color state. You're now ready to adjust those two image areas to your target end point values.

Now is the time to invoke the Levels palette and adjust Dynamic Range and Tone Compression. Referring back to Figure 2-13, you can see that the Levels palette has two sets of sliders. The first is Input Levels. Input Levels is associated with the histogram information of the particular image being edited. As you move the highlight and shadow sliders, you are redistributing the tonal information between these points. *You are not changing the Dynamic Range.* Once

you OK your adjustment the Levels palette closes. If you were to reopen that palette, you would recognize that the histogram's shape has altered to reflect the redistribution of tone, and there are vertical lines in the histogram indicating that the digital information has been edited. Output Levels is used to fix the values of the highlight and shadow information, regardless of where you moved them in Input Levels. By fixing our end point information in Output Levels to 10 and 245, for instance, we make sure that we will have an open shadow value and a printable highlight. Output Levels changes actually compress Dynamic Range.

Curves

Anyone with experience in this digital image manipulation game is familiar with the concept of *curves*. All image manipulation software from the initial Scitex systems of the late 1970s through every permutation of Photoshop, Linocolor, Color Studio, Live Image, etc. featured and continue to feature curve editing options. One also finds curve editing options in every color RIP or server

software and hardware for output devices (such as color printers, image setters, and plate setters) with calibration controls, as well as the expanding array of color management software solutions.

Curves are sometimes referred to as *gradation* controls, or *tone adjustment* controls. In a masterful stroke of simplicity, the Photoshop and the GIMP development crews decided to call them "Curves." There is no more powerful and useful feature in all of Photoshop or the GIMP than Curves when it's time to edit an image (Fig. 2-16). There is also no better place to control the three pivot points of tone compression than in Curves.

It's astonishing the amount of image editing that can be done quickly and easily with curve adjustments. It's been my experience that nearly 80% of all corrective adjustments can be accomplished using only Levels and Curves features.

The following table in Figure 2-17 shows eight common curve adjustments in RGB and CMYK. Each curve adjustment is identified as to when it would be used, what areas of the image are affected, and how much of an adjustment needs to be made for visible results.

The term "curve" implies an elegant rounding of a line. The less curved, and more angular the gradation move is graphed, the more likely harsh breaks and visual anomalies will occur. Also, the more changes there are in a gradation line, the less pleased we are likely to be with the results. The following table shows no curves moves with more than two actual pivot points in any graphed gradation line. That's not accidental.

What Are the Best Contrast Settings?

One infers after studying the provided table of common Tone Distribution moves that different curves are required for different situations. The truth of this color

Figure 2-16
The Curves palette from the GIMP photo editing software. Notice the ghosted histogram used as a background, which is a useful little reference.

Basic Curves Adjustments Cheat Sheet

Curves Adjustment	RGB	CMYK (grayscale)	Use when...	Visual Effect	Possible Side Effects
Increase Midtone	*(RGB curve: Input 128, Output 105)*	*(CMYK curve: Input 49%, Output 59%)*	a. image looks faded or overexposed b. image size is to be enlarged significantly	added weight and richness; added shape and color saturation	too much of a move can plug shadow detail and dirty up colors
Decrease Midtone	*(RGB curve: Input 126, Output 151)*	*(CMYK curve: Input 50%, Output 41%)*	a. image looks dark and underexposed b. image size is to be reduced significantly	brighter and cleaner overall; added shadow detail	too much reduction can burn out lighter details and cause loss of shape and drawing
Increase Contrast	*(RGB curve: Input 192, Output 206)*	*(CMYK curve: Input 76%, Output 82%)*	image appears flat, dull	brighter whites and colors; added saturation and punch	too much of a move creates gaudy, two-dimensional colors; skin tones suffer first
Decrease Contrast	*(RGB curve: Input 62, Output 78)*	*(CMYK curve: Input 24%, Output 31%)*	image is too gaudy, overly contrasty, shape is required	whites and colors gain weight; shadows open up, colors lose saturation	can suck all the life right out of an image; this move is seldom required
Increase Quartertone	*(RGB curve: Input 191, Output 171)*	*(CMYK curve: Input 76%, Output 76%)*	whites and lighter tones are lacking shape and detail	whites and lighter tones gain weight; colors pick up shape; no change in darker tones	dirty, grayish light values and colors, reduction in apparent contrast overall
Decrease Quartertone	*(RGB curve: Input 193, Output 210)*	*(CMYK curve: Input 24%, Output 17%)*	whites and colors are too dirty and grayish	whites, lighter tones and colors brighten up; no change in darker tones	whites and lighter detail can be lost, colors can become cartoonish
Increase Three-Quartertone	*(RGB curve: Input 61, Output 41)*	*(CMYK curve: Input 75%, Output 82%)*	colors look desaturated, shadow end lacks punch	added color and added weight in dark tones	loss of shadow detail, colors can begin to look fake
Decrease Three-Quartertone	*(RGB curve: Input 63, Output 82)*	*(CMYK curve: Input 76%, Output 69%)*	shadow detail is plugged and indistinct; colors are oversaturated	lessening of apparent contrast; reduction in color saturation, more apparent shadow detail	image can become unappealing and flat; colors can become desaturated and grayish

Figure 2-17

As in anything else, practice makes perfect. This table is designed to encourage sound decisions in tone adjustment based on visual impressions of the image.

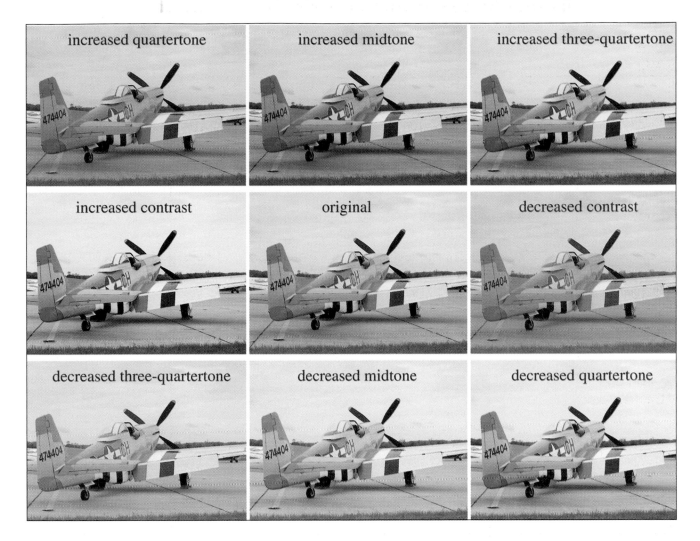

reproduction trade is that different images call for different settings, in the Dynamic Range and the Tone Distribution. There is no silver bullet setting that perfectly reproduces excellent images and perfectly repairs inferior ones. The best Dynamic Range and Tone Distribution settings are those that best represent the details and mood of a given image within the specifications of its intended output condition (Fig. 2-18).

If the imaging technology changes, then so does the contrast settings. Wide-format ink jet devices call for different amounts of ink than do toner-based digital presses. Offset presses behave differently than toner-based

presses. Flexographic presses have their own idiosyncrasies.

Choices in paper or nonpaper substrates dictate changes in contrast settings. Uncoated stocks feature dirtier highlights due to paper color and finish, and less saturated colors due to reduced reflectivity and higher ink absorption. Coated stocks feature brighter whites and brighter, more saturated colors. Specialty stocks used for the packaging world are all over the map and require close collaboration with the pressroom talent for best contrast results. Changes in enlargement and reduction call for adjustments to contrast. As images are enlarged, an optical lightening occurs, which can be corrected

Figure 2-18
Eight common curves adjustments, each one in comparison to the center image, are shown. Study each one against the provided table in Figure 2-17 and compare the visual effects of the actual images against the expected stated visual effect from the appropriate curve on the chart.

with increases in midtone. As images are reduced in size, an optical darkening occurs, again corrected with a midtone adjustment, in this case a reduction. As we proceed through the chapters of this book, we will engage in exercises to help clarify the decision-making process required for successful color correction and image reproduction.

Chapter 2 Summary

The human visual system is not an accurate measurement mechanism, but rather a comparative evaluation tool. We are programmed to notice difference and ignore sameness. An image's contrast reflects difference between lighter and darker regions of the image. Contrast adjustments control saturation and richness of color as well as shape and dimensionality in the image. Mastering the adjustment points that control dynamic range and tone distribution have more effect on the success or failure of a reproduced image than anything else.

Chapter 2 Review

1. Is the human eye a reliable color measurement device? Explain.
2. What are the three predominant light measurement devices used in the color reproduction industry?
3. Which two components combine to control contrast in an image?
4. Name the three pivot points used to adjust tone.
5. Why is 0% considered an unreliable highlight value for grayscale and CMYK printed images?

Balance

Chapter Learning Objectives

- Appreciate the role of neutrals in image evaluation
- Become familiar with RGB, CMYK, and LAB neutral values

3

"Now *that*, folks, is balance!"

That phrase was once exclaimed in reference to your humble narrator, at a steak sandwich emporium in the Philadelphia suburban mall where I toiled one college year.

The owner kept a slab of beef on a rotating chain in a glassed oven display fronting the store, to sharpen appetites and steer shoppers into his eatery, where the aromas of shredded sirloin, onions, and mushrooms on the grill tended to close the deal.

When the beef was slow roasted to perfection, the short-order cook would remove it and carry it back to the sandwich counter, where it would be sliced to order. Wednesdays through Saturdays on the evening shift, I was that short-order cook. The floor behind the counter would start the day clean and gradually accrue a skin of meat drippings, cooked onions, mayonnaise, sautéed mushroom fragments, you name it. As I began each evening shift, the floor was mildly treacherous and by closing time it was downright life threatening. One would skate as much as walk, despite continual mopping, because of the furious pace and collateral spillage.

One particular meal rush, I had to grab a done slab of beef from the front display and hustle it to the sandwich counter. In my haste, and carrying this roast on a board with both hands, my boots lost their purchase on the floor. I was obliged to execute a panicked flamenco parody as I strove to prevent the roast from dropping overboard or being flung into the crowd, with the added humiliation of my crashing gracelessly to the floor. Hands occupied, I danced for all I was worth, each foot testing for a dry patch of tile.

As it happened, and proof positive of somebody's infinite mercy, I came to rest on my feet in the upright, with the roast still centered on its board. The crowd went nuts. "Now *that*, folks, is balance!" shouted the owner over the applause and cheers, celebrating his narrow escape from the expense of ruined product.

What does any of that have to do with image editing? Well, *balance*, even in image editing, is the secret to ensuring that your perfect roast of a color image does not land butter side down (to mix food metaphors) on the greasy floor of failure.

Balance Defined

The first definition of *balance* is "a state of equilibrium; an equal distribution of weight, amount," in my edition of *Webster's*. This is the only one of several uses of the term *balance* that we will need. Balance, for our use, is a state of equilibrium and an equal distribution of weight, or amount. Weight, or amount, of what? Well, of the primary color values, whether Red Green Blue (RGB) or Cyan Magenta Yellow (CMY), which we mix to create **neutrals** as well as color. The places where we look for an indication of the balance in an image are the neutrals, those hueless values ranging from white through all the values of gray to black.

One can view the idea of color as being born out of neutrals. The additive primaries of red, green, and blue are subdivisions of white light. White is the first neutral, the cleanest and brightest neutral, we encounter in an image. All the various color models, whether two- or three-dimensional, grow colors from a neutral center. Complementary colors, such as yellow and blue, or magenta and green, face each other from opposite sides of circles or rough ovals in these models, canceling each other out at the center and creating gray (Fig. 3-1). The gray

family has no hue and no saturation. The purely neutral grays have only a brightness value. Radiating out from gray in all directions in these color models, we encounter first the pastel tones, then semi-saturated colors, and finally saturated colors at the edge of the color space.

All neutrals, from white to black, are blends of additive or subtractive primaries. We mix precise amounts of RGB or CMY to create gray. In fact, one of the fundamental rules of color reproduction is that if you can't print gray, you can't print color.

When we evaluate images, we look for the neutrals to inform us if a particular image is in balance. Our visual sensitivity is such that out of balance conditions in an image are most noticeable in grays, though every pixel in the image shares the same non-neutral cast, or bias. The importance of knowing what numbers are needed to create measurable neutrality cannot be understated, as our eyes, in concert with our brain, have a tendency to adjust to non-neutral conditions such as lighting and adjacent colors, a condition that printers know as the phenomenon of adjacency, which artists call simultaneous contrast. Adjacency, or simultaneous contrast, causes us to see two objects of absolutely equal value and hue to be different colors based solely on the fact that each is surrounded by a different color (Fig. 3-2). In short, we can't trust our eyes to judge exact neutrality, as they tend to adjust to influences other than the neutral areas themselves, causing our visual system to skew the apparent balance one way or another.

This is not to say that we can't pick up cast, or the lack of neutrality, in an image visually. In fact, a quick visual inspection of an image is usually the tip-off that the particular image is out of balance with reality. Generally, our eyes are fine at picking

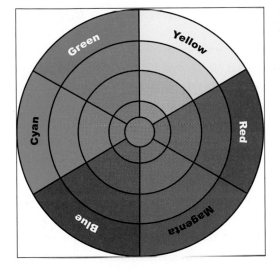

Figure 3-1
In this diagram of the Color Circle, we see the neutral core with the various color families developing progressively toward the edges.

up significant problems with balance, but can miss small imbalances.

An image noticeably out of balance will appear as if we are viewing the image through some sort of colored filter. Everything in the image skews away from normal and features a distinct color bias. The areas of the image that are normally neutral will feature the most apparent bias. Imagine a clear glass jar filled with nickels, dimes, and quarters sitting on a stainless steel table, with a label showing an elephant standing on asphalt, penned in by a white picket fence. Your brain is producing images of items that are neutral, or without hue, in the real world. Because they are neutral, these areas can be

Figure 3-2
All the circles in this diagram are the same tint of black ink only. Their apparent visual differences are due to the influence on our visual system of the surrounding colors.

counted on to reveal whether an image is balanced.

Now imagine that everything in your mental picture has a yellowish cast, or bias. The elephant is jaundiced. The coins look stained. Not good.

If your imagined image also featured vivid colors, those colors would also be stained yellowish. Many of the colors would not be as evident in their yellow bias as the neutrals. Nonetheless, they are equally casted, equally out of balance. How do we know this? We know this because the causes of color bias in an image are overall in nature. Colors are influenced in equal measure to neutrals. Neutrals, however, announce their imbalances in a louder fashion than do colors, and that makes neutrals very useful, indeed.

My wife and I happen to own two Australian Shepherds, dogs of uncommon intelligence, loyalty, and usefulness, on a 2.5-acre tract shared with three sheep, eighteen ducks, and a goose, surrounded by acres of predator-infested woods. One dog is additionally a four-legged photographic control element, an absolutely neutral-colored beast with superb patches of

highlight, midtone, and shadow. I intended to name him Grayscale when we picked him up as a pup, but my wife wouldn't go along with it. Any photo that this dog appears in has a built in gray balance evaluation element as part of the scene. All I have to do is put my cursor on this dog's fur and check out the Info Palette (Fig. 3-3).

As you go about your daily business, look about you and notice the household items, building materials, and natural objects that are without hue, that are some value of gray. When any of these gray objects are captured in an image, they become part of the color specialist's toolkit, built-in control elements that help us reproduce the best possible image.

The Causes of Color Cast

Lighting is the major cause of color cast. All outdoor light is not neutral. During the times of day closer to sunrise and sunset, ambient outdoor light tends to be warmer. Light from stormy skies is different than from clear skies. In the Midwest, when the sky takes on a yellow-greenish cast, it's time to drop the camera and hustle with kids and pets down to the basement.

Figure 3-3
Meet Timber, the four-legged photographic control element.

Figure 3-4
Note the overall harsh cast to this image, caused by the color temperature of a warming lamp above the ducklings.

Different forms of indoor lighting are anything but neutral (Fig. 3-4). In fact, most consumer lighting is intentionally warm, as people tend to look healthier in warm lighting, and tend to prefer warmer ambiences to cooler.

Unless the photographer "white balances" the color bias out of an image, the camera will pick up these lighting biases and everything in the captured image will carry that cast. Films requiring a longer exposure time can accentuate color bias caused by lighting.

What else causes cast? Photographic processing errors, for one. Mistakes by processing technicians, or used up and tired chemistry, can skew images out of balance. Again, everything in the image suffers, some areas more evident than others, but casted overall nonetheless.

An uncalibrated scanner can also introduce color cast. If a scanner is not white and gray balanced it will impart its out-of-balance condition to the pixels it creates as it scans an image. Again, every pixel is affected.

Paper can, and does, influence neutrality. If we have a perfectly neutral digital image, and we print that file to any substrate that is not neutral, everything in the image picks up the cast of that substrate. If we know our eventual press run is destined to use ivory-colored stock, we need to skew our image slightly to the opposite side of the color circle from ivory, which is a light yellowish-white. We'll need, in this case, a slight blue or violet cast to the image to counteract the ivory cast of the stock.

In fact, the sad truth is that a perfectly balanced image can easily be thrown into a casted condition by slovenly press operation and poor proofer calibration. Press operators who understand their craft know that controlling ink film thickness means assuring that neutrals in the image remain that way. Too many press operators chase ink densities without understanding how each ink's density is arrived at during the press fingerprinting stage. Control elements such as the one shown in Figure 3-7 occupy press profiling forms for the purpose of balancing ink densities in order to reproduce gray.

Similarly, proofing devices that aren't properly calibrated will improperly reproduce grays, thereby improperly reproducing color. Any variation in

choices of colorants or substrates requires adjustments in CMY values to ensure that gray balance is maintained.

RGB Balance

If we can't trust our eyes for fine balance evaluation, what do we trust? We trust the numbers. Once again, we use the hard certainty of mathematics to ensure visual appeal. In the RGB color space, neutrality is based on an assumption of white light. Most consumer digital cameras allow the shooter to adjust the white balance, and therefore the color cast of the picture, before shooting. Color monitors and television sets allow for the balance to be adjusted visually. Assuming a balanced condition, equal values of red, green, and blue light, no matter the strength, blended together, create a neutral condition.

Recalling that the range of possible RGB values is from 0 (Lights OFF) to 255 (Lights ON) in all three channels, adjusting to a perfect neutral is simply a matter of equalizing the three values. Thus, 0R, 0G, and 0B is as black as it gets; 255R, 255G, and 255B is pure white light; and 128R, 128G, and 128B is a perfectly neutral midtone. A perfectly neutral quartertone is located halfway between highlight (255) and midtone (128). Thus 192R, 192G, and 192B is a perfectly neutral quartertone. Indeed, any place along the RGB continuum where the three channels report equal values is neutral.

Although several RGB spaces are in play, perhaps the three most often encountered are the Adobe 1998 space, sRGB, and ColorMatch RGB. Each spaces is based on equally strong red, green, and blue light, so the formula of equal values equals neutrality applies.

L*a*b* Balance

There is only one CIELAB (LAB) color space. This is the all-encompassing space that features every possible visible color and within which all RGB and CMYK color gamuts are plotted. The LAB model features a central axis, the L* axis, which is entirely devoid of hue and saturation. In other words, it's perfectly neutral. In a LAB color file, looking at the L* channel by itself is the same as looking at a perfect grayscale rendition of the scene (Fig. 3-5).

The L* axis goes from 0, which like RGB, represents black, to 100, which represents white. 50.00 L* is our midtone. The other two axes in LAB space cross each other to create a grid on which any hue and level of saturation can be plotted. The plotting of points on these two axes, the a* axis (red to green) and the b* axis (yellow to blue), also relate with the L* axis to form the second and third dimensions of any color. So, any color can be fixed in this three-dimensional space by first plotting it's lightness or darkness along the L*axis, then its relative component of either red or green by moving on the a* axis away from the center one way or the other, then by plotting its component of yellow or blue along the b* axis, again by moving one way or the other away from the L* axis.

In the a* and b* axes of LAB space, the axes range from 127 to −128. 0 is the halfway point, where the a* or b* axis crosses, or intersects, the L* axis. 0, in either the a* or b* axis, represents perfect neutrality, perfect balance, between the colors on the outer ends of the axis.

For instance, the a* axis represents pure, absolutely saturated Red at 127. Pure, fully saturated Green is at −128 on that same axis. 0 on the a* axis is the perfect balance between Red and Green, absolutely unsaturated, absolutely neutral gray.

Likewise, the b* axis features fully saturated, pure Yellow at 127 and fully saturated, pure Blue at −128. 0 on the b* axis is the perfect balance between Yellow and Blue. In other words, absolutely unsaturated, absolutely neutral gray.

Figure 3-5

The L* channel in a LAB color image is a perfect grayscale rendition of the subject.

So, it makes perfect sense that no matter where we plot a value on the L* axis, if the a* and b* axes are 0, we are neutral, and it doesn't get any more neutral than that.

With the increased use of the color measurement device known as the spectrophotometer, we are now able to read printed colors anywhere in a control element or an image and evaluate the L*a*b* values of that color. So, we now have not only our eyes to evaluate a printed sample for balance, we have the absolutely objective optics of the spectrophotometer. And the numbers tell us which way the image is leaning, if it is not truly neutral. With that information, we can make accurate adjustments. The spectrophotometer, although a professional tool whose price may be out of reach for all but the most serious hobbyist, is gaining increased acceptance by professional printers, prepress houses, and creative agencies. This increased acceptance is being driven by a combination of need for the device in color management workflows as well as plummeting prices for this technology.

Also, Photoshop, LinoColor, and other software applications allow us to examine the L*a*b* values anywhere we can put our cursor in a digital file.

CMYK Balance

The CMYK world is where gray balance gets rather elusive. In CMYK, almost every different ink set, in combination with the chosen substrate, the type of press, and even the ink rotation (the sequence of color lay down on a multi-color press) influences the percentages, or exact sizes of the halftone dots required, on each of the printing plates, to result in gray.

The other issue with process CMYK inks is that the cyan ink, due to pigment and reflectance impurities, can't compete with the yellow and magenta inks at equal

strengths. So the RGB rule of equal values doesn't hold with CMYK. More cyan ink (and therefore a larger halftone dot) is needed than yellow and magenta to create a balanced gray.

To get a CMYK formula into the gray ballpark, so to speak—something similar to the equal values of RGB equals gray—one could start by saying that taking an existing cyan dot percentage and multiplying by 0.8 (80%) would result in decent numbers for the yellow and magenta for the three inks to blend into a gray value.

$$20\% \text{ (sample cyan value)} \times 0.8 = 16\%$$
$$\text{(ballpark yellow and magenta values)}$$

$$20\%C + 16\%M + 16\%Y = \text{nice light gray}$$

This ground shifts almost immediately, for all the reasons listed three paragraphs above, as well as the brightness value of the gray blend in question. As grays progressively darken, the relationships among the CMY inks need to shift to retain neutrality. As we get close to the shadow end, it seems that no possible combination of the three gives us a good dark neutral. Which is why we bring black ink into play, to add density to the shadow end and provide neutrality.

Before you throw up your hands and abandon all hope of achieving gray balance in the CMYK universe, know that I have found two methods to be quite useful in fine tuning these neutrals.

Figure 3-6
The Info Palette with the first readout showing CMYK values and the second readout showing LAB values.

The first method, using Adobe Photoshop, is to use the two fields in the Info Palette to your advantage (Fig. 3-6). The Palette Options settings should have the First Readout set to Actual Color and the Second Readout to show LAB color. As we know from this chapter's description of LAB space that the L* axis is purely neutral, we have only to attend to the a* and b* readings. The closer these readings are to 0, whether they are positive or negative, the more purely neutral is the area being read.

Be aware that Photoshop is referencing the Working Space choices you have made in the Color Settings Palette. If, for instance, you have Generic CMYK as your CMYK Working Space, your CMY blends to create neutral LAB values will be one thing. Change that Working Space to SWOP CGATS TR001, and your CMY blends to achieve those same neutral LAB readings will be different.

Why? Simply because the software files that define these different conditions, known as International Color Consortium (ICC) profiles, were produced under different conditions and reflect the neutrality of that given condition. Change the given condition by changing either the paper substrate or the ink type, and you change the values required to achieve gray.

So we see that the ease in which we can evaluate neutrality in the RGB and LAB spaces is quite another thing in CMYK space. The truth is that any set of CMYK percentages does not indicate a universally precise color. It simply indicates an amount of colorant for a device to place down at a given point. The results will vary among different devices, so precise CMYK gray balance values need to be discovered on a device-by-device basis.

The second method, which is time-honored and visually useful, is to surround printed chips, or circles, of CMY blends with a field

Figure 3-7
An example of a gray balance, print control element. Varying circles of CMY are surrounded by a uniform black value. The circle which best matches the surround is the most neutral.

of black ink only of the same visual darkness, or weight. Since the black ink by itself is neutral, our eyes will easily note any lack of neutrality in the CMY chip. Some control targets feature a grid of CMY chips of changing values against a uniform black tint. The CMY blend which best fits the surrounding black ink in weight and neutrality will be difficult to distinguish, if not almost disappear, within its surround (Fig. 3-7). The CMY percentages that make up that optimal chip become our target values when we correct images for that particular print condition.

Gray Balance Exercise

On the accompanying CD is a file named GrayBalanceBar.eps (Fig. 3-8). Open this file in Adobe Illustrator. The file has nine boxes filled with a given value of Black only, in 10% increments ranging from 10% through 90%. Centered inside of each box is a circle filled with the same amount of Cyan ink as the surrounding box is with Black. So the Black box filled with 30%K contains a circle filled with 30%C.

Your goal is to make the circle disappear within the surrounding box, by altering the makeup of the CMY values in the circle. You may not change the Black value of the

box in any way, either by altering the Black percentage or by adding any other inks to that mix. Nor may you add any Black ink to the circle. You can only add Magenta and Yellow, or alter the Cyan value in the circle. Get cracking!

Once you're satisfied with the visual match on screen, File/Save As to GrayBalanceBar_x1.eps and go ahead and print this new file. I'm guessing you won't be very happy with the results. In fact, I'm confident your lamentations will be loud and long. What looks good on your computer display looks very different and very poorly matched indeed. Why?

The answer to this question should result in a lifelong habit of mistrust of the visual information on the computer display and the beginning of a respect for evaluating images using the visual information and the supporting numbers. The point here is that your monitor is an RGB device. Your printer is a CMYK device. Your monitor emits Red, Green, and Blue light. Your printed Sheet reflects light through the filters of the Cyan, Magenta, Yellow, and Black ink on it. Two very different things.

In fact, your monitor, being an RGB device, is emulating CMYK values. So, although you may be working in the CMYK space in your file, the computer display is busy mixing RGB values to represent those CMYK percentages. In this case, you are manipulating CMYK numbers while evaluating RGB information visually. Your initial satisfaction is based on the RGB version of the CMY circle visually matching the RGB version of the surrounding Black tint.

Once the file is printed, the CMYK percentages in the file have been transferred to CMYK toner or ink on actual paper. Now the CMY circle is filled with CMY colorants, and the surround is really Black. And they don't match, do they? The beautifully

matched circles and squares on the monitors disagree wildly on the print. Dang it! Now the task is to evaluate the printed sample visually and decide which CMY percentages to adjust and by how much. Here is another case where the color circle comes into play. The color circle is useful in organizing the most effective adjustments. Keep in mind that the activity of restoring neutrality is adjusting a CMY mix toward the center of the circle from whichever direction away from center the image is showing.

Let's consider two scenarios. In the first scenario, the CMY chip is lighter than the black surround and appears too pink in comparison to the black. Since the CMY chip is too light, it makes sense that we need to increase the percentages of something to add weight to the chip. But we also have to rebalance the numbers to rid the chip of its pink cast. Consulting the color circle diagram, we see that magenta is the culprit when grays appear too pink. So we have to add weight and push the gray value to the neutral center. Pushing that value toward the center means pushing in the direction of the color occupying the opposite side of the color circle from magenta, which is green. Since there is no green ink available, we need to increase the cyan and yellow percentages, which normally mix to create green, and accomplish the same thing.

In the second scenario, the CMY chip is too heavy in comparison and again is too pink. In this case, we need to subtract something while pushing the CMY mix to the center of the color circle. So, we subtract a portion of the magenta percentage, lightening the CMY mix and moving toward green, which moves the CMY mix to the center.

In altering your CMY values in the digital file, you will begin to lose the visual perfection of the gray balance on your workstation monitor. Unavoidable.

The point is to learn which percentage blends of CMY combine *when printed* to deliver neutrality.

Again, change any of the printing conditions—different printer, different paper, different colorants—and you change the right answers for which CMY blends create a balanced gray.

In summary, we achieve neutrality, based on the color mode, by

- Adjusting RGB values so that all three channels are equal at whatever luminosity the neutral is found, in RGB space.
- Adjusting the a* and b* values to 0, regardless of the L* value, in LAB space.
- Adjusting a higher Cyan value to roughly equal values of Magenta and Yellow in CMYK space until the printed tint blend appears neutral or measures as neutral with a spectrophotometer.

Gray Balance in Practice

The Gradation, or Curves, controls in scanner software or in Photoshop are quite effective in addressing casted conditions. As stated earlier in this chapter, cast is an overall problem with images, and so needs to be corrected with an overall strategy. By overall, we mean every pixel in the image receives correction. No need for masks or selections.

Experienced operators will tease trends out of the image by sampling several aim points in the image from the light areas through the shadows. A white area, a medium gray, and a dark shadow are three such points. In addition, an experienced operator might also check a skin tone, when one is available, as skin values are well understood and fine indicators of an overall cast. Skin tones will be discussed in detail in Chapter 5, Believable Colors.

If, for instance, in a CMYK file, an overabundance of Yellow is noticed visually, and later confirmed by the numbers in the midtone, then the highlight and shadow need to be checked as well. One would expect to see the same overabundance of Yellow throughout. If this is the case, then a Yellow midtone reduction or a Magenta and Cyan midtone increase are needed, based on whether the image looks too light or too dark.

Figure 3-9
The Photoshop CS Photo Filter allows for relighting the image to neutralize an unwanted cast or to impart a cast in order to convey mood. In this example, the Deep Emerald filter at 40% of strength is used as a complementary, or balancing, cast to the image's original pinkish bias.

In effect, the same types of gradation adjustments are being made as in the previous chapter to improve contrast, but in this case are isolated to an individual channel or pair of channels in the image.

How much of a move is enough? Enough to eliminate the cast, or to noticeably reduce the cast. How much is too much? When a complementary cast is created by overcorrecting the original imbalance. For instance, too much yellow reduction can result in the yellow cast being replaced by a violet imbalance.

The release of Photoshop CS included a new approach in balancing an image: Photo Filters (Fig. 3-9). This technique is found under the Image/Adjustments pull down menu. In effect, when you use this option, you are relighting the scene through a color filter. This is a highly effective technique, used in conjunction with the Info Palette. Again, the point is to assess your work visually and numerically.

The trick here is to choose a Color Filter (there are eighteen factory choices and you have the ability to create custom filters) complementary to the cast in the original image. This pulls the casted neutrals back toward the center of the color circle. How much of a move is controlled by the Density slider and dictated by the numbers in your Info Palette. A good practice here is to Shift-Select a gray area in the image with the Eyedropper Tool which loads those point values. As you adjust the Density slider, watch the numbers in the Info Palette change until you are satisfied with the results.

Figure 3-10
The warmth and mood of this image in the center section requires preserving the color bias, not neutralizing it.

Figure 3-11
The center image in this collection is the balanced image. The six copies circling the center image are all out of balance. Each non-neutral image is labeled with its color bias in RGB and CMYK modes.

Intentional Cast

Photographers seeking to create a certain mood, or to elicit a certain response from the viewer, will build in a color bias through colored lighting or filtration. In these cases, the image will

show a color bias overall that needs to be maintained throughout the print process (Fig. 3-10). Most of the time, we are able to recognize the intention of the photographer or art director and preserve the color cast; with some images or uses, it is sometimes

unclear whether the non-neutrality is desirable. In these cases, consult with the providers of the image or the client to make sure that everyone is in agreement on whether to preserve the color cast or eliminate it.

Intentional color casts are used to convey warmth, romance, autumnal themes, cool relief, pain, stress, depression, etc. The blues ain't called the blues for nothin'.

Chapter 3 Summary

In all three-dimensional color models, colors radiate outward from a neutral center. Colors gain saturation and purity as they distance themselves from this neutral, or gray, center. In any color image, the gray subject matter reveals whether or not the image is balanced. If neutral subject matter is casted, or biased, away from neutral, all color hues in that image share the particular color bias. It is as if the entire image is being

viewed through a color filter. In RGB files, equal numeric values of red, green and blue at any intensity create gray. In CMYK files, cyan's inability to compete in color intensity with magenta and yellow require that a greater value of cyan ink be mixed with existing magenta and yellow values to achieve gray.

Chapter 3 Review

1. Why are neutral objects in an image useful to the color specialist?
2. Why is it said that colors grow from neutrals in modern color gamut modeling?
3. Numerically, how is neutrality achieved in the RGB color spaces?
4. How do spectrophotometers help us evaluate neutrality of printed matter through color measurement?
5. Why would a photographer intentionally balance an image away from neutral?

Sharpness and Detail

4

Chapter Learning Objectives

- Be familiar with the role of file resolution in the representation of detail
- See how digital images are sharpened and detail enhanced
- Identify the differences and roles of ppi, lpi, and dpi
- Grasp the concept of the Unsharp Mask
- Recognize when an image's detail is soft, properly sharpened, and over sharpened

Today's mail brought a reminder from the local eye clinic that it's time for my biannual eye exam. It's time to have my eyeglasses prescription checked and adjusted, if necessary. Time for the ophthalmologist to recalibrate the focal apparatus of my visual system. Not much different from the ways we teach our students to calibrate the focus of the laser imaging film, plate, and proofing devices in the Graphics and Printing Technologies Center.

Experienced scanner operators accustomed to applying careful Unsharp Masking adjustments to every scan notice a lack of sharpness and detail in digital camera shots. There is an unnatural smoothness and slight lack of clarity in the digital camera capture. Millions of digital photos are shot every day. And millions of those images are displayed on computer monitors or printed on consumer level color printers every day in their original, smooth and unsharpened state. In the process, people are inadvertently schooling themselves to accept photographic mediocrity in terms of image sharpness.

Part of this digital smoothness is the total absence of photographic emulsion grain in digital images. The application of carefully judged Unsharp Masking in Photoshop, the GNU Image Manipulation Program (GIMP), or Linocolor snaps them into complete focus in the same way that my glasses snap the morning paper into focus.

What is it about digital cameras that produce this need for added sharpness?

Why do some printed images look beautifully rendered, and others are soft or nasty and jaggedy? What's the right amount of resolution for color image reproduction? What the heck is anti-aliasing? And why do we use something called Unsharp Mask to increase the sharpness in an image?

Let's plunge right in and figure it out.

Pixels

Pixels are the direct result of cross breeding between two fantastical races: pixies and elves. Hence, "pixels." These almost microscopic creatures reside inside computer monitors, can change color on command and congregate in large numbers. They delight in arranging themselves in the form of images, and . . . and . . . all right, I'm making this up. But it would be cool if they were. The truth is much less interesting, as it often is.

The word **pixel** is derived from the phrase "picture element." A pixel is the smallest graphic element to which an image can be reduced. The atom of the digital image, so to speak. Every bitmap image, whether generated on a digital camera or digitized on a scanner, is nothing more than a collection of pixels.

Each pixel is an exact square. This square contains a uniform, flat value of color or gray value. Since the individual pixel has no shape or variation, we need to describe detail and color variation in an image with a great number of pixels. The more pixels we pack into each square inch of an image, the more ability we have to describe detail and variation.

There is a term for a single row of pixels in any image: a **raster**. The output of digital images is known as raster imaging, as any output device exposes, prints, or ablates an image row by row. The computer controller for any output device is known as a **RIP**. This acronym stands for raster image processor, and denotes any combination of

computer and software that is devoted to translating Postscript and portable document format (PDF) files into rows, or rasters, that the imaging device can understand and reproduce.

How big is a pixel? It depends. Since any given pixel is an exact square of a single uniform value, that pixel can be one micron or one mile across without any change to its inherent detail or value. Color technicians alter the size of pixels every day.

We need to concern ourselves with resolution, or the number of pixels per inch (or per millimeter, for the European and Asian readers) during the creation of an image, during any resizing of the image, and during the output of the image (Fig. 4-1).

Pixel Creation

Digital photographers are constrained to capturing a scene with the available number of pixels within the capacity of the CCD array or CMOS chip in the camera. This CCD (charged coupling device) array or CMOS (complementary metal oxide semiconductor) chip is the "film" of the digital camera. These arrays and chips are classified by the total amount of pixels that they can produce. A 5-megapixel camera creates a maximum image of roughly 5 million pixels. This image is essentially a rectangular grid with a given amount of pixels in the width and the height. Assuming an aspect ratio of 4 high to 5 wide, our image will be 2,000 pixels high and 2,500 pixels wide (2,000 × 2,500 − 5,000,000).

The photographer, or later the color technician, controls the dimensions of this image by determining how many of these captured pixels will be packed into a linear inch. Because pixels are square, however many pixels packed into a linear inch horizontally will be the exact number packed into a linear inch vertically. If, for example, the photographer or desktop

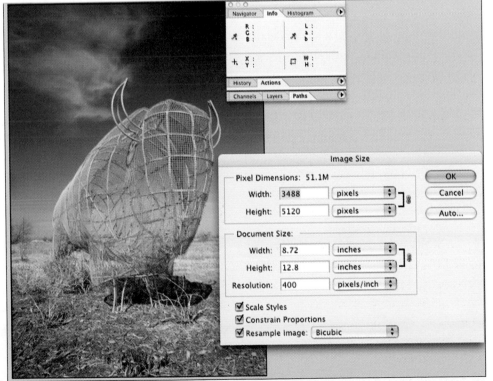

Figure 4-1
Photoshop's Image Size palette displays the pixel count, image dimensions, and resolution. Resizing images in Photoshop is accomplished using this feature.

technician decides that the resolution of the image is going to be 100 ppi (pixels per inch) and the number of pixels in the image is 2,000 high by 2,500 wide, the resulting image dimensions will be 20″ × 25″. Each square inch is a grid 100 pixels high by 100 pixels wide, or 10,000 pixels per square inch. Each pixel has been sized to 1/100th of an inch on a side.

If one changes the resolution of this image to 200 ppi without in any way changing the total amount of original pixels, then the image will shrink to 10″ × 12.5″. Now every pixel is 1/200th of an inch. A square inch now contains 40,000 pixels. By doubling the linear resolution, we end up quadrupling the number of pixels in a square inch. And each pixel is 1/4th its previous size.

Unlike conventional photography, where the image size is dictated by the film frame, whether that be 35 mm, 60 mm, 4″ × 5″, etc., the digital camera image dimensions are mutable, answering to how the CCD or CMOS pixel count is distributed. Without doing anything other than restating the resolution, an image can be enlarged or reduced without sacrificing a lick of detail. Decrease the resolution without throwing out any pixels, and the dimensions grow. Increase the resolution without inventing any new pixels, and the dimensions shrink.

Because larger images have larger details, larger pixels, and therefore lower resolutions, are appropriate. A 24″ × 30″ poster-sized image doesn't need anywhere the same resolution as a postcard-sized version of the same image. As we shrink the details that define an image, we need to shrink the size of the pixels that support those details. Smaller pixels, higher resolution. Shrink the image to postage stamp size, and the pixels need to shrink further, driving a further increase in resolution.

When a conventional original, such as a photographic print or a watercolor drawing, is scanned, the image resolution and dimensions are determined through software commands that produce pixels dictated by the optical resolution of the device, or how small a spot the scanner's optics can scan. Scanners sample an original in rows with a stepper motor moving the scanner optic in small increments. In the case of a drum scanner, the Plexiglas drum on which the original is mounted spins while the scanner optic moves in a perpendicular direction to the drum's rotation. In flatbed scanners, either the optics are moved while the bed containing the original is stationary, or the bed moves in one direction while the scanner optic traverses it back and forth (Fig. 4-2).

Figure 4-2
The Creo EverSmart Pro flatbed scanner.

Figure 4-3
Halftone screen
resolutions, or screen
rulings, are chosen to
best represent an image
within the possibilities
of a given printing
condition. Scanning
resolutions should be
chosen to capture
enough information to
support the halftone
screen ruling, which is
itself selected to best
conform to the job's
specific printing
condition.

A scanner operator might instruct the scanner to scan a 4″ × 5″ original to 300 ppi at 200% enlargement, desiring a final size of 8″ × 10″. The scanner actually scans the original 4″ × 5″ area of the scanner drum or bed occupied by the original at 600 ppi at 100%, or same size. The scanner software then redistributes the pixels to the requested 300 ppi, doubling the dimensions of the file. If the scanner operator's instructions exceed the capacity of the optics, the device will display some sort of error message saying that its parameters have been exceeded, and the scan is not possible. For instance, the Creo EverSmart scanner displays a nasty little stop sign. Some other devices will show the universal yellow triangle with the black exclamation mark. Denied!

Some scanners feature **interpolated** resolution to enhance shortcomings in their optical capabilities. Interpolation is the calculated addition of pixels through software to raise input resolution. This methodology is not recommended, as image softening is a common side effect.

Through much testing and experience, we have come to the understanding that two rows of pixels for every one row of halftone dots for a screened image produce the best possible detail (Fig. 4-3). Fewer than two rows of pixels will not deliver all the detail that the halftone screen frequency (the lines per inch [lpi] or number of rows of halftone dots in a linear inch) is capable of, and more rows than that retains detail that the particular screen frequency is incapable of showing. So if I am preparing an image to be published in *USA Today* at 85 lpi, I need 170 ppi in my image. If I intend to publish in an art magazine accustomed to 175 lpi separations for its coated stock and careful presswork, my image needs to be 350 ppi.

Whether one captures an image by scanning a photographic or art original, or by capturing the original scene with a digital camera, the resulting file is a fixed grid of pixels. The resolution of this image is sometimes erroneously classified as so many dots per inch (dpi). The proper terminology is ppi. We'll meet the term pixels again at the output stage when we discuss the phrase "machine pixels." The basic rule of digital image clarity and detail: the more pixels, the better.

File Compression

Color reproduction technicians need to understand the various **file compression** techniques commonly used in everyday digital workflow. Files are compressed, or reduced in size, for three reasons, all of which have to do with file size, which impacts time, which means money. The need for compression recalls the ethically challenged stand-up comic's complaint that his hotel's towels were so plush he could barely close his suitcase. We compress files:

1. To expeditiously send a file from point A to point B. No matter what transmission rate one uses, the smaller the file size, the quicker it travels from the originator to the intended recipient.
2. To economically store images. Consumer-level digital cameras can store as many pictures as their memory stick will hold. Compressed images take fuller advantage of the storage medium and are more convenient for the user, requiring fewer reloading of memory sticks and in tune with the modern user's ever-reduced threshold of annoyance.
3. To allow for fast display load and refresh rates of Web pages (see the above comment on "threshold of annoyance").

All compression strategies fall into one of two categories: **lossy** and **lossless**. Lossy compression techniques are unable to restore all original data when the file is uncompressed, as when one opens a JPEG file in Photoshop or the GIMP. Lossless compression techniques allow a compressed file to be restored to its pristine, uncompressed condition. Each category has its uses.

Beginning with lossy compression techniques, let's consider the **JPEG** and **GIF** formats. JPEG (Joint Photographic Experts Group) compression reduces the file size, not by down sampling the pixel resolution, but by progressively sacrificing color differentiation from pixel to pixel (Fig. 4-4). JPEG compression averages out color data that is least perceptible first, depending on its inventory of the particular image's data (think of the low valleys in a Levels histogram) and progressively averages out from there depending on the dictates of the technician doing the compression. The more color data we average out, the smaller the file size shrinks. At some point, visible artifacts, or side effects of this compression, begin to degrade the quality of the image. Luminosity differentiation seems to be respected by JPEG compression, with color data (hue and saturation differentiation) bearing the brunt of the data loss. Get into the habit of saving all photo editing work as uncompressed TIFF when editing original camera JPEGs, because resaving them as JPEGs adds a second helping of compression to an already compressed image.

GIF (Graphics Interchange Format) compression is commonly used in Web design, but is also useful in keeping PowerPoint files to a manageable size. GIF compression applies color indexing to the compression routine, which reduces the palette of colors that represent the image to 256 colors or fewer. This may well be a relic of the days before video cards, when RGB

Figure 4-4
Photoshop's JPEG
compression palette.
Note the slider control
for directing amount of
compression. At the
bottom of the palette is
the new size of the
compressed file and an
estimate of the transfer
time required, depending
on the bandwidth chosen
by the adjacent pulldown
menu.

displays could only represent 256 distinct colors at any given time. Nonetheless, color indexing radically reduces the file size, while rendering the file entirely inappropriate for print. So, GIF should be used sparingly, and only for computer display purposes.

ZIP (this is apparently not an acronym) is a form of lossless compression that shrinks file size by replacing chunks of binary code (0s and 1s) with markers that indicate exactly what the marked binary sequence needs to be when uncompressed, or extracted. This compression format works splendidly for text files and software applications, but has limitations regarding image compression as color images feature significant and continual variation of pixel content. ZIPped files require extraction, or decompression, to their original state before viewing or any other use other than storage or file transfer.

PNG (Portable Network Graphics) uses lossless compression and was developed to improve on, and eventually replace, GIF. PNG can compress to either 8-bit or 24-bit files. PNG-8 formatted files color index just like GIF. PNG-24 features fewer blocky looking artifacts than severely compressed JPEGs, but often features file sizes too bulky for fast Web page refreshes. However, the PNG format supports the concept of transparency, which means that Web designers can mask certain portions of a PNG image to show a silhouetted, or outlined, portion of the image on Web pages.

TIFFs are converted to JPEG in Photoshop or the GIMP via the Save As command. GIF and PNG files are converted via the Save for Web command in Photoshop and via the Save As command in the GIMP.

Resampling

Resampling is the subtraction or addition of pixels usually associated with resizing an image. When we subtract pixels from the image, we **down sample**. When we add new pixels to the original grid constructed by the scanner or camera, we **up sample**. Neither process is recommended, though certainly down sampling the resolution *if we are reducing the dimensions of the file* is less damaging than up sampling. Up sampling creates new pixels and requires the mathematical inventory of all surrounding pixel values to any newly created pixel, which results in that new pixel's value being the best guess that the software can make. Significant up sampling invariably results in a softening of the image, as the newly created pixels, being averages of what they are surrounded by, tend to smooth out image definition.

Resampling involves a process called **interpolation**. Interpolation is the introduction of new objects between existing objects; in our case, it is the mathematical method used in determining what the value of new pixels will be when up sampling. **Nearest neighbor** and **bicubic** interpolation are the two most employed strategies. The basic rule of nearest neighbor (which examines the value of the pixels on either side of the new pixel in its row) is fine for flat graphics; bicubic (which adds the values of the adjacent pixels in the rows above and below the new pixel as well as its nearest neighbors) is used when up sampling color photographic images.

Anti-Aliasing

We know that digital photographic images are composed entirely of pixels, which are square. But images invariably contain curving objects and details. Even in a high-resolution scan or digital photo, if one were to zoom in on these curved details, particularly in a grayscale image, one would at some point see the stair-stepped effect created by the corners of the pixels on the edge of the object as they create the upward or downward curve. The same problem applies to diagonal lines in the image. Since square pixels can't be sawn in half and turned into triangles, diagonal lines feature this same stair-stepped issue.

To prevent this stair-stepping along a curved or diagonal edge, the technique of **anti-aliasing** is invoked. Anti-aliasing alters the value of pixels along the edge to create little gradient wedges (Fig. 4-5). A **gradient wedge**, or step wedge, is a strip of squares, or rectangles, of progressively darker values. In the case of our anti-aliasing example, each gradient wedge is bounded by a pixel of black on one end and a pixel of white on

Figure 4-5

On the left is a magnified hard edge of a curved black object against a white background, with the stair-stepped edge built where black pixels meet white pixels. On the right is that same edge with anti-aliasing applied to blur and smooth the edge.

the other. Depending on the number of pixels between the extreme values, the tint of black ink in each pixel changes to support a blurred, or feathered, transition, when this edge is viewed from a normal distance.

Whenever we feather the edge of a selection marquee in Photoshop, we state a pixel radius within which to constrain the feather effect. That pixel radius is the total number of pixels that will build the gradient wedge and create the blur effect we desire.

Edge Definition

The term **edge definition** is related to earlier discussions of contrast. We stated earlier that our visual systems are designed to notice differentiation. Our visual systems are not built for precise measurement, but for comparing. How different is the object from the surround? How similar is the object to the surround?

Detail in digital images is enhanced through emphasis of difference and de-emphasis of similarity. Difference in a digital image is created when clusters of light pixels are adjacent to clusters of dark pixels; or when clusters of pixels of one color family are adjacent to clusters of pixels of a contrasting color family. The boundary where these contrasting clusters meet is the

edge. We define, or emphasize this edge by introducing added contrast along this edge by lightening the lighter pixels and darkening the darker pixels.

The edge is defined in software sharpening algorithms through its pixel radius (how many pixels along the light side of the edge and the dark side of the edge is the sharpening going to be allowed) and its intensity (how mild or severe of a contrast adjustment do we need).

Grain

Anyone familiar with conventional photography and scanning is experienced in working with grain. Grain is a reality in film emulsions. The faster the film imaging speed the more evident the grain. The greater the reproduction enlargement through the scanning process, the larger the individual film emulsion grains appear. Photographers and scanner operators have long used grain as a focusing element; photographers in the darkroom enlargement process and scanner operators during the focus sequence in a scan set up. Scanner operators combat grain by oil mounting or double oil mounting transparent originals. Oil mounting is achieved by floating the original on a layer of mineral oil. The scanner optics, which

Figure 4-6
Drum scanning is being replaced by digital photography, flatbed scanning, and "virtual drum" technology, which is similar technology and mechanics to a traditional drum scanner, but removes the Plexiglas drum and with it the related mounting tasks.

normally analyze a beam of light which passes through the drum or bed and the transparency, soften that light by diffusing it through the oil on which the original floats (Fig. 4-6). Double oiling involves sandwiching the original in two layers of oil and containing the whole under a clear sheet of acetate. So the light received by the optic is diffused through two additional layers of oil and the acetate sheet.

After the image is digitized, the imaging technician is able to increase the edge definition with more than normal intensity without calling any undue attention to the photographic grain, which has been blurred and minimized by the light diffusion.

In a digital photo, there is no grain. So normally, there is little to fear from that quarter. Software sharpening algorithms will allow the imaging technician to protect areas of low contrast from the effects of edge definition enhancements by regarding those low contrast areas as grain.

Let's consider a close-up of a models face. To make that close-up as pleasing as possible, we want to emphasize certain aspects of the features while softening others. The eyes, lips, and hair are natural areas where we

require clarity and detail, while the skin pores and rouged cheeks are areas where we want a pleasing smoothness.

So, how do we sharpen parts of the image while leaving others alone, or even softening these other areas? Unsharp Mask.

Unsharp Mask

The term **Unsharp Mask** dates back to the days before electronic scanners. When journeymen camera operators roamed the earth. And by cameras, we mean these monstrous horizontal beasts that looked like a giant version of what Matthew Brady used at Gettysburg (Fig. 4-7). Bellows that you could climb into, protruding from a darkroom. Long-toothed rails on which the copy board could be moved by means of an iron wheel that the camera operator, who had forearms like Popeye the Sailor, would wrestle. The only thing missing were jets of steam. The camera lens was the size of a tyrannosaur's eye. Extending out from the frame on both sides of the rails and copy board were large exposure lamps that flashed like lightning bolts in Frankenstein's lab. That's right, we're talking the 1970s. All of the above plus ugly clothes and silly haircuts.

Figure 4-7
The 1960s and 1970s era color separation device—the horizontal camera.

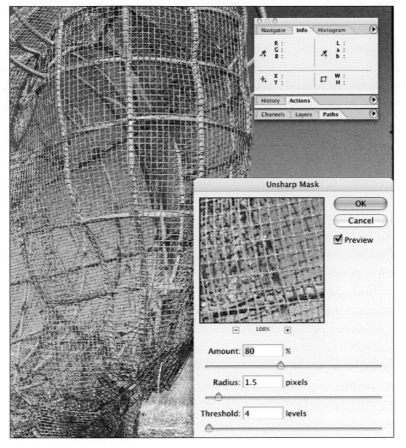

Figure 4-8
The Photoshop CS
Unsharp Mask Palette.

Believe it or not, these huge horizontally mounted cameras were what we separated with back in the day. Since the byproduct of producing CMYK separations from RGB filters on these cameras, with the chemistry available then, invariably produced rather soft images, a method had to be created to sharpen these images. The answer was a continuous tone diffusion mask created by layering the CMY separations one by one to raw sheets of film on the camera back and overexposing, creating a blurred duplicate separation, the Unsharp Mask. By duping (copying) the individual separations on camera with an added exposure using the resulting mask as a blocker, the CMY separations would pick up that edge definition we achieve through pixel enhancement. The modern software developers honor this technique by naming their image sharpening filters after it.

The Photoshop filter Sharpen/Unsharp Mask is a tolerable, if simplistic version of this technique (Fig. 4-8). The menu features three adjustment sliders: Amount, Radius, and Threshold. The order in the GIMP is Radius, Amount, and Threshold (which makes more sense). Radius and Amount work hand in hand to control edge definition. The Radius field expresses how wide, in pixels, are each side of the edge. Think of the edge, the border where lighter and darker pixels meet, as a two-lane road. One lane represents the light side of the edge, and the other represents the dark side. Each lane is as many pixels wide as you indicate in the Radius field. So the edge ends up being twice as wide as your Radius number. If we choose 3 as our Radius, we create a 6-pixel wide edge. The Amount field controls the intensity of the contrast adjustment along the edge *within the width defined by the Radius*

number. The higher the Amount value, the greater the intensity of the contrast adjustment within the edge. Threshold softens the low contrast, nonedge areas by protecting these areas from the Radius and Intensity settings. Increasing the Threshold amount increases the areas defined as nonedge.

Never work in Unsharp Mask without viewing your image in Actual Pixels zoom. In any other zoom you won't get accurate visual feedback on sharpening adjustments. Actual Pixels zoom, which is found in Photoshop under the View pulldown menu, corresponds to 100% zoom in other software. When one views an image in Actual Pixels zoom, each pixel in the image is mapped to a single pixel of monitor resolution. If my monitor resolution is set to 1,280 x 854, the exact same grid of pixels somewhere in the image will be displayed. So if my image resolution is 300 ppi, this particular 1,280 x 854 resolution could only accommodate an Actual Pixels view of 4.26″ x 2.85″ of image, which will fill the screen. If the image dimensions are greater than that, then we need to shift the image around with the Move Tool to inspect the entire thing. It makes sense that since we are defining the width of the edge in pixels, then we need to

be viewing at Actual Pixels zoom to best judge the results of Unsharp Mask adjustments.

Optimal Unsharp Mask Results

What are the optimal Unsharp Mask settings? This is another one of those pesky "it depends" answers. The proper Unsharp Mask settings have everything to do with the resolution of the image, the size of the image details, the nature of the image, etc. Some subjects, those heavy in foliage or busy detail, don't tolerate as much Unsharp Masking as less busy subjects. Facial close-ups require a certain softness to the skin, with nice detail and clarity in the eyes, lips, and hair.

A properly sharpened subject looks crisp and believable, neither too soft nor too sharp (Fig. 4-9). Subjects that are oversharpened take on a nervous, jumpy look to them, and feature objectionably thick edges with too much white or black outlining and noticeable grain. Any overlooked dust and scratches picked up from the original or because of slovenly scanning are enhanced.

Undersharpened subjects look soft, defocused, and somewhat flat. Transitions between contrasting shades or colors are downplayed. The entire image can take on

Figure 4-9
The image on the left has no Unsharp Mask. The right most image has too much. A properly sharpened image must not betray any overt evidence of sharpening, namely pronounced edge definition.

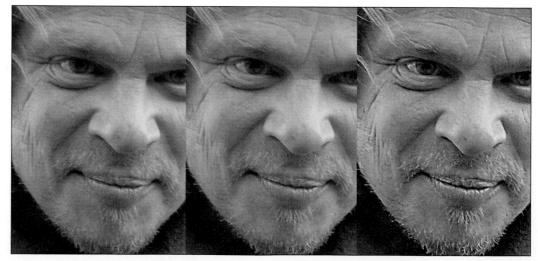

Figure 4-10
The Creo EverSmart
Pro's Advanced Unsharp
Masking Menu.

a look as if it features less pixel resolution than it actually does.

When applying Unsharp Mask edits, the normal practice is to push the adjustments until the results have gone past optimal to an oversharpened appearance, and then back off until a satisfying look emerges. Previewing before and after screen views or History palette snapshots at Actual Pixels zoom is strongly suggested. Generally, the lower the pixel Radius number, the greater the Amount can be increased. Again, the trick is to emphasize the edge, where differentiation is found, without calling undue attention to it by creating any hard black or white outlining. It seems logical that the higher the pixel resolution, meaning the more pixels per inch the image supports, the larger the Radius that the image will support; it is actually more dependant on how fine the details are in the subject. Smaller details, such as foliage or textile patterns, don't tolerate aggressive sharpening. Wide edges obscure fine details.

Advanced Sharpening Techniques

Let's consider the Creo EverSmart scanner's Unsharp Mask feature, not because most readers of this text will own or use that scanner, but because its Unsharp Mask feature is as good as any other sharpening option on the market and far better than most, including Photoshop or the GIMP (Fig. 4-10). And this is a cross-platform, software-independent text, so it is worth discussing what is possible in software sharpening, even if not in the dominant image editing solution.

Where Photoshop and the GIMP have three adjustment options (Amount, Radius, and Threshold), the EverSmart scanner Unsharp Mask software features nine adjustments. Though three of these are of dubious use, the remaining six still leave you with twice the control of normal Unsharp Mask filters.

Among these Advanced options are the ability to sharpen through a color filter. This is an interesting and very useful option,

as it allows the user to sharpen certain color families while leaving others soft. Let's consider the Color Circle. The Additive color primaries of Red, Green, and Blue are arranged in a complementary fashion with the Subtractive primary colors Cyan, Magenta, and Yellow. Choosing to sharpen through a given filter Color will soften the adjustment in colors of that filter's hue, or adjacent to it, while concentrating the greatest impact on the exact opposite side of the circle and hues adjacent to that point.

Reflecting on our image of the facial close-up, if that image is digitized on Creo's EverSmart scanner, the operator's informed choice on Unsharp Mask color filters would be the Red filter, as that filter will hold an agreeable softness to the skin and rouged areas while emphasizing the blue or green irises of her eyes. (See Figure 4-12.)

We can emulate, if not exactly duplicate, this procedure in Photoshop by Channel sharpening. This technique is pretty much what the name infers, sharpening individual Channels, as opposed to sharpening the image as a composite color file. This technique calls for one of two normal approaches. The first is to convert our RGB file to LAB space. In LAB space, the L* channel has no color attributes, only luminosity (Fig. 4-11). So the L* channel carries all the detail and lightness/darkness information free of hue or saturation.

Therefore, if we convert our color image to LAB space, select the L* channel only, and apply our Unsharp Mask moves, the result will be sharpened detail, which we want, without emphasizing the information that supports hue and saturation. This is an effective approach to an image that shows a variety of different hues and saturation levels.

If one color family dominates the image, then we take advantage of a second technique in RGB space by isolating the

Figure 4-11
The L*, or Luminosity, channel is selected to isolate sharpening to noncolor, detail areas only.

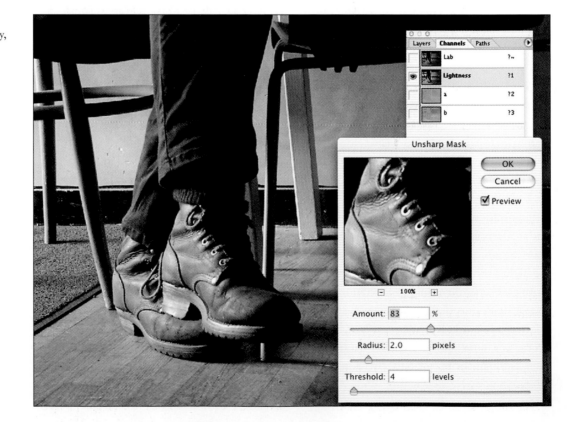

Figure 4-12
The Red channel is isolated for sharpening to prevent the skin tones from becoming harsher than desired.

channel or channels that are "weak" in pixel strength. For instance, our facial close-up is going to feature more Red and Green information than Blue information. Bear in mind that the RGB color space is the Additive space. So the "weak" channel is that which appears to have pixels with the highest luminosity, or are lightest on your display; that would be the Red channel. So we sharpen the Red channel information, just as we would use the Red filter on the Creo scanner (Fig. 4-12). This Red channel information later will build the Cyan separation when the Mode conversion from RGB to CMYK is carried out.

The Cyan channel just happens to be the weakest color separation in a skin balance. Which is to say, sharpening the channel destined to be the weakest printed color separation in a skin tone will result in the most agreeable result regarding keeping skin tones smooth.

In addition, the edge definition and the grain controls on the Creo EverSmart Pro's Unsharp Mask controls are divided into two options. The edge definition divides the intensity of move into separate controls for the light and dark sides of the edge. So we can downplay the black line edge while enhancing the white line, which on certain darker subjects can be useful. The grain

controls not only allow the user to define how much of the nonedge area is going to be defined as "grain" but how much smoothing, or softening, is applied.

So those are the basics of Unsharp Masking. Like a lot of other photo editing techniques, comfort level and success come with practice. It's better to assume that any provided digital images require at least close inspection at Actual Pixels zoom than to assume that the images are as sharp as they need to be.

DPI and LPI

Equal care must be taken when printing images—even to consumer-level devices—as is taken when the image is captured and edited, or all the hard work on the front side of the process is damaged at output. Part of that care at the printing stage is understanding and taking advantage of the resolution of the printing device, whether that device is an ink jet color printer or a six-color press.

The first thing we need to understand about printers and presses are that they do indeed have optimal resolutions (Fig. 4-13). In the case of a digital imaging device, the expose, or printing mechanism operates along its own grid of rows and columns of pixels. On the expose or printing side, these

Figure 4-13
Printers and other digital imaging devices have resolution considerations as well. The Epson 10000 is capable of 1,440 dpi across the roll but only 720 dpi vertically due to the advancing mechanics of the paper feed.

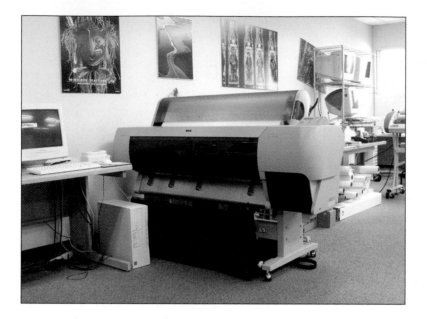

pixels are classified as **machine pixels** and generally are much smaller than the original pixels that the make up the digital image.

All output devices have maximum resolutions, and many have a range of resolutions to choose from. This output resolution is the true dpi (dots per inch). Every dot of the dpi is a machine pixel. This acronym might be better served by naming it "spots per inch," because each machine pixel invariably ends up being imaged as a round spot due to the characteristics of ink jet droplets and laser beam exposures. Also, halftone dots are the logical objects to call dots. Each halftone dot is made up of anywhere from 2 to 256 machine pixel spots. So, spots make dots. Since halftone dots are imaged in rows, or lines, on a halftone screening output device, the resolution, also known as the **screen frequency**, is identified as **lpi**.

Since a single row of machine pixels is known as a **raster**, digital files that have been translated for output, by printing them to a raster image processor, or RIP, are called raster files. Every digital output device is driven by some form of RIP, generally specialized software residing on a computer that is connected directly to the output device.

In summary, we have three classifications of resolution:

- **Pixels per inch (ppi)**—the resolution of the original image prior to and after any corrections, edits, and resizing. This resolution is created by the digital camera's CCD or CMOS chip, the scanner's optics and software, or by the creation of original digital art in an application such as Photoshop.
- **Dots per inch (dpi)**—the resolution, in machine pixels, of the printer or output device. Each machine pixel is an "on" or "off" signal to the print or expose mechanism. Ink jet printers, laser printers, film and plate setters, digital presses, and proofing devices all generate machine pixels.
- **Lines per inch (lpi)**—the screen frequency, or number of rows of halftone dots, of a halftone screening output device, which forms these halftone dots with clusters of machine pixels. Film and plate setters,

some proofing devices and direct imaging digital presses organize their machine pixels into halftone screens.

If our digital image is 300 ppi and our output device's resolution is 2,400 ppi, the digital image's larger pixels will be processed to the output device's smaller machine pixels before the image is printed. This processing takes place after the original digital image is sent to the printer but before it is output, during the RIP sequence.

Bit-Depth and the Rule of 16

Printing the best representation of your digital color image requires an understanding of **bit-depth** and the **Rule of 16**. Understanding bit-depth by itself is all well and good, but it is in the relationship to the output device that bit-depth plays a crucial role. This relationship between these two needs to be respected or printed results will suffer.

The bit is the fundamental computer programming command. A bit is an on/off signal. Or a yes/no or a black/white or any other way one chooses to interpret an either/or command. It doesn't get any more basic than that in computer programming language. One bit can describe a black and white or line art original, which only needs two pixel values, a white paper (0%K) value and a solid black ink (100%K) value. Think of a pen and ink drawing, or this book's black text on white paper. If this book were only black text and pen and ink illustrations, a 1-bit bit-depth would be sufficient to produce all of the graphics and copy. Grayscale images, or those that the average person refers to as "black and white" are 8-bit images. In other words, it takes eight on/off signals working in combination with each other to provide all of the tonal values needed to properly represent a scene. These 8-bit

images are capable of displaying 256 (28) distinct tones, or gray levels, from white paper to solid black.

To properly represent an 8-bit grayscale image, the printer, or output device such as a plate setter, needs to be able to render all 256 of those gray values in the image. The output device does this by creating cells, or grids, of machine pixels. Each cell is capable of displaying any one of the 256 gray levels only if the cell is a grid of 16-machine pixels by 16-machine pixels (16 x 16 = 256) (Fig. 4-14). So any number, from none of the pixels to all of the pixels in this cell, can be activated depending on the gray level it is instructed to represent. Bear in mind that every halftone dot in a screened image is created within one of these cells. If we take the dpi resolution of the output device, and divide it by the number 16, we get the number of cells per inch that the output device requires to fully represent all 256 gray levels, which is also the optimal screen frequency for that particular dpi. This is the **Rule of 16**.

**DPI of Output Device ÷ 16
= Optimal Screen Frequency**

Let's assume the output device's maximum resolution is 2,400 dpi. If we take 2,400 and divide it by 16, the result is 150. In this case

Figure 4-14
This illustration shows a single output cell with a grid of 16 pixels square. Exposing, or applying colorant to, a cluster of machine pixels of the desired size forms the halftone dot.

150 lpi is the optimal screen frequency for representing all 256 gray levels in the image on that particular output device. Now let's check some other screen frequencies to see how they represent the image. Let's say our press house requires 175 lpi images for the fine detail required for a particular brochure they are running. If our output device's best resolution is 2,400, we can take that number, divide it by 175, and determine the cell size for halftone dots that small. In this case it is 13.7 pixels (and round this number up to 14). If I multiply 14 x 14, which is our cell size, the number that we arrive at is the number of gray levels that this output device will support at 175 lpi. In this case, the answer is 196. Bummer! We just lost 60 gray levels of tone in our image. We might have nice small halftone dots, but we aren't going to show all of the tonal variation of the original. If we sacrifice tone, we damage the contrast of the image. Why? Dynamic range and tone distribution combine to create the image's contrast. Subtract tone, and you damage contrast.

What would our dpi have to be to capture all 256 gray levels at 175 lpi? Simply multiply the lpi x 16 and you have your answer: 2,800. Let's take another example, newsprint. Your daily newspaper's color images are probably 85 lpi. The nature of the newsprint process, with its uncoated, highly porous paper and its non-heatset drying process cause high dot gain and muddy images at higher lpi. So, taking 85 lpi and multiplying by 16, we see that our output device's dpi only needs to be 1,360 to represent all 256 gray levels. If we output 85 lpi at a higher resolution, we gain nothing because there will only be 256 gray levels in an 8-bit image, so there is no point creating cells capable of capturing more. The higher the dpi, the greater the imaging time, so we waste time as well.

Chapter 4 Summary

In summary, we concern ourselves with pixel resolution when we create or capture a bitmap image, resize or otherwise edit it, and output it. The more pixels we pack into a square inch, the greater the detail we will be able to display in the image itself.

To properly print a color image we need to coordinate among the various resolutions related to the process. Optimally, for print production, the digital photographic image file should have enough resolution to assign two rows of pixels for every one row of halftone dots specified by the printer. Each of these halftone dots should be constructed in an output device cell of 16 machine pixels by 16 machine pixels to retain all 256 gray levels in each 8-bit channel in the image.

The sharpening algorithms in the software use pixel values by emphasizing difference and smoothing similarity. Unsharp Mask filters emulate decades-old camera and darkroom techniques to enhance edge definition and smooth out grain.

Chapter 4 Review

1. Which two components act as film in a digital camera?
2. Why do digital camera shots appear smooth and imperfectly focused?
3. What is anti-aliasing?
4. What is it about JPEG compression that prevents us from seeing the true initial results of our digital camera captures?
5. Why is resampling the pixel count in an image undesirable?
6. What does pixel radius have to do with edge definition?
7. What is the Rule of 16 and why is it used?

Believable Colors

Chapter Learning Objectives

5

- Comprehend how additive and subtractive primaries mix to form colors
- Be able to identify the three attributes of all colors
- Recognize the ways that colors are affected by contrast and balance adjustments
- Gain an awareness of proper skin tone color balance
- Develop an understanding of expanded gamut printing

We all have pictures stored in our heads of what certain colors should look like. When we think fire engine red it's not the same color as beet red. Navy blue is a different color than sky blue. Grass green, forest green, olive green, chocolate, grape, blood red, blaze orange, etc. are all examples of memory colors. These are color families that we've seen so many times that we commit them to long-term memory, calling them up as needed to supply a visual when we encounter these colors while reading or holding a conversation. These memory colors could be saturated, intense hues, or they could be pastel colors.

As we begin to look at dozens, then hundreds, of printed images, we begin to notice, from time to time, colors that just look wrong. They don't look believable. They don't really look as if they belong in the scene. These colors stand out too much. Or perhaps they are more subdued than we expect. They don't agree with our memory of what that color should be. Perhaps they are oversaturated, or lack the same shape and definition of other colors in the scene. Often there is a harsh edge where these colors meet surrounding values.

Color correction, or color alteration, is a risky business. It's risky because to carry out specific color corrections, our adjustments become localized (Fig. 5-1). By localized, we mean that the entire image is not going to be affected by the adjustment, just the target color family. So there is now a risk that the corrected area can look out of place with the rest of the shot, and we leave evidence that the image was corrected in the first place. We lose the "unobtrusiveness" of the correction.

Because certain colors just don't photograph accurately, or because their closest Cyan Magenta Yellow blacK (CMYK)

Figure 5-1
The center section of the pyramid is where color adjustments, which by their nature are selective, are made. Since this area localizes corrections, there is more risk of pulling the corrected area visually away from the rest of the image.

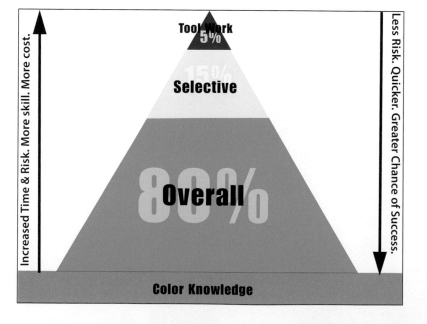

equivalents tend to disappoint, clients will often ask for localized color changes when the rest of the image is to their satisfaction. For us to judge to what extent we can improve a color, we need to understand how color is constructed in Red Green Blue (RGB) and CMYK spaces, look at how color is affected with contrast and gray balance adjustments, and learn what is possible with localized, color-specific adjustments. We will not always be able to deliver the exact color the client desires. So we need to understand when we have room for improvement and when any further adjustments are a waste of time and money.

The bottom line is a four-color process job has only three colored inks to make whatever colors the image needs. Black is a neutral. Black has no role in defining hue or saturation, only the relative darkness, or value, of a color. Only so many colors are achievable with cyan, magenta, and yellow, even under the best of printing conditions. One of the biggest shocks to inexperienced color technicians and print buyers is the change in hue and loss of saturation in royal blues, oranges, and reds when RGB files approved on a color monitor are converted to CMYK and printed. It is estimated that of the perhaps 2 to 3 million

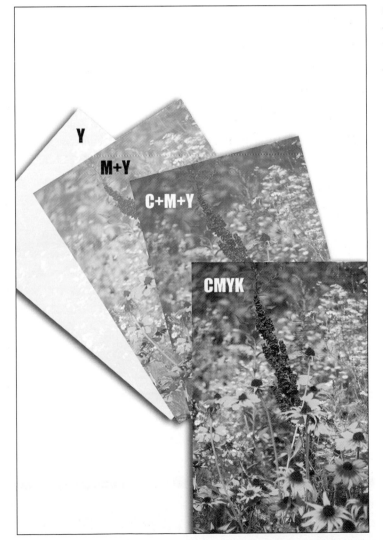

Figure 5-2
A representative CMYK image showing how the four-color plates combine to create the illusion of thousands of different colors.

colors that we humans are able to perceive, only 5,000 to 6,000 are achievable under the most stringently controlled press conditions (Fig. 5-2).

The royal blues that look so magnificent on our computer display lose saturation and pick up a purple-grayish feel. Your client's product is blaze orange? You're getting pumpkin, baby. Crimson? Sorry. Yellow and magenta inks overprinting each other just don't have that richness of red.

This is one of the major challenges of the color specialist. We live in a publishing world that does not have the budgets to pay for the quality of paper, the purity and different number of inks required, nor the number of print stations on a press, to deliver printed images that match the varieties possible in the additive, RGB color space. And the inkjet printers hooked up to our household PCs do not deliver perfect color, even on glossy coated photographic papers.

For the most part, we live in a world where existing budgets and other production realities ("I need it today! Today!") constrain us to a world of tightly standardized cyan, magenta, yellow, and black hues with which

we do our best to represent every color in the visible universe.

For those customers with generous budgets, **expanded gamut** strategies are available which augment the CMYK ink set with two or even three extra inks that significantly enlarge the palette of possible hues. We'll study these expanded gamut solutions later in the chapter.

Color Alterations and Corrections

To the color specialist carrying out color adjustments, there is no difference between a correction and an alteration. The only difference in the business of color reproduction is alterations are billable to the client. Corrections are not. Alterations mean the client wants something altered in the original image. Corrections imply that an earlier round of work could have been done better, and so a nonbillable adjustment is required.

Either way, when a color adjustment is required that is localized to a given color family (e.g., the reds are too orange), then we need to restrict any adjustments to that

Figure 5-3

The Creo EverSmart Pro scanner color correction palette shows where in color space the target color value is found after the color correction is applied. Note the slider bars available to adjust the range of impact.

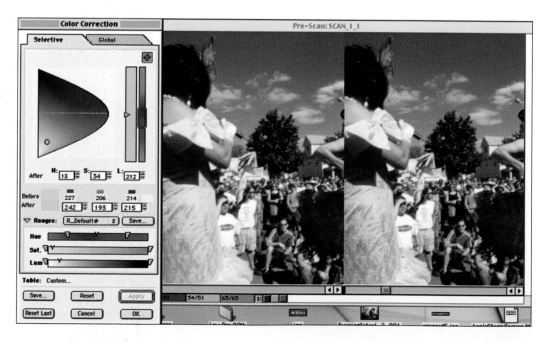

specific color family, protecting the rest of the image from the adjustment.

A color adjustment in a digital file is not difficult, because each pixel in the image, using scanning software or color editing software, can be evaluated and either included in the adjustment or protected from it (Fig. 5-3). Imagine the classic image of a stone tossed into a pool of water, creating a series of concentric circles. The exact spot where the stone hits the water is the target color pixel of our adjustment. Any pixels of that value, or very nearly that value, will receive the maximum impact of the adjustment. Next, there is a ring of pixels somewhat near the target value that will receive a lesser adjustment. There is another ring of pixel values that will receive a slight adjustment, and so on, until we get to the various pixel values that are completely untouched and unaffected by the adjustment.

There are a number of different approaches to altering color. They include, but are not limited to, the following:

- Adjusting an entire color family, such as all greens
- Adjusting to a target color value with a specified range of included colors
- Creating a selection or mask to adjust a specific color area in the image while protecting the rest
- Temporarily transferring the file into LAB space to alter hue or saturation, independent of shape and detail.

Each of these techniques will be addressed in detail in Chapter 8, Masked and Invisible.

Color Attributes

Any given color can be defined in a number of different ways in this color reproduction trade. It can be specified by its LAB coordinates, RGB values, CMYK percentages, etc. At a more fundamental level, any given color has three attributes that define it as that particular color, and not another. These three attributes are **hue**, **saturation**, and **brightness** (sometimes

Figure 5-4
The GIMP's Hue-Saturation color adjustment feature presents the six selectable color zones arranged as the color circle.

termed as lightness or value). The **hue** tells us what color we are looking at. Hue is fixed in the color circle by defining on which degree of the 360° in a circle this particular hue can be found (Fig. 5-4). For instance, pure RGB red is where the circle begins at 0°, RGB green is at 120°, RGB blue is at 240°, yellow is at 60°, magenta at 300°, and cyan at 180°. So the Hue tells us whether we're looking at a blue or a purple, or some sort of red.

Saturation defines how rich of a color we are looking at. Remembering that the center of the color circle diagram represents neutrality, the saturation percentage tells us whether the color we are looking at is a pastel tint, a semi-saturated color, or is fully saturated. This number is a percentage, from 0% to 100%; the larger the number, the more saturated is the color. The larger the saturation value, the further out from the center of the color circle it is.

The third dimension of a color is the **brightness**, or **value**. This dimension is very much like the Luminosity axis in LAB space,

controlling how clean and bright, or dark and subdued is the color. 0% Lightness is basically black. The lights are off. 100% Lightness is essentially white. All hue and saturation have been washed out.

Linking Contrast to Color

One of the interesting facets of color reproduction is the manner in which adjustments to contrast in a digital image have such an immediate and profound impact on the colors in an image. In RGB and CMYK spaces, you can't separate the two. Contrast and color are linked together. You can't affect one without affecting the other.

In fact, the hue, saturation, and brightness aspects of any color are directly connected to the end points of highlight and shadow on the gradation curve and the three pivot points of quartertone, midtone, and three-quartertone.

Recall that in Chapter 3, Balance, we stated that in all current color models, colors grow out from a neutral center.

Figure 5-5
The GIMP's Color Picker Information palette identifies the sampled color by RGB values and corresponding hue saturation value numbers.

Neutrals are created when primary colors coexist in a balanced state, either equally balanced, in the case of the RGB world, or with the yellow and magenta roughly equal and the cyan leading in the CMYK world.

As we pull these primaries out of balance, causing one of the primaries to fall below the rest and one of the primaries to increase in value over the other two, we begin to create color. The further we pull these primaries out of balance, and away from each other, the purer the color becomes, and the more saturated it becomes.

For example, let's start with a balanced RGB midtone: 128R, 128G, 128B. If we mix those values in any desktop application, we will get a neutral, medium gray. Now let's pull these primaries apart a bit. Let's subtract 50 points from the red and add 50 points to the blue. We now have 78R, 128G, and 178B. We have created a color that is definitely in the blue family, something of a slate blue. If we remove 50 more points of red and add 50 more points of blue, we now have a very vibrant blue (28R, 128G, 228B). If we were looking for these last numbers on our gradation curve, we would find the 28R between the three-quartertone and the shadow. Very little red light needed. The 128G lies exactly on the midtone. The 228B is between the quartertone and the highlight.

Any given color is constructed in the same fashion. Pull the neutral balance apart just a bit, and you have a pastel tone. Pull it apart more, and you have a semi-saturated color. Pull the primaries widely apart, and you'll arrive at a saturated color.

As we pull our neutral midtone balance apart, different areas of the gradation curve increasingly affect different color channels. Because of this, every time we make a contrast adjustment to an image, we are altering the colors in that image.

Hue is predominantly affected by midtone adjustments, and somewhat less by three-quartertone. Saturation is affected by three-quartertone and shadow adjustments in CMYK and by quartertone and highlight adjustments in RGB. Brightness is affected by highlight and quartertone adjustments in CMYK and by three-quartertone and shadow adjustments in RGB. In summary, there are no adjustments that can be done to either dynamic range or tone distribution, the two components of contrast, that do not directly impact every color in an image. Adjustments to improve gray balance, which are essentially tone distribution adjustments to a specific channel or two, will also have significant impacts, most noticeably in the hue.

Describing Color

Let's take a known color. We'll select this color from the **Pantone solid coated** library (Fig. 5-6), allowing any of us with a Pantone guide to look up the particular color and hold it in front of us, or at least to reference the color in Photoshop or some other application and view it on our monitor. We'll go with Pantone solid coated 3015, which is one of the colors used in my school's logo. It's a saturated blue, as far as general classifications go. But if any of us were to just say the phrase "saturated blue," there is every chance that the specific color that one of us have in mind is not identical to the shade that another conjures up.

Let's use Pantone solid coated 3015 as a saturated blue that all of us can reference exactly. The blue that we agree on is an ink formulation that has been mixed to Pantone's recipe using very specific amounts of very specific base ingredients. It is what it is. There is no other shade of blue that one can mix and announce that this is "my version of" Pantone solid coated 3015. For this reason, corporations around the world specify their corporate logos

Figure 5-6
The Pantone Coated
and Uncoated Formula
Guides, the Pantone
Pastel Formula Guide,
and the Trumatch Color
Swatch Guide.

and other brand colors by their Pantone designations.

Here's our challenge as color specialists. We just defined the three attributes of any color as hue, saturation, and brightness. How do we classify Pantone solid coated 3015 within these parameters? We also need to display this Pantone solid coated 3015 on our computer monitor (in RGB) and we need to print this same 3015 color in CMYK on our color printer, and later perhaps, on a four-color sheet fed press. How do we best do that?

Photoshop's Color Picker

Let's consult the **Color Picker** palette in Photoshop. We launch the Color Picker by selecting either the Foreground Color icon or the Background Color icon near the bottom of Photoshop's Tool palette (Fig. 5-7). The Color Picker palette emerges, and we see that it includes a button labeled **Custom**. Selecting the Custom button jumps us to a second palette labeled Custom Colors (Fig. 5-8),

which has a pulldown menu labeled **Book**. We access the Pantone solid coated library with that pull down menu, and are able to use a slider bar to find the exact Pantone solid coated ink desired, in this case 3015, or type in 3-0-1-5 in the provided field. That color is now enabled as either the Foreground or the Background color in Photoshop's Tool palette, depending which route we took to access the Color picker in the first place.

On this Custom Color palette is a button labeled **Picker** that jumps us back to the original Color Picker palette (Fig. 5-9). On this palette there are no less than five translations of Pantone solid coated 3015 into other color spaces or classifications. Let's start with the hue saturation brightness (HSB) translation. My HSB values are H:204°, S:100, B:63. (Are your HSB values identical? If not, sit tight, we'll explain in a bit.) The H stands for hue. A hue of 204°, assuming that 0° on the color circle is the 3-o'clock position, is roughly 8 o'clock. The S for saturation is 100% and that is full

Figure 5-7
Note the location of the Foreground and Background color icons on Photoshop's Tool palette. Selecting either will launch the Color Picker.

brightness is pitch black and 100 is absolute white, a 63 is somewhere in the middle, slightly brighter than it is dark. We have now, or Photoshop has, fixed Pantone solid coated 3015 in the three-dimensional HSB space.

Fine. What good is all of this to the color specialist? There are two nuggets of useful information regarding the definition of any color by its HSB values. For one thing, the combination of the hue and saturation values neatly plots any given color on our color circle. That's handy when it comes to making color correction decisions. Two, we will encounter a concept known as hue error when dealing with colorants. See the sidebar on Hue Error.

Our secondary consideration is displaying this color correctly on my color monitor. Again, referencing the Color Picker, we see that certain RGB values are deemed equivalent to 3015. My Color Picker says R:0, G:96, B:161. Remembering that the RGB space ranges from 0, which is lights out, to 255, which is light fully on, we see that Pantone solid coated 3015, when displayed on my color monitor as an RGB mix, requires the red completely shut off, green at less than half strength, and blue well short of full strength. The RGB space is defining our color as a blue with a

saturation. We can't get any richer than that. That means this color, 3015, is sitting at 8 o'clock on the very rim of the color circle (or clock face), as far away from center, or gray, as possible. The B, or brightness value, is 63. Assuming 0

Figure 5-8
This is the Book pulldown option set to Pantone solid coated.

significant amount of green component. On the color circle, we can check this against the degree of hue in the HSB space for this color, and see that 3015 inclines in the direction of cyan, which lies between blue and green. Reviewing the RGB values of 0R, 96G, and 161B, we see that 3015 is well within the outermost tolerances of RGB space.

Since we have to print this Pantone solid coated 3015 using only the CMYK inks budgeted, we need to be concerned with the exact mix of CMYK percentages to either match this color exactly, which is improbable, or at least best represent it. Here the Color Picker reports the values as 100%C, 51%M, 17%Y, 3%K. So we need as much cyan ink as we can get, we need a

Hue Error

Hue error is the contamination of any given color, particularly a process cyan, magenta, or yellow, by any hue other than the pure hue of the color itself. Hue error can be imagined as the bending of a color either clockwise or counter-clockwise around the color circle away from true, and is often a by-product of normal ink formulation. Cyan ink formulated for Specifications for Web Offset Production (SWOP) offset printing is not absolutely pure cyan. It actually has some contamination of yellow component. Conversely, normal process cyan formulated for flexography is contaminated with red. Laying down too much ink film thickness on press reveals the hue error in a more pronounced fashion. As the ink film

thickness (the depth of the ink layer above the surface of the substrate) increases, its ability to accurately absorb and reflect portions of the visible spectrum changes. The visual result is the pollution of hue, or loss of purity of color, away from what is expected. Hue error can be measured by either a densitometer or a spectrophotometer. Before understanding hue error, we need to understand that hues are identified by the degree value that they occupy in this circular color space. Again, why is hue error important? What hue error indicates is a failure to accurately render the colors of the digital file on press. So, all of the color specialist's hard work is ultimately in the hands of the technicians who formulate the ink or who control the printing press or digital printer.

half-strength magenta, which will help build the cyan into more of a blue, we need a decent amount of yellow to help achieve the green tinge of this color, and just a little black to darken the color very slightly.

The fourth translations of interest are the LAB values, which we know from earlier reading is the all-encompassing color space within which every color visible to humans can be plotted. Our Color Picker here reports that Pantone solid coated 3015 is L:36, a*:−23, b*:−48. What do these values mean? An L*, or Luminosity value, of 36 means the color is closer to black than it is to white on the gray continuum, 0 again being black and 100 representing white. An a* value of −23 indicates it inclines to the green side of the red-green axis, but not by very much, as −128 is as green as we get. A b* reading of −48 puts the color on the blue side of the yellow-blue axis, which makes

sense, but again is not as high a value as we might think.

The last translation on the Color Picker simply has a number sign (#) designation. The inscrutable looking code in this box is indeed code: HTML (HyperText Markup Language) used to indicate the precise values of RGB any design elements on a Web page will need to display Pantone solid coated 3015. (Included on the accompanying CD is a paper called *RGB to Hexadecimal Translating*. If you happen to practice well-formed HTML coding, this paper can show you a method for computing exact hexadecimal values for any given RGB combination.)

Before we go further, it is crucial to understand that Photoshop's Color Picker palette references Photoshop's Color Settings palette to compute any and all color space translations and transformations. This is

Figure 5-10
These settings in my Color Settings palette produced the precise HSB, RGB, and CMYK values for Pantone solid coated 3015 used in the above text.

important, so I'll say it another way: the Color Settings palette in Photoshop controls the HSB, RGB, CMYK, and hexadecimal results found in the Color Picker. So, in the above example, there are really only two constants. The first is the Pantone solid coated 3015 designation, which describes a particular ink formulation, and no other (Fig. 5-10). The other constant is LAB space, where a particular three-axis address describes an exact color in the visible spectrum, and no other. When we say a color in LAB is L:36, a*:−23, and b*:−48, it is that specific blue, and no other. There is only one LAB space, just as there is only one Pantone solid coated system.

As soon as we get into RGB and CMYK spaces, and those related to the HSB and hexadecimal values, we are on much less firm ground. There are several different standard RGB spaces, and there can be a different specific space for every different color monitor out there, as well as a different space for every single scanner and digital camera in existence. The HSB values seem to track with the RGB Working Space selected in Photoshop's Color Settings. There are a dozen or more standard defined CMYK spaces, and again, thousands of potential device-specific spaces; not just one for every color copier, proofing device, and press in existence, but one for every different combination of substrate, colorant, and printing device.

Since every color space defined, standard or otherwise, has an **ICC profile** (a software look up table in which is recorded a device's ability to describe color), for any two people to reach agreement, just inside their respective Photoshop Color Picker palettes, they have to have the same ICC profiles available on their respective computers, and point to those profiles using the Color Settings palette. Specifically, the RGB and CMYK

Working Space selections need to match, as do the Conversion Options Engine and Intent settings.

Communicating Color

What is one to make of all of this? Just this: there are a number of ways to specify a color, especially a color of importance between two people, say, client and color specialist. One way is to use a recognized system, such as the Pantone Color Matching System. Another is to specify precise LAB values. From there we can discover the appropriate RGB or CMYK values to best represent a given color.

Once we start communicating in RGB or CMYK values, we need to understand that a given set of RGB or CMYK numbers make different colors based on the color devices chosen, and even the materials used in conjunction with the device. Two different computer monitors are going to display slightly different colors from the same RGB values. Even if I use the same printing press as on an original press run, but change the paper or the ink, my CMYK values are going to reproduce differently.

The color specialist does not want to assume that because a given CMYK blend worked under one set of printing conditions, it will work on all. If a green John Deere tractor printed beautifully in a dealer brochure was produced on a sheet fed offset press on coated cover stock, using 78%C, 13%M, 100%Y, 2%K to make the green paint color, there is every guarantee that those specific blend values won't print the same green in the Sunday newspaper. In fact, the John Deere green would reproduce very poorly indeed on newsprint with those values. Our newspaper green might well be 60%C, 3%M, 95%Y, 0%K to achieve a very similar color to John Deere's corporate brand color.

All of this leads into the topic of Color Management in Chapter 11. There we will take a more considered look at managing the entire color reproduction process using consistent process control habits in conjunction with special software and color measuring devices. For a complete treatment on the subject and practice of Color Management, see Sharma's *Understanding Color Management.*

Wanted and Unwanted Components

The phrases **wanted colors** and **unwanted colors** are often associated with color correction. I prefer to use the phrases **wanted components** and **unwanted components** to prevent confusion created by overusing the word "color." In the CMYK color space, a "color" is a combination of CMY primaries plus, in some cases, K, for added darkness and shape. This combination is often referred to as a **blend**. The wanted components in a blend, or what we'll call a color, are those channels or separations that contribute to hue and saturation, and the unwanted components are those that impact brightness. In our Pantone solid coated 3015 example, the CMYK process ink equivalent's cyan and magenta would be wanted components. The yellow and black would occupy the unwanted category. In a fire engine red, magenta and yellow would be wanted components; cyan and black would be unwanted. What would be the wanted and unwanted components in a CMYK forest green?

In an image with a variety of colors the same separation, or channel, will serve as a wanted component in many colors while simultaneously serving as the unwanted component in others. The yellow separation, or yellow channel, is a wanted component in reds, oranges, gold, and greens. This same yellow channel is the unwanted component in blues, purples, and violets.

When the term unwanted component is used, it should not be interpreted to mean that the best thing a person can do to the unwanted component in any given color is to eliminate it completely (Fig. 5-11). In Chapter 2, Contrast, we saw how the reduction of an image's highlight value to 0% damaged the image's detail. The unwanted components actually carry the shape and detail in any color blend. If we don't want our colors to look two-dimensional, or cartoonish, we need the unwanted colors to do their job.

How much unwanted component do we need? Just as we don't want the highlight

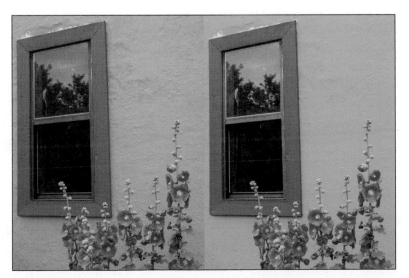

Figure 5-11
In the side-by-side comparison in the color center section, the image on the right has too much unwanted component removed. Note the loss of detail in the blue stucco wall.

dot to drop to 0% in CM or Y in an image's highlight, we don't want the unwanted component to completely disappear, even in the most vibrant, brightest part of a color. In other words, we want to see a minimum of 1%–2% of the unwanted component in the most vivid, brightest area of any color, so that when we need shape near that area of the image, there is something there to build that shape with.

The temptation when editing digital color images is to try and force more saturation or brightness into a color than it can handle, and this causes the color to separate out from the rest of the scene.

Again, using CMYK values as our reference, we should check to see if the most saturated channel's percentage in a vivid color is in the mid to upper 90 percentile. If it is, then we can't get any more saturated than that. We should also check to make sure that the unwanted component (not including black) has not vanished anywhere in the color. So, our unwanted component should have a minimum dot of at least 1%–2%. If those two conditions are satisfied, than the color cannot be any more intense or bright. All we can do from that point is to alter the hue one way or the other by adjusting the secondary component, which is the lesser of the two wanted components. A vibrant fire engine red, using the above guidelines, should have 95%–99% magenta, 85% yellow (or thereabouts), and maybe 2%–3% cyan. If the magenta and cyan are set to the above values, then the red can't get any more intense or any brighter, it can only change hue based on adding or subtracting yellow.

Skin Tones

There is arguably no more crucial color family to master than skin tones. The visual impact of skin tones in an image is profoundly connected to a viewer's perception of its relative appeal. Out of balance skin tones conjure up implications of ill health, alcohol abuse, sunburn, poisoning, old age, and even death. Well-balanced skin tones imply robust health, youth, vigor, and life. Buyers of print advertising commonly spend as much time evaluating and asking for adjustments and corrections to skin tones as they do to product colors.

Observe a photo shoot if you ever have the chance. The make-up artist isn't applying any of her products to the dress the model is wearing. She's trying to get the best skin tones possible on the model. The photographer is working with the lighting technician to eliminate any harshness or unwanted cast. Nobody wants to buy a product that appears to be endorsed by an extra from a zombie movie (okay, I have some Goth acquaintances that might. But, besides them. . . .

Given so much effort to capture healthy skin tones in the photo, and so much concern on the print buyer's part that the skin tones reproduce properly, it is incumbent on the color specialist to master the proper relationship of the different color channels in RGB, CMYK, and LAB spaces that deliver acceptable, and even appealing, skin tones.

We're All Brown

Here's the deal. Under the absolutely objective optics of the spectrophotometer, we're all brown. Everybody on the face of the earth is brown (Fig. 5-12). Digital cameras, scanners, and printing presses all confirm this reality. All of humanity, from Nigerians to Norwegians, separate out somewhere on the brown continuum, from a light cream or beige to a rich walnut hue—everybody's brown.

There are no black, white, yellow, or red people on the planet. Not according to absolutely objective measurement devices.

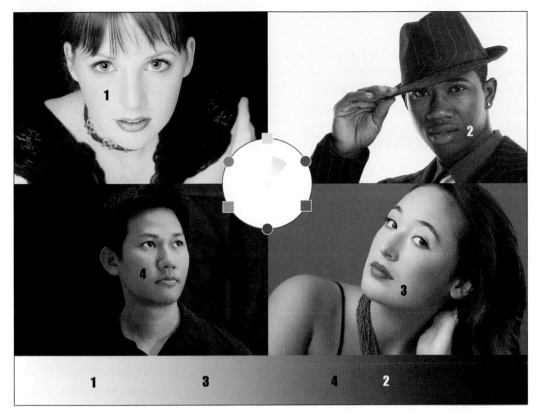

Figure 5-12
Every different skin value in this image is somewhere on the brown continuum.

There are only different shades and sub-hues of brown. Recalling Chapter 2, Contrast, we are reminded that our eye is not a measuring device. It is a comparative device. We call certain people white because they are perhaps closer to white on the luminosity scale then they are to black. We call others black, as they appear so much darker than a Caucasian norm. But of all the available luminosity values from absolute white to pitch black, under the objective optics of a color measurement device such as a spectrophotometer, the human race only uses up maybe 70% of the available visible luminosity values, from the lightest Scandinavian to the darkest African.

What that means in the world of digital imaging is that in the RGB world, a flesh tone must have more red than green and more green than blue, or it will not look right, no matter how light or dark the complexion of the individual.

In the CMYK world, there had better be more yellow than magenta and more magenta than cyan in a skin tone or nobody's going to be happy. In fact, using the magenta value of any possible skin tone as a base value, one can do some fast and easy math and arrive at yellow and cyan values that will combine into a pleasing blend. My personal skin tone formulation is for the yellow value to be slightly higher than the magenta (about 110% of the magenta, actually) and for the cyan value to be somewhere between 30% and 50% of the magenta value.

$$Y (M \times 1.1) + M + C (M \times .3–.5) = \text{pleasing skin tone}$$

Let's start with a lighter skin tone, one with 15% magenta. Using the above formula, an appropriate yellow will be 110% of the 15% magenta value, or 16.5%, rounding down to 16%. The cyan value will

fall between 30% and 50% of the magenta, which puts the cyan between 5% and 7.5%. So, a blend of 6%C, 15%M, and 16%Y will build an appealing skin tone. Bear in mind that this formula needs tweaking based on paper color or colorant variances, but it's a solid, ballpark recipe nonetheless. Call up an image of someone with terrible skin tones, and you will find out that their CMY balance is well out of agreement with the provided recipe.

This skin tone formula works tolerably well, no matter the weight, or value, of the magenta. We deviate slightly as needed to finesse the different hues found in the human race. What we don't want to do is to stray far from the basic formula. If, for instance, the yellow value is allowed to drop below the magenta, skin tones will quickly take on a raw, reddish look. If the cyan value increases above that 50% value, skin can take on a bruised, purplish look. If the magenta is allowed to fall well below the yellow, then we will pick up a jaundiced look that will stray toward a greenish hue as the magenta is reduced further. And finally, if the cyan falls below that recommended 30% minimum balance, then we will see the skin tones tilt toward either an orange or a raw, reddish hue.

Skin tones are a crucial part of the print advertising repertoire. Use the provided formula as a guide to inform what needs to be accomplished visually with hard numeric data. Again, be mindful that the color of the substrate influences the colors of the image from the highlight well into the midtone area. If your paper has a pronounced ivory, or yellow, cast then you need to accommodate that by reducing the yellow percentage in the skin balance, and may need to bring your yellow value down to equal that of the magenta or even less than the magenta by a couple percentage points.

The chances are good that our color image will be an RGB file when we are doing these corrections. So what is the formula for good skin in RGB? You'd need to be a mathematician to figure that out, as RGB channels appear to have a logarithmic relationship with each other when forming skin tones. The best way to manage it when scanning is to make sure grays are balanced, as skin tones react quickly to overall color bias; and when working in Photoshop, to make sure you have the CMYK equivalent values open in the Info palette as the second readout so you can judge the effect of RGB adjustments. Make skin corrections in RGB, but evaluate the moves by keeping an eye on the CMYK readout.

The Expanded Gamut

There are many printing devices, especially presses, which are capable of printing more than four colors. Six-color presses are common in offset and flexographic printers. Less common, but still abundant, are eight-color and even ten-color presses. Essentially, these are in-line operations where each color has its own inking unit on press. There are any number of reasons why more than four inking units are useful that impact CMYK only printing, including protective varnishes and other coatings, and opaque white lay downs required for printing saturated colors on foils, metallized papers, and clear film.

Another commonly used, and effective, method for the color printing industry is taking advantage of these extra inking units to add colors outside of the CMYK gamut. This method increases the palette of colors available to the designer for everything from corporate brand color reproduction to striking packaging applications, and is used every day in the commercial and package printing industries.

Forward-thinking image reproduction specialists began to take advantage of

incorporating these custom colors into photographic images decades ago. The simplest example of this technique is the duotone, which is a two-color image that combines a nonprocess custom color, often a Pantone ink formulation, with a process black. See Chapter 10, Special Treatments, for duotone creation and manipulation.

More sophisticated extra-color strategies combine custom color inks with the existing CMYK inks to expand the CMYK gamut beyond its normal limitations. This technique, therefore, is known as **expanded gamut** printing. There are several examples of expanded gamut strategies in use. They include touchplating, Pantone Hexachrome, Opaltone Digital Color, and Aurelon ICISS.

Touchplating, the simplest of these expanded gamut tactics, calls for the addition of an extra color separation to the CMYK set (Fig. 5-13). The image on this separation is localized to a certain color family, and is usually printed with one of the many Pantone custom color inks, or some other specific, in-house formulation. The most saturated value of the touchplate is typically constrained to no more than 65%–70%, in order that the additional ink

does not overwhelm the rest of the image as it is supported underneath by CMYK.

Let's say we wished to print a hunting catalog, featuring a line of blaze orange outerwear. The client has approved a budget for one extra color. The printer has a six-color press available. We're in business. We take all of the images featuring blaze orange products and create a fifth channel, which is a duplicate of only the orange areas. Using Curves, we constrain the highest value in this new channel to 65%–70% and shape the tone distribution to our satisfaction. This fifth channel becomes a fifth plate for the press. The image on this fifth plate is inked normally with either Pantone Orange 021 or Pantone Hexachrome Orange. Understand that this final blaze orange color is a combination of magenta and yellow values from the original CMYK separations added to the custom orange ink value. This overprinting of the three component inks results in a much richer, denser, and well-shaped color than a custom color created on its own.

Pantone Hexachrome and Opaltone (Fig. 5-14) expanded gamut solutions add either two or three inks to the CMYK set. Hexachrome adds a specially formulated

Figure 5-13
The addition of a Pantone Hexachrome Orange touchplate adds considerable added impact to this sunset shot.

Orange and a Green to a purer CMYK set than is required by the SWOP guidelines. Hexachrome Orange and Hexachrome Green separations are rendered using the Hexware Photoshop plug in. This plug in alters the original CMYK information to accommodate the additional colors, replacing CMY in certain hues, such as skin tones or emerald with either orange or green ink values.

Opaltone supplements the CMYK inks with Opaltone Red, Opaltone Green, and Opaltone Blue inks. Rather than re-rendering the existing CMYK values to accommodate the new colors, Opaltone in effect analyzes the entire image and builds touchplates of red, green, and blue. One advantage of the Opaltone process is that it substantially improves blues and purples, as the blue portion of the CMYK gamut is the most compressed and arguably the most disappointing region of the CMYK color space. Opaltone also features purer CMYK inks than the normal SWOP–compliant CMYK set.

Aurelon ICISS boasts the ability to import and export any colors into its software. These colors can be the familiar Pantone or Opaltone inks or custom colors of one's

own invention. ICISS allows the output of almost any number of plates in a single image. I once was hired to consult and work on a commemorative Jerry Garcia poster shortly after the Grateful Dead musician's death. The artist of the original acrylic painting had created an explosively colorful, psychedelic image that bordered on the fluorescent. There was no way that this image could have been approximated using CMYK inks only. Using ICISS, we produced an eight-color image of which only cyan and black were used from the process color ink set. The other six colors were a mixture of Pantone inks and one or two colors that we created in the software to match the original art, which were custom mixed at the printer.

Our challenge was that there was no prepress proofing system that offered a way to proof this mix of process, Pantone, and custom inks off press. Probably there never will be. And there was no computer monitor available to accurately render this mix in RGB space. So, the only way to look at our work was to go on the intended eight-color Heidelberg sheet fed press and print a half-size image with the actual inks. From this image the artist, printer, and I agreed on

Figure 5-14
Opaltone's color guides.

corrections. We went back to ICISS, made the corrections, and produced a new set of plates at full size. Back to press we went, making the final color tweaks on press as we strove to match the original.

Of course, this particular workflow is enormously expensive and extremely unpredictable. Proofing on press adds greatly to expense, as does printing as complex an ink mix as an eight-color custom job. It requires a highly skilled group of technicians, from the original artist to the prepress technician to the ink technician to the press operator. We were not totally satisfied with the results. Nonetheless, we produced a printed image that had far more visual impact than we ever could have with CMYK inks, and was far more faithful to the original painting than we could have achieved without working in an expanded gamut.

Currently, there are several digital proofing solutions certified by Pantone and Opaltone that accurately render their respective expanded gamut solutions. These include Kodak Polychrome Graphics Approval, Latran Prediction Proof, and Fuji ColorArt.

Nonetheless, there still is no way to accurately render these multichannel solutions on an RGB monitor, so experience is required in evaluating expanded gamut images prior to proofing and printing.

Chapter 5 Summary

Editing specific colors in an image, as opposed to editing all colors, requires that we localize our correction. Localized corrections are riskier than overall corrections as overcorrecting is easily apparent. The corrected area stands out, unnaturally, from the rest of the image. At the same time, the client due to disappointments related to process CMYK ink impurities, often requests specific color corrections. Color correction is typically a matter of either reducing the value of unwanted component inks or increasing the value of wanted components. The color circle is a valuable graphic in regards to color correction judgment calls. Care must be taken to avoid completely removing all unwanted components, or oversaturating wanted components. Skin tones are a color family that support evaluation of color bias in an image, as skin tones are all some form of brown.

Chapter 5 Review

1. What are memory colors?
2. Why is color alteration a riskier and more time-consuming activity than a contrast or gray balance adjustment?
3. What are the three chief attributes of any color?
4. Roughly, how much cyan and yellow would I need in combination with a 50% magenta value to create a pleasing skin tone?
5. What is the attraction of expanded gamut color printing?
6. Name two challenges that are implicit in the expanded gamut workflow.

Image Evaluation

Chapter Learning Objectives

- Understand how to systematically evaluate a color image
- Learn how to recognize trends revealed during the evaluation process

6

The color specialist charged with the task of image editing in this 21st century is less and less likely to be the same person who digitized the original image. This circumstance is due to the rapid replacement of scanned photographic images with digital camera shots. Using a digital camera, the photographer is now the pixel originator. In this book, Joe Esker's photographs are examples of scanned photographic slides. Joe shoots almost exclusively to 35 mm slide film. Joe's 35 mm slides were scanned to generate the digital files required for this book (Fig. 6-1). The original images shot by Theresa Aldridge, Stoney Stone, and Marylou Rivard are digital photographs, ranging from consumer-level, 4-mega pixel images to professional studio 8-mega pixel images.

When a photographic print or slide is scanned, the color specialist controls the creation of the pixels that represent that photograph. As discussed in the previous chapters, the quality of the digital image relies on the number of pixels used and the color values of each of those pixels. The scanner operator decides the file resolution, or how many pixels are used to represent the image. The scanner operator also sets the highlight, shadow, and tone distribution values; adjusts the gray balance; and

applies sharpening. Color correction is often applied at this scanning stage.

When a photographer shoots a digital image, the total number of pixels representing the scene is decided by the resolution of the camera's charge-coupled devide (CCD) array or complementary metal oxide semiconductor (CMOS) chip. The color values of these pixels are decided by a combination of camera settings controlled by the photographer and the available light at the time of the exposure. Therefore, the pixel creation stage has been shifted to people who historically have not concerned themselves with pixels. Prior to the emergence of digital photography, photographers judged the quality of their work by the visual evidence of either developed prints or slides. In the case of most amateur photographers, their success rate, whether known to them or not, may have been boosted by the skill of the technicians developing their film, who were able to open up underexposed images and add weight to overexposed images.

The emergence of digital photography erases the development and scanning stages, and with it, any chance that corrective intervention occurs between the exposure and the pixel creation stages. So the correction needs to occur in the digital darkroom, which is Adobe Photoshop for the professional market; Photoshop, Photoshop Elements, or the GNU Image Manipulation Program (GIMP) for informed hobbyists and serious amateurs; and whatever software came with the purchase of the camera or computer for the consumer market.

The sad fact of the average consumer-level image enhancement software is that all feedback to the user is visual. To be sure, there are adjustment controls, and these controls have numbers associated with them indicating an inferred degree of intensity, but these tools are primitive, at

Figure 6-1
Joe Esker's original image "Point Reyes" was captured on 35 mm slide film, and scanned to RGB TIFF format for the purposes of this book.

best. Very few consumer-level software solutions allow one to evaluate Red Green Blue (RGB) values in the image itself. Since most consumer level shooters are unschooled in formal image manipulation, this is not viewed as a problem. As long as users can see changes on their monitor and have some level of confidence in the results from their color printer, everything is fine. When results are less than optimal, however, the average consumer is without the skills and tools to evaluate what needs attention and by precisely how much. Is my printer behaving

in a consistent manner? Is it the camera? Is it me?

This chapter's subject matter covers the analysis of the digital image itself for conformance to known specifications of an optimal image. To do this, we must be able to measure our image. So, if we're not working in Photoshop, then we need an application such as the GIMP with its Color Picker (represented by the Eyedropper icon in the tool box). As discussed in the previous chapters, there are four characteristics, or attributes, of any pleasing

color image. For the sake of review, they are: contrast, balance, sharpness and detail, and believable color.

The Evaluation Checklist

We teach our students to evaluate an image in its entirety before attempting any corrective measures. Because this technique is somewhat time consuming initially, many students will attempt shortcuts or just jump right in and start making visual adjustments. However, the methodical approach always results in a superior final image, as it promotes an organized and comprehensive analysis of any weaknesses in the image. Also, fewer problems will be overlooked with a step-by-step approach. Through repetition, this initial image evaluation shortens to a minute or two at most, which is time well spent.

The evaluation checklist is based on a normal scanning set up procedure, which is itself based on the four characteristics of an optimal image. We review the image's contrast first, then check the neutrals and maybe a skin tone or two for overall balance, followed by an analysis of the image's sharpness and detail, and then finish off by checking a prominent color or two in the scene. When teaching this technique, we require a student initially to use the provided Image Evaluation Check List (Fig. 6-2), and do not allow any image adjustments to be made until the student can show the existing color values for all targeted points of interest. Eventually, the student just jots down reference data on a notepad.

The point is to collect enough information about the existing image to be able to recognize any overall shortcomings. These overall problems will announce themselves in various ways. Taken alone, any given set of color values may leave us any number of ways to adjust that combination toward a more optimal set

of values. Taken together, all of the measured target points tend to tell a story, suggesting the most efficient and effective corrective strategy.

All of this is at the very heart of what we as color specialists are all about. The experienced professional knows that we manipulate the visual through the informed adjustment of numeric values. This is the intersection of art and science. We increase the impact of a visual image by adjusting the numbers that determine exactly how that image will be reproduced, whether on a computer screen or when printed.

As an example, we are going to evaluate Joe Esker's "Point Reyes" (Fig. 6-1), which you will find on the accompanying CD as Fig06_1.tif.

Let's get started with the evaluation. In list form, we are going to do the following:

1. Open the digital image in Photoshop.
2. Note any immediate visual impression, in general terms.
3. Determine the location of the Highlight.
4. Determine the location of the Shadow.
5. Measure and record the Highlight.
6. Measure and record the Shadow.
7. Determine the location of any useful neutral areas.
8. Measure and record these neutral areas.
9. Determine whether any useful skin tones are available.
10. Measure and record these skin tones, if applicable.
11. Change the View option to Actual Pixels.
12. Note any visual problems with sharpness and detail, focusing on edges and grain.
13. Cruise through the image in Actual Pixels View to spot any dirt, scratches, or hair that need to be removed.
14. Determine the location of any prominent colors.
15. Measure and record one or two samples of these prominent colors.

Dunwoody
COLLEGE OF TECHNOLOGY

Image Evaluation Check List

Color Technician _____

Image Name _____

Before Correction	After Correction

Area of Interest	Before			After		
Overall Impression						
Color Space	RGB	CMYK	HSV	RGB	CMYK	HSV
Highlight						
Shadow						
Midtone Neutral						
1/4 Tone Neutral						
3/4 Tone Neutral						
Skin Tone 1						
Skin Tone 2						
Unsharp Mask		Yes/No		Radius___ Amount____ TH___		
Prominent Color 1						
Prominent Color 2						
Total Ink Coverage						

Figure 6-2

This Image Evaluation Check List is a handy tool for data collection and analysis, as well as proving the degree of success of any corrective action. The provided windows are for showing Before and After states of the corrected image. This check list is available on the accompanying CD.

16. Review all sample readings, looking for trends.

That's the checklist. It's not meant to be memorized, but it's worth using faithfully until such time as the steps are lodged in your brain in the same permanent place as favorite pop songs, names of state capitals, and the shortest route between work and your favorite watering hole.

Now let's look at each of these steps in further detail.

Open the Image in Photoshop

What could be simpler? Well, not so fast. A complete discussion in setting up one's copy of Photoshop for best results is a chapter in itself, but we'll distill the subject to a paragraph or two. First, understand that Photoshop displays an image based on

the configuration of its Color Settings menu. So, if you wish to view an image in the most accurate visual agreement to your printer, Photoshop has to see that particular brand of printer identified in the Color Setting's Working Space (Fig. 6-3). Generally, the RGB Working Space in the Color Settings palette is set to your digital camera's space or perhaps to your own monitor manufacturer's profile; and the CMYK Working Space is set to your specific color printer's profile or to an industry standard space that you are striving to emulate, such as US Sheetfed. The Color Settings option is found under the "Photoshop" pulldown menu. Printer profiles, for those that don't build their own, are generally available on manufacturer Web sites and also are to be found on software CDs packaged with the printer.

Figure 6-3
Note my choices in Photoshop's Color Settings. For you and I to get the same numbers in our Info palettes, your Color Settings need to be identical. One item of interest in this palette's setting is the change of dot gain from Specifications for Web Offset Production's normal 20% to US Sheetfed's 17%. Sheet fed offset presses using coated stocks feature a lower dot gain profile than Web offset presses.

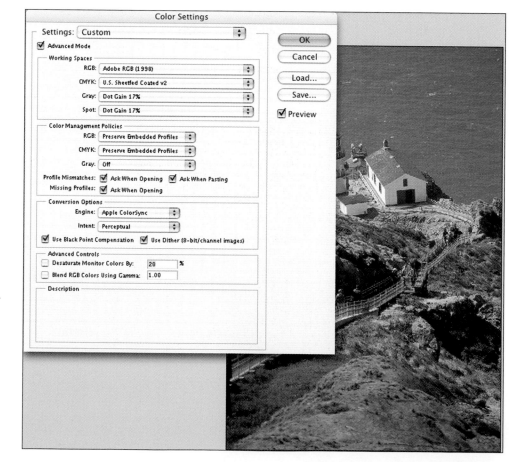

To rid your eyes of any distractions from the desktop itself, select **Full Screen Mode With Menu Bar,** a Photoshop display option found near the bottom center of the Tool palette. This option devotes the entire computer display to the Photoshop GUI, and surrounds any image that does not occupy the full screen with a flat gray tint, helping the viewer to better notice any color bias or out of balance condition in the image (Fig. 6-4).

Finally, make sure that the **Info** palette is launched. This palette turns your cursor into a roving densitometer, and is absolutely mandatory for image evaluation. I keep mine in the upper right corner of the screen out of habit. The Info palette has its own pop up screen that has a choice called **Palette Options.** The Palette Options window has a **First Color Readout**, a **Second Color Readout**, and a **Mouse Coordinates** feature. Set the First Color Readout to **Actual Color** and never change it. Never. The First Color Readout controls the left upper half of the Info palette, and should always reflect accurate values based on the mode of the image being displayed. If the color mode of the file being displayed is RGB, then the first values we encounter in the Info palette should be RGB. And so they will, if the First Color Readout is set to either Actual Color or RGB. But if I open a CMYK file and the First Color Readout is set to RGB, then I will still get RGB values as I peruse the image with my cursor; a translation of the actual color values in the CMYK image, not the actual values. Only by setting the First Color Readout to Actual Color will any image, regardless of mode, display accurate color readouts.

Note Any Visual Impression, in General Terms

First impressions visually are important. Any displayed image is either going to look appealing or it's not. If the image doesn't appeal, it needs help. If the image appears indifferent, as opposed to downright ugly, there is room for improvement, just by a lessened amount.

Figure 6-4
Note the entire display is reserved for the application. The gray surround helps us detect a non-neutral bias in the image. The Info palette in the upper right is set to give RGB and CMYK feedback.

Ambient Lighting and the Color Work Area

Earlier in this book we pointed out that the eye is not a calibrated measurement device. The human eye is more of a reference device. How close is this color to that color? How much darker is this proof to the original photograph? How much of a change is this corrected image to the previous version? To give our eyes the best chance to properly evaluate color, whether from a monitor or from some form of print, we need to control the environment within which we intend to pursue that evaluating.

In a professional creative studio, color trade shop, or press house, much care and expense are devoted to setting up and maintaining that environment. The intent is to create an environment of color neutrality in lighting and surround so that displayed and printed images can be evaluated free of non-neutral influence. The industry standard for color neutral lighting is 5000° Kelvin. Light boxes and viewing booths are available from vendors such as GretagMacbeth and GTI, which are designed to meet professional lighting requirements. These professional viewing stations require periodic monitoring with color measurement devices such as light meters and colorimeters so that aging lighting can be detected and replaced. In addition, surrounding walls, carpeting, furniture, etc. are generally some shade of neutral gray, to eliminate any referential influences. Overhead lighting above color workstations is generally very subdued, if lit at all, keeping any ambient light from shining on and flattening the impact of the displayed computer image.

Computer displays need to be kept in a calibrated state so that neutrals are properly balanced and brightness and contrast are properly set. For the home color corrector whose spouse frowns on industry standard interior decoration, it's best to just work with as little ambient light as possible competing with your computer display. And take your color prints outdoors for best evaluation.

Energy level has a lot to do with proper color evaluation, as one's brain is required to process the data collected by the eye. Fatigue, poor health, and the attendant effects of drug and alcohol use adversely affect one's ability to properly view color and to process what is being seen.

This step is the color specialist's opportunity to form a general opinion of the image. Is there too much of something? Too washed out, too dark, too flat, too much contrast? Does the image lack something? Not enough weight, not enough sharpness, not enough pink in the skin tones? If there is food in the shot, does it appear edible? Do the colors look real or not? Is it, as in the tale of Goldilocks and the Three Bears, just right?

These first impressions need to be noted, then either confirmed or ruled out based on numerical data gathered in subsequent steps.

After opening the image, it is my practice to hit the TAB key once to temporarily remove all the supporting palettes from view (Fig. 6-5). This helps focus all my attention on the image without any peripheral distractions.

My overall first impression of the "Point Reyes" shot is that it's not bad at all. The overall contrast appears agreeable. The image doesn't have any gross cast to it, though it leans to the blue side. There seems to be sufficient detail and sharpness to the image. None of the colors in the

Figure 6-5
The Photoshop Full Screen Mode with Menu Bar after the Tab key has hidden all supporting palettes.

scene appear out of place. Since we know this image began as a 35 mm slide and was scanned, it should not be a big surprise that on the whole, this image appears acceptable.

Determine the Location of the Highlight

The pivot point on which rests the shape and detail of the whites and light grays as well as the shape and brightness of colors in the image is the highlight. Much depends on the correct setting of the highlight. Selecting Image/Adjustments/Threshold allows one to view the image simply as a black and white bitmap or line art rendition of itself (Fig. 6-6). Moving the slider control to the right progressively fills in areas of the image until only the lightest patches remain. The lightest patch of image remaining when all else is filled in is your highlight. Notice that we are looking for the lightest *patch*, not the lightest *pixel*. Don't fill in the image till only a tiny dot of white remains; stray, individual pixels don't mean anything by themselves. Shift/Select this highlight patch with the

Eyedropper Tool to load the highlight value into the Info palette.

In our case, we see after moving the slider to the right that the last remaining patch of white after everything else has filled in is actually two patches, the left side of the building and the left side of the lighthouse (Fig. 6-7).

Determine the Location of the Shadow

Without leaving the Image/Adjustments/ Threshold option, move the slider control to the left, progressively blasting away at the image area till only the last patch of black remains. This last surviving patch of black is the image's shadow area. Properly setting this point contributes to darker detail areas, color saturation, and overall contrast. Again, we are looking for the last remaining *patch* of black, not the last remaining *pixel*.

In the "Point Reyes" image, the last remaining dark patch after all else has been blasted away to white is in the lower left side

Figure 6-6
The "Point Reyes" image when it is first rendered to a bitmap image via the Image/Adjustments/Threshold option.

of the image (Fig. 6-8). Shift/Select this patch with the Eyedropper tool as well.

When the Highlight and the Shadow have been identified, select the Cancel button. Do not select the OK button as that will convert the file to bitmap format.

Measure and Record the Highlight

Review and record the Highlight value captured in the Info palette on the inspection checklist. In our case, the center of the patch on the left side of the building gives us a RGB reading of 247R, 251G, 249B. Anyone working in the graphic communications industry will expect your numbers to be ordered in this sequence. A glance at the CMYK values shows us a 2%C, 0%M, 2%Y, 0%K. Do not make any adjustments to the

highlight in our image, or any other that you evaluate no matter what the numbers reveal.

Measure and Record the Shadow

Review and record the Shadow value captured in the Info palette. You should see 2, 1, 0 as your darkest values. Again, we are honoring the ordering of the numbers as above: red, green, and blue. Do not make any adjustments to the shadow no matter what the numbers reveal.

Determine the Location of Any Useful Neutral Areas

Recalling Chapter 3, Balance, we know that neutral areas in an image reveal whether that image is balanced, and if not, which way the cast, or bias leans and by how much. We

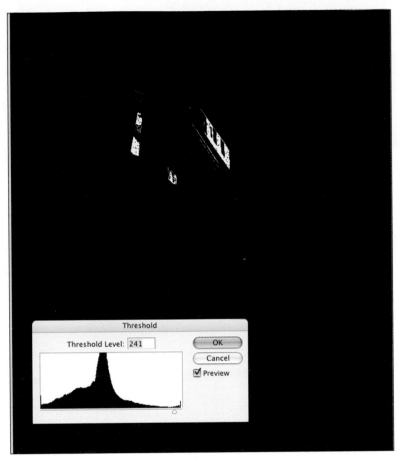

Figure 6-7
The slider shows us a
couple areas that share
the lightest values of the
image. Either one can
serve as our Highlight.

know that in any given color space, colors grow outward from a gray center, so any imbalance in the neutrals also skews the hue of the colors in the image. If the image features several neutral areas, note the most important ones, which are those that are most prominent.

In the case of our "Point Reyes" image, we have an abundance of neutrals to choose from. The flatter the gray area, the better. We have nice, flat areas in the lighthouse buildings of the house and the tower (Fig. 6-9).

Measure and Record These Neutral Areas

We know that in the RGB color space, equal values in each channel create neutrality, no matter what weight, or value, those numbers represent. The most useful

information regarding the overall neutrality of the image needs to be gathered from several different tonal values. For instance, a neutral whose values are close to 128 is useful because this is the midtone area of the image. We also benefit from neutral information gathered at or near the quartertone (192) and three-quartertone (64) areas.

Using the Eyedropper tool, we sample the neutrals of interest, holding down the Shift key to load these readings into the bottom of the Info palette. Reading #1, near the base of the tower, gives us neutral balance of 129, 135, 165. Reading #2, which is difficult to see but is on the rocks just to the lower right of the stairway landing area, gives up a reading of 207, 213, 216. Reading #3, the dark doors of the lighthouse, gives up a reading of 46, 50, 67.

Figure 6-8
In the lower left, we see
the last remaining patch
of Shadow.

Determine Whether Any Useful Skin Tones Are Available

Skin tone data supports any information gathered from neutrals. Since we know that all skin tones fall somewhere along the brown continuum, we can be assured that the red value needs to be highest, the green value second, and the blue third. Avoid measuring any areas where colored make-up, such as rouge or eyeliner, has been applied. Typically the forehead, chin, neck, arms, and legs are in play.

The figures in this image are far too small to test for reliable skin tones, so we aren't going to waste any time sampling them.

Measure and Record These Skin Tones, If Applicable

For skin tone readings, I always use the Second Readout values from the Info palette set to CMYK. Because, numerically speaking, skin tones are more easily evaluated in CMYK space, I use this set of readouts to better interpret the actual RGB values. I record the values in RGB and CMYK, because I'll need to determine the amount of any corrections in RGB by checking their impact against the CMYK equivalents.

Change the View Option to Actual Pixels

This step ensures that every pixel in the image is mapped to a single screen pixel. At this particular zoom we will be able to judge whether any additional Unsharp masking is required, and we will be able to see all dust, scratches, hair, etc. that need to be removed.

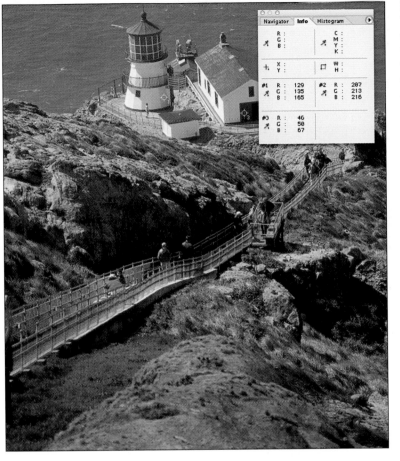

Figure 6-9
The lighthouse structures are reliable whites with areas in shadow, therefore, dependable neutrals. The granite rocks in the center foreground also provide a variety of grays to sample.

Note Visual Problems with Sharpness and Detail, Focusing on Edges and Grain

This part of the inspection process is not one that is measured and evaluated numerically. This part involves judgment that inclines toward the subjective. Do the edges, those areas where dark pixels meet lighter pixels, look crisp? Are there noticeable white or black lines along the edges? Is grain obvious or distracting? Can we see every pore in the model's skin? Does any blurriness or lack of focus present itself?

In our "Point Reyes" image, the first thing that strikes us is the graininess of the image at Actual Pixels view. What we are seeing is the emulsion grain from the original slide magnified a few hundred percent due to the enlargement settings applied during scanning.

Because the photographer didn't want to remove the original 35 mm from its frame for the scan, I dry mounted the original and so lost the chance to soften the original's grain by oil mounting (Fig. 6-10). Scanner operators will generally oil mount any slide original whose enlargement exceeds what they have discovered to be the safe margin for a particular film's grain reproduction. This margin differs for different photographic emulsions, with faster film speeds showing more grain, as a rule. Since most 35 mm slides are enlarged 300% or more for print reproduction, most 35 mm slide film (and 60 mm slide film, for that matter) gets the oil mounting treatment from quality-conscious scanner technicians.

The edge definition looks plenty sharp as is.

Figure 6-10
Note the obvious
graininess of the
enlarged, dry
mounted 35 mm.
There are also some
prominent dirt specks
that need to go away,
via the Clone Brush tool.

Clean Up the Image Using Actual Pixels View

Few things are more visually distracting than to see an otherwise crisp, beautifully reproduced image with a scattering of dirt or an obnoxious strand of hair or scratch exactly reproduced. Note the location of all prominent examples, making sure that you don't intend to spend a lot of time cleaning up areas that will later be cropped out of the layout.

And cruising around our image in Actual Pixels View reveals a few spots that will need to be retouched out, such as the little chunk of dirt on the roof of the lighthouse tower or the specks on the back wall of the shed (Fig. 6-10).

Determine the Location of Any Prominent Colors

Return to a zoom where the entire image occupies the screen and look for any prominent colors. Often these colors will be primaries. Saturated reds, blues, oranges, greens, etc. Also look for important pastels, those colors close to the neutral center of the color gamut.

The two prominent colors in this image are the blue of the water and the green grass on the hillside.

Measure and Record One or Two Samples of These Prominent Colors

Recall that any color is defined by its hue, saturation, and brightness. These color attributes are controlled by the numeric values of the individual channels. We measure and record these color values to later support whether the dynamic range and tone distribution settings are proper or otherwise. How is it that we relate the colors to the image's contrast? We know that the Shadow and three-quartertone (3Q) settings influence a color's saturation. The midtone setting controls hue. The quartertone (1Q) and Highlight setting control the color's brightness. Again, just as in the skin tones, we can refer to the CMYK readings in the

Second Readout section of the info palette to help us evaluate a given color.

When searching for a blue value to record, I kept an eye on the CMYK readings in the Info palette. What I looked for was any reading where either the leading ink hit 100% or the unwanted component showed as 0%. I did find a blue where the values of 87R, 115G, 182B translate to values of 75%C, 47%M, 0%Y, 0%K. The third number in the sequence is the yellow ink and is completely missing: a known problem with reproducing **shape** in colors properly. Shape in colors includes any shading and detail that builds the color from two-dimensional, or cartoonish, to three-dimensional and believable. Shape in colors is supported primarily by the unwanted component.

I also found a grass color where the RGB values of 79R, 93G, 45B translate to 69%C, 40%M, 100%Y, 26%K. In this color the yellow ink is going to plug, or oversaturate shadow values, which can be problematic for shape and differentiation in the color. The third obvious color is the pinkish hue of the lighthouse roof. In the case of our image, we can't tell much from this particular color, as it is not saturated or bright enough to give up much useful information.

Review All Sample Readings, Looking for Trends

Earlier in this book we defined the productive color technician as being effective and efficient. By effective, we mean doing the quality work that results in the visual and measurable improvement of a color image. By efficient, we mean accomplishing that quality work in the shortest possible time. Therefore, it makes sense that we want to not only quickly determine whether an image needs improvement and where it needs it, but

how we can most efficiently carry out these improvements. An adjustment that improves multiple weaknesses is preferable to an adjustment that targets a specific weakness. Overall adjustments, meaning those that affect every pixel, are preferable to localized adjustments.

Do any of the readings reveal a color bias? Does more than one reading reveal the same lack of neutrality and balance? How does the value of the Highlight relate to the unwanted component in the colors? Over time, it becomes second nature for the color specialist to quickly evaluate the numeric feedback from the checklist. Exactly what to do with all of this data is the subject of the next chapter.

Let's review our inventory of data gathered during the evaluation:

1. The overall visual doesn't suggest much, other than that the image is in pretty decent shape.
2. The Highlight values are too clean and too greenish. If left as is and converted to CMYK, there would be no magenta dot in the Highlight, and we can't have that.
3. The Shadow value, though neutral, is too dark. We need to lighten that a bit to properly set a printable dynamic range.
4. All three gray values show a lack of red and an abundance of blue, which reflects a blue-green cast overall.
5. The image has too much evident grain, which needs to be smoothed.
6. There is a little janitorial retouching required.
7. The blue and the green areas support the dynamic range issues requiring correction. In the blue, we need to see some unwanted component, and in the green the leading ink has gone solid.

So we have our work cut out for us. In the next chapter, we will get it done.

Chapter 6 Summary

Developing competence in image correction requires the practice of a system that ensures a complete and cohesive image evaluation designed to tease out weaknesses responsive to overall adjustments. Practicing the same corrective system repeatedly develops both speed and effectiveness. Also, increased understanding of the relation of measured numeric values to apparent visual effects is integral to improved color correction.

Chapter 6 Review

1. What emerging technology shifted the pixel creation step in the color reproduction process?

2. How does the use of a checklist in the image evaluative process result in more effective and efficient image editing?

3. Actual Pixels View in Photoshop is useful in evaluating what?

4. Describe three major features of a professional color viewing environment.

5. Should an image be corrected as it is being evaluated? If so, why? If not, why not?

The Plan of Attack

Chapter Learning Objectives

- Use the data from the image evaluation process to guide corrective strategies
- Employ Rivard's Pyramid as a guide for the most effective, natural-looking adjustments
- Experience the power of basic Contrast, Balance, and Sharpness settings

7

Most everyone has seen magazine pages that have two very similar pictures, with the accompanying text declaring how many differences picture 2 has from picture 1. *"Hey kids, are you sharp-eyed enough to spot all eight changes we made?"*

Earlier in this book, we mentioned that all color editing should be as unobtrusive as possible. If you've just made eight edits to an original, the last thing you want a viewer to pick out is the exact location and amount of each one. *"Well, let's see, there's an obvious clone brush track. The edges look like they were cut with scissors. What's with the lime green color? No shape at all. Way overcorrected. Hmm. Can't say as I care for the edge definition in the Unsharp Masking . . ."*

The proficient color specialist, like the conscientious backpacker, strives to leave no trace of herself behind. The best color correction is that which never appears to have been done in the first place. If the viewer has no other version of the image for reference, they should never be consciously aware that the image wasn't simply a perfectly exposed photograph.

There are many colorful, eye-popping books stuffed full of incredible visuals executed by Photoshop ninjas. Hundreds of Web sites groan under the weight of sophisticated tips and tricks. It's understandable that novice color specialists assume that if a file doesn't contain six layers and four or five selections then they haven't done their job. The intention of this chapter is to demonstrate that three or four overall moves are all that most images need and commonly look as dramatic as the most masterful photo-sorcery.

With that in mind, we reference Rivard's Pyramid (see Chapter 1 and accompanying CD). This model reminds us that the most reliable, least risky, and quickest adjustments are those that are overall in nature (Fig. 7-1). If we apply any adjustment that is likely to affect every pixel in the image, then we

Figure 7-1
Rivard's Pyramid is designed as a reference to remind the color specialist of the dozens of options in her arsenal likely to be the safest and most effective.

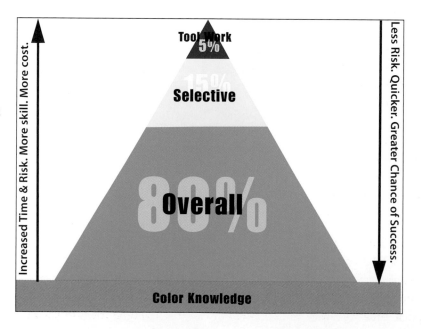

avoid changing any localized part of the image to the extent that it begins to noticeably separate itself out from its surround.

So the question becomes, how do we use the data that we collected from our image evaluation to inform the nature and amount of adjustments that we need to carry out?

Perhaps the best way to answer this question is to walk through the correction routine on the "Point Reyes" image.

Reviewing the Image Evaluation

Here again is our inventory of data gathered during the evaluation:

1. The overall visual inspection of the "Point Reyes" image doesn't suggest much, other than that the image is in pretty decent shape visually.
2. The Highlight values are too clean and too greenish. If left as is and converted to Cyan Magenta Yellow blacK (CMYK), there would be no magenta dot in the Highlight, and we can't have that.
3. The Shadow value, though neutral, is too dark. We need to lighten that a bit to properly set a printable dynamic range.
4. All three gray values show a lack of red and an abundance of blue, which reflects a blue-green cast overall.
5. The image has too much evident grain, which needs to be smoothed.
6. There is a little janitorial retouching required.
7. The blue and the green areas support the dynamic range issues requiring correction. In the blue, we need to see some unwanted component, and in the green the leading ink has gone solid.

Going back to Chapter 1 on the four characteristics of an optimal image, we know that it is in the interest of the image to ensure that the Contrast is properly set before we do anything else. From that point we attend to the Balance, then the Sharpness and Detail, and finally check any prominent colors.

So, remembering that there are two parts to Contrast, Dynamic Range and Tone Distribution, a glance at the checklist reminds us that the Highlight and the Shadow require tweaking, thus affecting the Dynamic Range. Since our initial visual first impression did not offend, the Tone Compression is fine as is.

Highlight Repair

Right, then, as the Brits are fond of saying. Let's set our Dynamic Range to rights, shall we? Starting with the existing Red Green Blue (RGB) Highlight value of 247R, 251G, 249B, and comparing that to what we would like to see in the Highlight, which would be a balanced value of 245R, 245G, 245B, we see that the green value (251) is the most in need of adjustment, followed by the blue (249), and then the red (247). So our highlight values are higher than we would like to see them (meaning brighter and with less detail because we're in RGB space) and skewed to a slight greenish balance.

We'll fix that straightaway. Selecting Levels (Command-L) calls up the **Levels** palette, which is as good a place as any to tweak our Dynamic Range. Near the bottom of this palette is an area defined as Output Levels. This area has a field in which is displayed the default highlight value of 255. By changing this number to something smaller, we alter the image's extreme allowable light value. This alteration of the lightest value can be done in balance, with all three channels being equally affected, or we can isolate individual channels. Since our highlight is too light and out of balance, we will treat each channel individually.

Selecting the Green channel via the Channel pulldown menu, we change the Output Level highlight value from 255 to 249. Why 249? Looking at the Info palette,

we can see that the stored Highlight value has a left and a right column to it. The left column of RGB values is the original, uncorrected RGB Highlight. The right column's values change away from the original in reaction to whatever adjustments we are making. The change of the Levels palette Output Level from 255 to 249 adjusts this image's Green Highlight value from 251 to 245. Right where we want it. Selecting the blue channel in the Levels palette, we try a few Output Level numbers to adjust the image's blue Highlight to 245. Turns out this new Output Level Highlight value needs to be 251. The Output Level for the red channel, when adjusted to 253, also gives us this 245 image Highlight.

In short, we tweaked the original Highlight balance from 247R, 251G, 249B, which was too light and too greenish, to 245R, 245G, 245B, which is right where we want it to be and perfectly balanced. Looking at the right side of the Info palette, where the CMYK values were originally 2%C, 0%M, 2%Y, 0%K, we see that they are now 2%C, 2%M, 2%Y, and 0%K. This may seem like a very slight change indeed, yet we have successfully balanced the highlight away from the greenish and established a printable magenta dot when the image is eventually translated to CMYK.

Shadow Repair

This part of the repair essentially repeats the use of the Levels palette to adjust each channel's Output Level Shadow setting from 0 to whatever it needs to be to get that channel's image's Shadow value to 10 (Fig. 7-2). In the case of our "Point Reyes" image, the red channel Shadow Output Level needed to be reset to 8, the green channel to 9, and the blue channel to 10.

The image's shadow detail benefits from this adjustment, as do the water and grass. Some might grouse that the image appears to be losing some contrast, with the water and grass losing some saturation. What is truly happening is that the colors are shedding some gaudiness and taking a more realistic color to them, while the shadow detail is yielding a little more differentiation.

These Highlight and Shadow adjustments lock the Dynamic Range right where we want it. Since the image wasn't calling for any Tone Distribution changes (it wasn't too flat, too washed out, or too dark), we have answered the Contrast needs of this image.

Balance Repair

Next on the list of critical features is Balance. The neutrals in an image are like gossips in a small town. If you want to know what's going on in town, you start a conversation with the town gossip. If you

Figure 7-2
These are final results of the Levels adjustments.

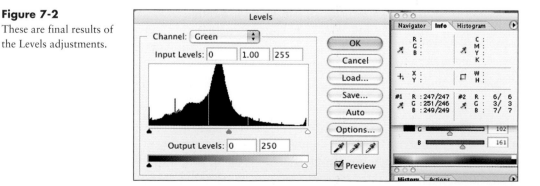

want to know what's going on in an image, you consult the grays. So let's make the rounds of the grays in the "Point Reyes" image and listen as they spill their guts.

We've mentioned several times in this text that equal values of RGB make a neutral, regardless of the weight, or luminosity, of the analyzed sample. If the RGB values are not equal, or very close to equal, then we don't have balance. It's as simple as that. And if the grays are out of balance, so is everything else in the shot.

We've sampled three gray areas in our image during the evaluation. The first sample was at the base of the lighthouse tower, and read 129R, 135G, 165B. Since we have adjusted the Highlight and the Shadow points, our original gray values are going to shift slightly. Most likely not enough to shift our original balance much, but we shouldn't be alarmed if we can't find those exact values. The values at or near that same spot now are reading 135R, 135G,

159B. So the red and green channels are right where they should be in reference to each other, but the blue number is too high, indicating a bluish imbalance.

The second gray sample on one of the rocks in the foreground is 207R, 212G, 216B, which is virtually identical to the original. This gray shows a lower red value as well as a higher blue value than is desirable. The final sample, on the lighthouse doors shows 45R, 45G, 67B, which mirrors the tale told by the first reading. Only the blue needs adjusting.

With two out of the three grays reporting only a blue value needing adjustment, that's what we're going to do. For balance fixes, we go to Curves. In effect, what we're going to do to fix the imbalance in this shot is to alter the contrast in this image in the blue channel only. Specifically, we are going to decrease the blue channel's midtone.

In this case we reduce the blue midtone, bending the curve downward from the

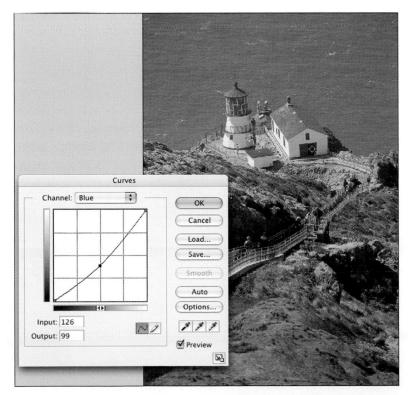

Figure 7-3
The results of the Curves adjustment to the Blue channel.

middle, just enough to knock the blue down just under the green value in the rock's gray balance, but not enough to perfectly balance the other two readings. Still, this move is pretty dramatic, as if we have lifted a blue filter from the image. The grass picks up color and more of a yellow-green value, the grays all shed their blue patina, and the water loses its surreal blue quality and looks not only more realistic but picks up some shape as well (Fig. 7-3).

If your idea or your client's idea of the ideal image requires more contrast, you can add a little at this point, not by altering the Dynamic Range one bit, but by adjusting the quartertone (1Q) and three-quartertone (3Q) into a mild S-curve (Fig. 7-4).

Sharpness and Detail Improvement

Our evaluation of the original image turned up a grainy texture to the "Point Reyes" image, a side effect of the dry mounting technique used during the scan.

For this image to appeal in the Sharpness and Detail category, we need to smooth this grainy aspect back without adversely affecting the edge definition that is supplying the required image detail.

Our next move calls for us to view the image in Photoshop's Actual Pixels View, which maps every pixel in the image to a screen pixel on the computer display. This is the only truly accurate view of the image's detail, so all adjustments need to be carried out at this zoom.

Since we are satisfied with the edge definition, but unhappy with the grain, Unsharp Mask is not the approach we want to use. Photoshop has at least two other options worth examining: **Despeckle** and **Dust and Scratches**, both found under the Filter pulldown menu as options under the **Noise** filter.

The thing with Dust and Scratches is the overall blur that this filter applies to the image. Unless the Threshold slider is

Figure 7-4

Using the original file as a reference, a minor Contrast increase is accomplished via the quartertones after the Dynamic Range and Balance have been repaired. This falls under the category of "season to taste" and might not even be considered necessary by many.

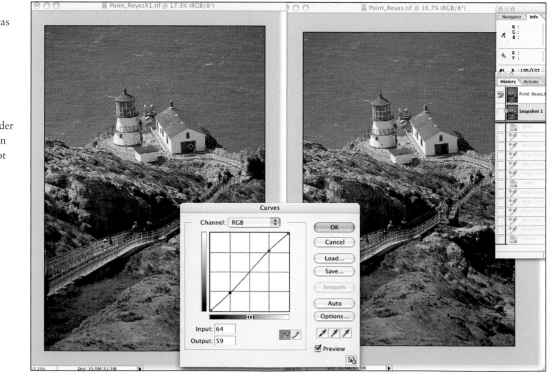

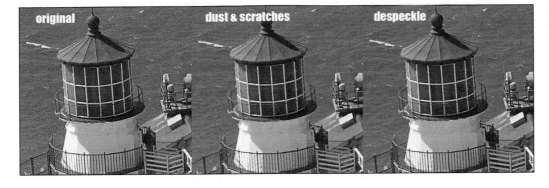
original dust & scratches despeckle

Figure 7-5
Here are two different
approaches to reducing
the visual distraction of
the grain in the scanned
image through the
application of
Photoshop's Dust and
Scratches filter and
Despeckle filter.

invoked, all detail suffers, including that which you'd just as soon not lose. So, on the triptych above, the center detail image features a Dust and Scratches filter application with the Radius set to 1 pixel and the Threshold set to 20. Despeckle doesn't allow for any operator tweaks; you apply the Despeckle option and either accept or reject the results. In the case of our image, Despeckle dials back the grain nicely and somewhat smoothes the overall image. See the right third of Figure 7-5.

I noticed the odd speck of dust here and there, and now is the time to clone stamp those little annoyances away.

Realistic Colors

Consulting our original evaluation, we had problems with two of the colors. The blue water lacked any third color, or unwanted component, and the grass showed a yellow saturation value of 100%, which might concern us. The problem of the water was resolved through a combination of the Dynamic Range adjustments and the blue reduction we applied overall to solve the Balance issues. Proof positive that when the Contrast, Balance, and Sharpness and Detail are properly set, along come the colors. In this corrected "Point Reyes" image, no color looks out of place or overcorrected.

Wait a minute. The grass, though visually appealing, still contains 100%Y, or will

when the file is converted to CMYK. Isn't that an issue?

We're not concerned with that, and here's the reason we're not concerned: yellow is too bright a color for anyone to distinguish much in the way of differentiation of tone in the saturated end. So, although tweaking the yellow shadow value might give us some mathematical satisfaction, it won't change things visually without desaturating the yellow to the point that the grass color changes.

We're done.

Correcting the Poor Image

The "Point Reyes" image was a decent scan of a very nice original 35 mm. So our job on that piece was to tweak it incrementally, but not dramatically, to improve it. Many times we are provided with very poor images that are taken under poor conditions by inexperienced photographers. What do we do then?

It is fairly simple to dramatically improve many poor images. About the only photographic condition that we can't make go away is an out-of-focus condition. We also can't turn a low-resolution image into a high-resolution image of the same height and width dimensions, but that is generally not a problem of the photographer's making. We can, and often are called on to, add weight and

Figure 7-6
There looks to be a whole lot wrong and not much right about this image. It's slightly out of focus, which we can't do much about. It's also extremely reddish in balance, and there are some contrast issues requiring improvement.

Figure 7-7
The Levels histograms for each channel of Ducklings.tif shows the absence of any green and blue information in the highlight region and the red highlight with an abundance of samplings jammed to the extreme right of the histogram, indicating a highlight plugged with red data.

shape to overexposed images, brighten underexposed images, and chase color cast out of poorly balanced images. In fact, one of the most difficult accomplishments in this trade is to satisfactorily reproduce a great photograph. Conversely, one of the easier accomplishments is to dramatically improve a ghastly image. You may not turn the ghastly image into an award winner, but you can show dramatic improvement.

Make Hay with Ducklings

Let's have a look at the image labeled Ducklings.tif on the accompanying CD. A truly appalling image, as I'm sure you'll agree (Fig. 7-6). For the sake of brevity, we're not going to go through the entire Evaluation Check List in this text, although you should on your own, to discover the extent of this image's flaws for yourself.

The overall first impression is one of red imbalance, followed by perhaps a sense of focus issues and, for the sharper eyed, one of too much contrast in the highlight and

Figure 7-8
This red channel only peek at the image in grayscale mode is also a good preview of what the cyan plate will look and print like. Notice the rectangle of blown out data in the lower right quadrant of the picture. This will have to be fixed, or no cyan dot will print in this region, which means that shape in our sawdust will be wanting.

darker shadows. The picture is so out of balance to the red side (caused primarily by the scene being illuminated by a heat lamp) that we can't be certain of the presence of any pure neutrals. One of the ducklings might be gray; another might be black. Under the heading of memory colors, we know from experience that sawdust is not white; it's more of a blonde color. We don't have a dependable white to anchor our correction.

Searching out this image's end points gives us a highlight in the lightest sawdust and a shadow near the darkest duckling's neck. The highlight, at 255R, 213G, 200B is grossly out of balance; the shadow at 2, 2, 0 less so, with almost every pixel between these two dominated by the red channel. When an image is this far out of whack, one of the most instructive steps we can take is to have a look at the Levels histogram for each of the three channels (Fig. 7-7).

This examination of the individual channel histograms (Figs. 7-8 and 7-9) is a useful way to begin to compile data about

Figure 7-9
The Green levels adjustment blends green data into the highlight region along with the existing red. Since you've memorized the color circle diagram, you know that green and red together create yellow, or in these amounts, beige.

Figure 7-10
The three-quartertone reduction shown in the Curves palette opens up more detail in the black duckling with no ill effects to the rest of the image.

the image that will inform effective corrections. In the case of ducklings, the channel histograms reveal a highlight region that is just choked with red channel value and devoid of green and blue data. To verify this channel histogram visually, we can look at each channel individually, making sure that we are viewing in grayscale mode rather than color mode. This is done under the Display Preferences in Photoshop.

Again, we know that we want the sawdust to have a blond hue to it, not white. In RGB that means, just like a skin tone, that red leads, green is next, and blue is third. We go into Levels, change the Output Levels highlight value from 255 to 245, and the Shadow value from 0 to 10 to constrain the end points, especially the red, which will create a printable value of cyan when we go to print. Then we go the green channel in Levels and push the highlight slider to the

Figure 7-11
The image just after the Levels and Curves adjustments. Already our ducklings image is looking far more real and believable.

Fig 7-6.tif @ 100% (RGB/8)

Figure 7-12
These Unsharp Mask settings were sufficient to coax a little better detail out of this out-of-focus image.

Figure 7-13
Three overall moves. Three minutes. Dramatic improvement over the original, and not a lick of photosorcery involved.

left as shown in Figure 7-9. This introduces green data into the highlight region and skews the highlight from red to beige. Voila! Sawdust.

The black duckling would benefit from being a bit better defined, so a quick 3Q curve adjustment opens up our shadow detail in a satisfactory manner (Fig. 7-10).

The image at this point has now been improved in Contrast and Balance (Fig. 7-11). The Balance was so far off when we started that our previous moves have attacked weaknesses in Contrast and Balance more or less simultaneously.

We now go into Actual Pixels View to examine the sharpness and detail. Again the picture admittedly has focus problems that we can't make go away. We can, however, sharpen the detail some. So using a rather thin pixel Radius (1.2) and setting the Amount to 80 and zeroing out the Threshold (no need to soften the nonedge areas in an image already out of focus) we can improve some of the detail (Fig. 7-12).

Let's review. Bad image. Levels-Curves-Unsharp Mask. One-two-three. An okay image (Fig. 7-13). Not a great image, because of the original focus and illumination issues, but an okay one. Certainly a dramatic improvement over the original. We used overall adjustments all the way. No selections. No tool work. This correction took 3 minutes to carry out and 3 hours to write it up and talk about it.

Good job, everybody. What say we take the rest of the day off, with pay? Lock up, and make sure you turn off the lights.

Chapter 7 Summary

The important points to take away from this chapter are:

- The data collected during the image evaluation drives the nature and amount of corrective action.
- The correction routine follows the priorities of the four features of optimal images detailed in earlier chapters.
- Simple, overall moves are usually all that is needed to take a poor or mediocre image and render it more appealing visually as well as improving its printability.

Chapter 7 Review

1. What influences are driving novice color specialists to overly complex corrective strategies?
2. When we say that corrections should be "unobtrusive," what does that mean?
3. What are two reasons why colors tend to be forced into compliance by overall adjustments such as contrast and gray balance?
4. Why is the histogram a useful tool in evaluating where corrective action will be best directed?
5. What was the root cause of the blown out highlight detail in the lower right portion of the ducklings image?

Masked and Invisible

Chapter Learning Objectives

- Recognize the signs that localized work is required
- Explore the several methodologies for localized adjustment
- Appreciate the different categories of masks and their uses

8

I'm a sucker for historical novels and films. Dress everybody up in 18th or 17th century garb, throw in some sword fights, season everything with that heartbreakingly beautiful Irish music, and put on the popcorn. Often enough, those books and films feature the masque, or masked ball, where everybody wears outlandish facial coverings and trades naughty repartee, pretending not to recognize, or be recognized by, their closest friends and associates. As if.

We color specialists employ the concept of the mask every day. Instead of our masks being foils to protect our identities, we use them to protect the rest of the image while we adjust an offending region. This text advances the idea that 80% of all repairable photographic weaknesses can be fixed with

overall adjustments. That leaves the other 20% of image maladies that are incurable without localized treatment.

Of that remaining 20%, only the minority requires tool work, which is the apex of Rivard's Pyramid—the most painstaking, riskiest, and expensive of all remedies.

The rest need localized attention. And to carry out these localized fixes, it is necessary that we be able to surgically attack certain areas while completely protecting the rest of the image. And that requires a mask, whether we actively create it or the software does without our assistance, or even our awareness.

Anatomy of a Mask

All masks carry out their function through the creation of regions that are **opaque**, **transparent**, or **semi-transparent**. In this instance we use these words to indicate a degree of sensitivity to the adjustment being performed. We are not using these terms in reference to their defined visual characteristics. So, **transparent**, in this case, does not mean "see-through." We can "see through" both transparent and opaque areas, whenever we use a selection option in Photoshop. An **opaque** area of a mask

Figure 8-1
Judging by the expressions of our masked "revelers" this is the part of the movie where they get the news that the rightful heir to the throne is not only not dead, he's headed their way and he wants his kingdom back.

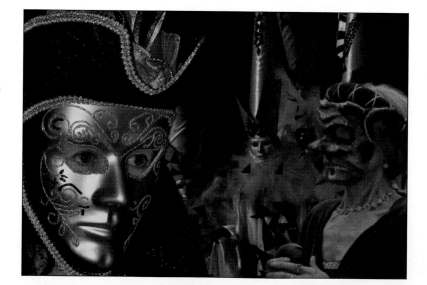

entirely blocks the effects of the adjustment from taking effect. A transparent area of a mask permits the full effects of the adjustment. A **semi-transparent** area regulates the degree of impact of the adjustment by either reducing the full effect to a lesser percentage or by altering the impact through some sort of filtering process.

As previously stated, an **opaque area** blocks any adjustment from taking affect in the regions protected by the mask. It's bulletproof. Any pixels protected by an opaque region will be unchanged from their original state. In Photoshop, using any of the **Selection** tools (Marquee, Lasso, Magic Wand) will result in the creation of an editable, or transparent, area (the selection) and an opaque protected area (the rest of the image). One of the best ways to visualize the concept of the mask is to draw or otherwise create a selection in

Photoshop with one of the selection tools and then to choose the **Edit in Quick Mask Mode** option near the bottom of the Tool palette.

The protected areas of the image flood with a flat red color (Fig. 8-2), familiar to veterans of the days of Rubylith, a film-based masking material from the pre-digital era where the transparent areas, or windows, in the mask were opened with the blade of an X-Acto knife. The concentration and posture of a journeyman dot etcher hunched over a light table and peering through a magnifier was such that the only way one could tell whether he was cutting a mask or sleeping off a bender was whether the handle of the X-Acto knife was moving.

A **semi-transparent** mask region will allow some of the adjustment to take place, but not all of it. Let's consider the idea of a color correction. It's helpful to have a diagram of the Color Circle handy. If we

Figure 8-2
The red region denotes the protected, or masked, areas of the image.

Figure 8-3
This screen grab shows Photoshop's Hue/Saturation Adjustment option with the green region selected. The little slider controls in the lower right area of the Hue/Saturation palette show the central area to be affected and secondary controls that indicate the range on either side of the target values into which the correction will reach.

set out to improve the green colors in a digital photograph, which is a very common occurrence, we need to protect all non-green values from the correction. Think of all the green colors in this photo (Fig. 8-3) to be one pie slice out of six in this entire color circle (see Fig. 8-4). The outer arc of this pie slice, or the rim of the color circle, is centered on green, and moving in either

direction half way to yellow on one side, and halfway to cyan on the other.

The full effect of the green region correction is centered on the purest greens in this pie slice, which are at the center of the slice exactly on the rim. All other pixels found in this slice receive a correction which lessens in effect as they move away from the pure green colors on the rim or move to less saturated values toward the center of the circle. The reason that the adjustment lessens is that these impurely green pixels occupy a less transparent area of a mask which fully protects all non-green values and extends some of its protection to somewhat green values.

Do we actually see this mask? No. A color correction, in effect, applies a virtual mask to the image during the duration of the correction. This mask is properly imagined as a grayscale mask, or a mask whose gray values change depending on the pixel's color value proximity to the target color.

Figure 8-4
In this Color Circle illustration, we see the above-mentioned green region. The area of the green region closest to the rim is most susceptible to color correction. Pixels with values closer to the center receive reduced corrective changes.

In the above example, the only values that are fully transparent to the correction are the target values, and all other pixels receive a lessened correction.

Categories of Mask

Let's draw up a list of common and useful mask categories. Then, we'll look at each category in further detail.

1. Outline, or silhouette, masks
2. Geometric selection masks
3. Pixel value masks
4. Gradient masks

The Outline Mask

The outline mask is also called a **silhouette mask** and in certain situations, a **clipping mask**. This type of mask is used to isolate, and sometimes remove, a foreground object from its surround, or background. Although there are three or four quick and somewhat sloppy ways in Photoshop to remove an object from its background, the favored methodology is the Pen Tool path (Fig. 8-5), which is executed by creating a path along, and just inside, an edge at Actual Pixels

zoom. The Pen Tool confers the greatest control and accuracy of all other options. In addition, smooth arcs in the path line, or **Bezier curves**, can be created through the use of adjustable handles at the path anchor points.

Once the Pen Tool's path is completed, the color specialist can either transform that path *and the pixels it surrounds* into a selection, or use the path itself as a clipping path. The choice to transform the path into a selection allows for the deletion of any of the surrounding pixels, which can be accomplished a number of ways. One way is to copy the selection and paste it into a new layer, which floats the copied selection in a transparent surround. The original layer can then be deactivated, hiding it from view and leaving only the new layer visible. Another way is to **Invert** the original selection, which protects the originally outlined region and permits the deletion of the rest of the image.

The advantage of the clipping mask, or clipping path, is that it hides the surround from view without deleting it. So, the option of using the image in its original surround is

Figure 8-5
The Pen Tool's path, with anchor points, is visible, running around the outer edge of the blossom. Note the Path palette in the lower right identifying that particular path.

preserved. The clipping mask is one category or what digital imaging technicians call nondestructive editing. Nondestructive edits are any changes that are made to an image that can be completely reversed if judged to be unsatisfactory, with no damage done to the original. A clipping mask, or clipping path, is generated from a path via the Path palette pop-up menu.

The disadvantage of any mask created with the Pen Tool is that the resulting path is a vector line, which needs to be remapped to run along pixel contours once a selection is created from it. Again, a path is a vector object, and a selection is a bitmap, or raster, object. This selection often needs to be feathered, or anti-aliased (see Chapter 4), to soften the effects of the hard vector line. In addition, some subject matter doesn't lend itself to Pen Tool cutting. Any complex edge that needs to be developed along highly irregular contours, such as hair, fur, foliage, etc. is far too time-consuming and prone to visual disappointment when cut with a Pen

Tool, unless augmented with a selective feathering treatment.

Be aware that silhouetting an image from its background and then placing that image against a white background always has an optical effect on the image itself. Usually the image will appear darker than in its original surround and will need to have a lightening tone distribution move applied (a reduction in midtone or quartertone). This effect is caused by the image being referenced against the white background by our eyes and brain, which then declare the object to be darker than it originally appeared (Fig. 8-6).

Another common side effect of the silhouetted object being placed against white is the increased perception of a color cast, or lack of neutrality, in the object. A cast that is barely noticeable when the object is nestled into an equally casted surround is glaringly obvious when that object is placed against a paper white.

There are other well-known pitfalls to silhouetting particular objects that contain

Figure 8-6

A fine example of what can happen when a transparent object is removed from its surround. The amount of work required to remove all of the background detail in the glass would result in greater expense than shooting a new photograph of the glass against a white background, and would never look as real. Notice how the silhouetted glass appears to be darker than the same glass in the original scene, even though the pixel values in both are identical. This is an example of what artists call simultaneous contrast, and others refer to as adjacency.

transparent elements, such as eyeglasses, cars, drinking glasses, glass or plastic jars, etc. (Fig. 8-6). Any background detail that is visible in the original through the transparent area will look mystifying and out of place when the object is silhouetted. Theoretically, the only thing we should see in these areas is the absence of detail, tying in the silhouetted object with the paper substrate surround. Often, creative selection and tool work are required to blur or remove any such detail.

Objects are outlined every hour of every day in this business for the purpose of localized color alteration. Some colors and surfaces do not photograph well, for a variety of reasons. In those cases, a particular product or object will need to be masked to alter the color without any change to the rest of the image. Once, while working on a Harley-Davidson catalog where the art director was dissatisfied with the look of the fenders and gas tanks in the photographs, we were given some actual motorcycle parts to inform our color corrections. We were instructed to view the paint job on these parts outdoors under full sunlight to experience the effect the client was after. Sure enough, under full sunlight, parts that looked more or less black in the photos revealed dark red qualities that we were asked to go after. And so we did. Our color specialists spent many hours that summer outlining motorcycle fenders and gas tanks.

It is not uncommon to be asked to take a single photograph of a car or some other product and a handful of paint chips and to make a new version of the product for every color. Well, we can do that. And it all starts with the outline mask.

Geometric Selection Masks

Selection tools that draw ellipses, rectangles, squares, circles, and the like generate Geometric Selection Masks.

Generally these masks are used to create "vignette" effects for images against a white background. The edges of the geometric shape are feathered to create a gradual fall-off effect from the image subject matter to paper white. Designers favor this technique for archival photos or current images that have been shot to resemble 19th-century, "vignetted" daguerreotypes and for conveying a soft, romantic treatment (Fig. 8-7).

This particular type of mask has occasional value for digital color correction or alteration. From time to time, it is useful to use an elliptical or rectangular selection to crop a small area of a larger image, when very particular work needs to be done to a particular area. That selection is then copied to a secondary layer to be treated in isolation and merged back into the entire image if and when the results are satisfactory. This technique prevents the original image from becoming irretrievably damaged by imperfect tool work or color alteration.

Figure 8-7
This subject has been given that "vignette" effect using a geometric selection mask with a 25-pixel feather applied.

Pixel Value Masks

One of the fine things about computers and digital images is the ability of the computer to evaluate large amounts of data in a short time. The capability of a software program such as Photoshop to instantly look at every pixel in the image and include or discard each pixel from a particular edit is tremendously useful.

Numerous masking techniques are based on pixel values, including Magic Wand Tool selections, Color Range selections (Fig. 8-8), Hue/Saturation adjustments, Extract filter, Magnetic Lasso Tool, etc. We can lump all these options into a category called Pixel Value Masks. Some of these options reference all image pixels against a target pixel chosen by the Eyedropper Tool or Magic Wand, and then include or exclude additional pixels based on a range defined by the color specialist, as the particular option permits.

One or another of these techniques is generally used to select the complex, irregularly contoured subjects such as hair, fur, foliage, etc. Professional photographers familiar with design and prepress concerns will shoot such subjects against flat backgrounds which contrast well with the subject to be silhouetted, thereby making it easy on the software to differentiate between subject and background.

One of the more interesting options in the Pixel Value Mask category is to use the image itself as its own mask. In this scenario, a duplicate of the entire image is copied to a new layer. Because every layer in Photoshop shares the same resolution as the original, or Background layer, this results in identical pixels being stacked on one another. The color specialist takes advantage of the luminosity values of the upper layer to control the force of correction to the lower layer. So if we wanted to increase the contrast of the image overall, we could apply a correction that would affect the lower layer's lighter pixels more forcefully

Figure 8-8

In this view of a pixel value mask, in this case Photoshop's Color Range feature, the white areas are transparent, the black areas are opaque, and every shade of gray is semi-transparent.

Figure 8-9
A gradient mask is fading the upper layer image of the harmonica player into the image of the guitarist on the layer below. A small graphic of the gradient layer mask is shown in the Layers palette to the right of the image. The tiny spot in the white area of the little gradient graphic represents an area where tool work has been used to erase any upper image blocking the guitar's peg head.

as the upper layer will be more transparent to the correction in those same lighter pixels.

Gradient Masks

A **gradient mask** features a smooth transition from opaque to transparent over a distance, and in a direction, dictated by the color specialist. Like the pixel value mask category, much of the gradient mask is semi-transparent. Unlike the pixel value mask, the colors or luminosities of the pixels themselves have nothing to do with the creation of the mask.

A gradient mask is used in conjunction with a normal linear gradient tool, and less commonly, a circular gradient tool. The color specialist will use the gradient tool to snap a straight line between two chosen points. Those two points set the end points of the gradient mask, either entirely opaque or entirely transparent. Any image information outside of those two points will assume a flat value of either opaque or fully transparent. All image area inside of those two points will represent a gradually changing level of semi-transparency.

Two common uses of the gradient mask as a layer mask come to mind. A layer mask either hides or reveals the layer to which it is applied. The first instance is used when the color specialist is looking to seamlessly blend two different images. Each image occupies its own layer within a single file. The gradient mask applied to the upper image allows the upper image to fade from fully opaque to fully transparent, revealing the lower image in the semi-transparent and transparent areas (Fig. 8-9). The second use allows the color specialist to fade a drop shadow gradually as it extends away from the image casting it, giving the drop shadow a natural appearance. We'll consider drop shadow techniques in Chapter 10.

A Masking Scenario

We'll assume that we are working with a client who owns a greenhouse business. This greenhouse owner promotes a sale on rose plants and has three varieties of a particular plant featuring yellow, pink, and red blooms. Unfortunately, the only blooms ready to photograph on the day of the shoot are the yellow roses. And, as they are shot

Figure 8-10
The photo of the client's
original yellow rose.

digitally, the green colors of the leaves
are not satisfactory. So, our job as color
specialists is to color correct the greens and
to produce, using only one shot of a yellow
bloom, a pink and a red variety. This is
definitely going to take some masking.

We have only one image of a yellow rose
but need three images: one each of a yellow,
pink, and red rose. The green leaves on
each need to be greener. Remembering
that we need to be both efficient and
effective, we need to get the work done
in a timely and accurate manner.

Our basic steps:

1. Color correct the green leaves.
2. Outline the yellow rose blossom to
 isolate it from the rest of the image.
3. Copy the selected blossom to a second
 layer for color alteration to pink.
4. Copy the selected blossom to a third
 layer for color alteration to red.
5. Carry out the two color alterations.

Follow along with this exercise by opening
Figure 8-10.tif from the CD.

Color Correcting the Greens

Many color specialists carry out
corrections these days in CIELAB (LAB)
space. Earlier in this book we introduced the
concept of LAB color space and some of its
advantages. The main advantage is that LAB
space splits shape and detail in colors from
hue and saturation. So, we can operate
within LAB space and make extreme changes
to hue and saturation without sacrificing a
lick of shape and detail, which is not possible
in Red Green Blue (RGB) or Cyan Magenta
Yellow blacK (CMYK).

Thus, the first move we make to the rose
photo is to convert the mode from RGB to
LAB.

We'll attack the green deficiency by
trying a simple **Image/Adjustments/Hue-
Saturation** move by selecting Green from

the Master pulldown menu and trying to push the Hue slider to the right. No effect? Me neither. Sadly, the LAB values for the green leaves in this image show that the a* axis value is not a very high negative number. It's not very green. The camera is recording the leaves as a slightly greenish neutral, and so they fail to respond to the generalized green region correction.

Time for plan B. We begin by creating a mask isolating the leaves. Using the Eyedropper Tool, we load a representative leaf sample as our Foreground Color. Under the Select pulldown menu we find the Color Range Option, which builds a selection based on the Foreground Color and a variable range, which is adjusted via the "fuzziness" slider control (see Fig. 8-8). The resulting selection will not be perfect but can be quickly cleaned up using the Lasso Tool or switching to

Quick Mask mode and painting any repairs to the area requiring transparency.

Once we are satisfied with the selection, all we need do is a very slight midtone adjustment to the a* axis channel (Fig. 8-11), which controls red/green hue saturation. Green correction—done.

Outlining the Yellow Blossom

We have any number of ways to outline the yellow blossom. We're going to try two different ways and time ourselves to compare choices. The first method is to **Pen Tool** a silhouette path around the blossom.

Always operate the Pen Tool in Actual Pixels View, or a slightly closer zoom, to make sure that the resulting path follows the edge of the subject. Make a habit of using the Tab key to hide all of the menus, devoting the entire screen to the image.

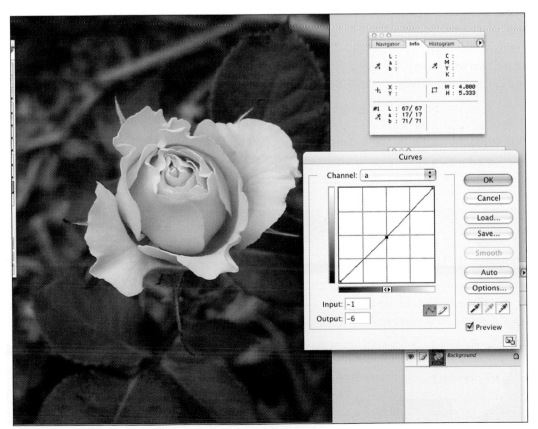

Figure 8-11
The most refined little tweak on the a* axis midtone greens up the leaves of our rose to our satisfaction.

There is no such thing as too much Pen Tool practice. A seasoned practitioner of the Pen Tool cuts as few anchor points as possible and makes extensive use of the Bezier curve directional handles to shape the smooth contours, controlling those handles with the Command and Option keys in conjunction with the cursor.

It took just under 6 minutes to create a path, save it, create a selection from the path, and save that selection. The saved selection added an **alpha channel** to the channels palette. An alpha channel is a grayscale channel that can be altered or edited and can be used to generate new selections. The selection was given a 1-pixel feather to minimize the hard edge of the vector path, and named "Pen Tool."

After deselecting the "Pen Tool" selection, a completely different technique, known in these parts as the "Combo Platter," was tried to see if there was an equally effective but faster approach to isolate the rose blossom. The "Combo Platter" is an approach using two or three different tools to create a single selection. This time we began with the **Magic Wand Tool**, which is a form of pixel value mask. The Magic Wand Tool was used to select a target pixel and its related pixels, holding down the Shift key to grow the new selection every time the cursor is clicked on a yellow value.

Because this method can leave stray pixels or pixel clusters scattered about, we switched to the **Lasso Tool** to round them up, holding down the Shift key again to add these strays to the main selection. Finally, because the Lasso Tool is inadequate along contoured edges, we switched to **Quick Mask** mode and used the Brush Tool to paint along the edges of the rose blossom, adding any overlooked yellow pixels to the selection. We saved this second selection, resulting in a second alpha channel, calling it "Combo Platter."

Although this approach may seem complicated, it took only half the time as the Pen Tool method, just over 3 minutes. Comparing the two alpha channels, it's apparent that the edge created by the Pen Tool is smoother and more uniform (Fig. 8-12). Although the second approach was faster, in this instance since we need to make copies of the selection for color alteration, we're going to use the "Pen Tool" selection.

Copying the Selection to New Layers

We need three colors of rose blossoms, of which we only have a yellow one. Our job now is to make two copies of the rose blossom selection and alter the yellow to the desired new colors, pink and red. We accomplish this by copying the selection,

Figure 8-12
The image on the left is the alpha channel generated from the Pen Tool path. Note its uniform smoothness around its entire circumference. The Combo Platter alpha channel features a much less refined edge.

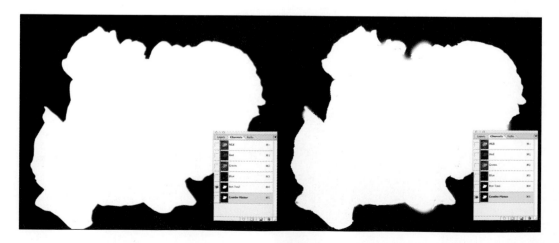

creating a new layer, and pasting the copied selection into that new layer. To stay organized, we name this new layer "Pink" and then duplicate this process, naming the newest layer "Red." At this point, our image should have three layers, the original Background layer featuring the entire image, the Pink layer, and the Red layer. All three show identical yellow blossoms.

Photoshop can have an annoying tendency to fail to paste selections exactly above each other. Check to see if your blossoms line up exactly above each other (Fig. 8-13). Clicking a layer's "eyeball" on and off in the Layers palette will do the trick. The blossom will jump from one position to another if both aren't perfectly aligned. If they jump, move the blossom on the offending layer so that it does line up with the Background layer. Reducing the offending layer's opacity allows us to see through the upper layers and perfectly align our copied selection to the original. We then restore the layer opacity to 100% to render the pixels opaque.

Altering the Color of the New Blossoms

I love LAB color space, and I want you to love it too. Working in LAB space allows us to make extreme color alterations with no fear of destroying a color's shape and detail. Before this option was available, color specialists tried all manner of separation swapping stratagems in an attempt to borrow from one channel to pay another. It never worked.

Prior to all of this work, we, the color specialist and client, should have had a conversation where the client specified a target color to strive to match. Perhaps the client gave us specific Pantone colors. Maybe he sat next to us while we cruised around in Photoshop's Color Picker. At some point, though, we should have an

Figure 8-13
The Layers palette with the original image on the Background layer and the selection of the blossoms copied and pasted into new layers are exactly positioned above the original blossom.

Figure 8-14
Our pink version of the client's rose, ready for client approval. Note the Layers palette in the lower right showing the red version of the rose in the topmost layer.

accurate enough idea of what the client means by "pink" and "red" to find target LAB values within the Color Picker. Our task is to compare the target LAB values against existing LAB values sampled from a given spot in the yellow blossoms.

Then, we activate Curves and do whatever it takes to move the existing LAB values to the target values, one channel at a time, starting with the L channel. Treat the L channel no differently than a grayscale file, making normal midtone and quartertone moves as needed to achieve a target value. As to the a* and b* channels, do whatever it takes, including pulling the extreme end points up, down, left, or right. Once the exact target values are achieved, go back and tweak the L channel to make sure the new color fits into its surround and fine tune the other channels as well, if needed.

When we're done, we still have three layers. Now each layer shows a different colored rose (Fig. 8-14). We restore the

Mode back to RGB color space. We can take a History palette Snapshot of each version and spin out new TIFF files from each snapshot, or just turn layers on and off and Save As to different files. The long and the short of it is—we're done.

Chapter 8 Summary

When we need to isolate a specific area of an image from the rest of the image, we need to create a mask. We isolate these specific areas for localized color correction or special effects, one of the most common being the silhouetted image. Selections, clipping paths, selective or regional color corrections, and alpha channels all come under the category of mask.

Essentially, there are four types of mask: outline masks, geometric selection masks, pixel value masks, and gradient masks. Each mask features both opaque and transparent regions. Some forms of mask feature semi-transparent regions.

Chapter Review

1. When referring to masks, what is meant by the terms "opaque" and "transparent"?

2. Identify two potential side effects of silhouetting a subject and placing that outlined subject against a paper white surround.

3. Why do we say that carrying out a color correction creates a "virtual mask"?

4. Identify two reasons for feathering the edge of a selection.

5. What is an alpha channel, and how is it created?

Tool Work

Chapter Learning Objectives

- Recognize the common situations when only highly localized corrective adjustments will do
- Appreciate the common types of software tools used for "manual work"
- Use the tools in a manner that leaves as little evidence as possible of their use

There are times when some sort of corrective action is called for that can only be accomplished through what I classify as **tool work**. Tool work is the use of certain tools in the software that allow the color specialist to employ drawing or painting techniques to eradicate unwanted features or perceived flaws in the image. Because certain conditions are immune to overall adjustments or masked adjustments, tool work is sometimes necessary. The risk involved with tool work is high, as poor or even mediocre tool work leaves evidence behind that can be distracting or even ruinous.

On Rivard's Pyramid, Tool Work occupies the peak (Fig. 9-1). The peak of the pyramid represents work that is not only the most time-consuming, and thus expensive, but is also most prone to failure because it is not easy to do well. Most corrections can be accomplished without tool work. Nonetheless, the color specialist needs to be competent with several different tools in Photoshop's tool kit, or any software such as the GNU Image Manipulation Program (GIMP) that features painting capability, to effect scratch, dust, and hair removal and to accomplish advanced and complex adjustments. Photoshop features as many as eighteen different options that arguably can be classified as "brush" tools, based on a definition of "brushing" as any very localized edits applied by the strokes of a cursor or stylus controlling a defined tip. The GIMP features nine such tools, almost all represented by icons bearing an uncanny resemblance to their Photoshop counterparts.

There are two ingredients to the success of tool work: the sophistication of the software tools and the competency of the operator. No one is born a master of painting and retouching tools. Mastery is

Figure 9-1
On Rivard's Pyramid, tool work occupies the apex. This is the most expensive and riskiest category of corrective action.

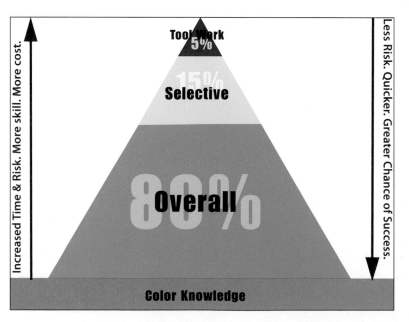

gained through a combination of education and experience. Those color specialists fortunate enough to work with recognized pros in this area benefit from their experience and tips. Also, not every workplace features the same opportunity to practice these tools. A direct mail print business is less likely to traffic in the type of work requiring fine tool work as is an operation dealing in high-end commercial work.

When it comes right down to it, there is no substitute for drawing skills, where successful tool work is required. The tools applied in Photoshop or the GIMP for extremely localized work are designed to emulate the paintbrush and the airbrush, both of which in analog life require a certain manual dexterity and eye-hand coordination.

Many color specialists carry out their tool work, and even masking, using not a mouse but a stylus and magnetic tablet, which gives them more of the feel of a real brush in their hand and pressure sensitive control over the application of the digital "paint." Wacom, the maker of one brand of pressure sensitive tablets, now makes a special LCD computer display on which a person can draw directly using a stylus specific to that display (Fig. 9-2).

The practice of drawing imparts a feel for line, perspective, shading, weight, and proportion, which is useful in digital tool work. A specialist working in the digital arena is not spared from the need for analog drawing skills. Yes, it is easy to draw perfect circles and apply perfect

Figure 9-2
A desktop specialist using a Wacom tablet and stylus to facilitate brushwork.

Figure 9-3
Time spent in the
practice of drawing is
all good in terms of
improving the success
of digital tool work.

when neither overall nor masked adjustments will do for the adjustment or effect called for.

What then are common situations where only tool work will do?

1. Removal of scratches, hair, dust, or other unwanted artifacts.
2. Extremely localized color alteration or correction, such as patchy or irregular areas that are not conducive to normal masking.
3. Digital cosmetic surgery.
4. The addition of an object or an effect to a very localized area.

It's worth considering each of these examples in more detail.

Dust, Scratch, and Hair Removal

Ever since digital photo editing came on the scene, people have been busy converting photographic originals into digital files. Initially, this scanning process was confined to those businesses that could afford scanners costing hundreds of thousands of dollars and staffed by highly trained technicians in the late 1970s and early 1980s. The cost of scanning was prohibitive enough that only those photos destined for commercial or educational publishing made it to digital form.

Now scanning capability comes bundled with printing and copying options in all-in-one home desktop devices priced under $100. Thousands of ordinary hobbyists and family photographers have scanning capability to convert their own vast personal archives of photo prints and even negatives to digital files.

Any damage in the original or to the original during the scanning process results in that damage being embedded in the resulting digital file. It goes without saying that any scratches, tears, stains, and wrinkles in old family or historical archive photographic prints will be

gradients in computer programs. It is even easier to ruin a fine photographic image with poor digital brushwork.

This chapter is not a primer on drawing skills. I highly recommend, however, that anyone reading this book who regards himself as below average or just average in drawing ability sign up for a class in basic drawing or life drawing. If you've taken drawing recently, consider a class in painting. Any of these analog areas of study are going to improve your digital abilities (Fig. 9-3).

Recognizing a Need for Tool Work

Again, tool work is expensive because it tends to be time-consuming, and it is risky because it is more difficult to carry out successfully than overall moves or even mask work. In fact, the only time it is required is

A Word on Work Habits

There are any number of tips on working as effectively and efficiently as possible, and no color work calls for these habits more than digital retouching. Retouching is a demanding pursuit that requires concentration, patience, precision, diligence, and creativity. So, anything that disrupts any of the aforementioned requirements adversely affects the quality of the outcome.

In conversations with many of the local digital ninjas who spend much of their workday polishing color images and creating eye-popping photo composites, shared best practices emerged that almost all of them adhere to. These best practices include:

1. Creating a quiet environment free from chatter, whether from colleagues or the radio. Music, if played at all, is at a low volume and quite often tends to be instrumental in nature. I know retouchers who are absolutely militant about music-free work areas. Commonly, these areas are out of the main traffic patterns in the shop and set up to minimize distractions. Professional digital retouchers totally get the Zen concept of being present in the moment, of paying perfect attention to what is in front of you right now.

2. Ambient lighting is reduced, and color monitors are hooded to block any ambient light from affecting the display.

3. The entire computer display is devoted to the image. Many of these operators use a second monitor for tool bars and palettes to keep the main display free of non-image data. Those that don't will clear the screen of palettes while they are retouching and restore the palettes when needed, using the Tab key.

4. All of them work two-handed, with one hand manipulating the mouse or stylus and the other poised on the keyboard, using all the shortcuts for zooming in and out and moving the zoomed image around, as well as launching frequently used palettes and features. Whether the work is done on a Macintosh, PC, or UNIX box, these shortcuts, though not the same, are all there. They save time, and it pays to figure them out, memorize them, and use them religiously.

5. They're generally curious to a fault and spend a good deal of time trying to discover ways to accomplish work more efficiently. They haunt Internet forums and favorite Web sites, show up at users group meetings and seminars, and subscribe to industry literature.

6. Most of them have really nice, ergonomically correct chairs and expensive, track-balled cursor controls. They sit up straight, take their posture seriously, and set up their work area to defend against repetitive stress injuries.

faithfully rendered or even enhanced in the scanning process.

Unless one does one's scanning in a clean room environment with humidity and dust control, there is a certainty that, from time to time, dust will settle on the original or the glass or Plexiglas on which the original rests or is mounted. This dust will also be faithfully rendered in the digital file. So too will scratches in the scanning glass

Figure 9-4
This close zoom reveals
some nasty examples of
dust, dirt, and hair on a
scanned original.

or residual streaking from incompletely
wiped glass cleaner (Fig. 9-4).

In Photoshop the Clone Stamp Tool, the
Healing Brush Tool, and the Patch Tool are
the most effective repair strategies, with the
common Brush Tool also having some
usefulness in this regard.

Extremely Localized Color Correction

Skin tones, especially those photographed
in candid situations without benefit of
professional make-up artists and lighting,
often reproduce in a less than smooth,
patchy manner.

Most of us are not professionally beautiful
and we compound our physical issues with
exposure to the elements, dietary choices,
alcohol use, etc. Ruddy, uneven patches
appear at the cheeks, nose, and other facial
areas, and benefit from smoothing out with
localized brushwork. Brown patches on an

otherwise flawless lawn or rust around the
edge of a car door present opportunities for
brushwork.

The Brush Tool, Color Replacement
Tool, Dodge Tool, Burn Tool, and History
Brush are the tools of choice for this work,
augmented with clever Layer and Selection
techniques.

Digital Cosmetic Surgery

None of us are getting any younger;
though some have careers that require that
they present the illusion of defying the toll
age takes. It's safe to say that almost anyone
who has graced the cover of a fashion or fan
magazine has had some post-photographic,
digital cosmetic work done for that cover.
Crows feet, laugh lines, and other normal
wrinkles are routinely either minimized or
removed, teeth are whitened, moles and
freckles erased, eye color is enhanced, and

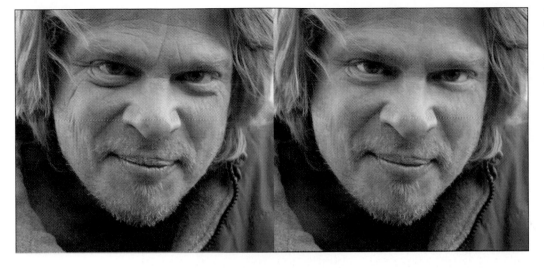

Figure 9-5
Twenty minutes of
brushwork and a little
color balancing scraped
years of hard living from
this gentleman's face.

sometimes even weight is shed via careful
tool work (Fig. 9-5).

The Clone Stamp Tool, Color Replacement
Tool, Brush Tool, and History Brush Tool are
used to great effect in this regard.

Adding an Object or Effect

The subject doesn't always perfectly
cooperate with the photographer. Recently,
we were asked to fix an image photographed
at night of the outside of my college's main
building. That shot was intended for the
college's annual alumni calendar.
Unfortunately, at the time the picture was
taken, the neon signage on the upper part
of the building's face featured two burned
out letters. There was enough shape to the
burned out letters to work with, and one of
my students "relit" the offending letters in
Photoshop with some clever tool work.

In that particular case, the student used
the Dodge Tool and Clone Stamp Tool in
conjunction with a selection created from
a Pen Tool path.

Tool Work Considerations

In the interest of inconspicuous work, we
want to leave no obvious signs that we have
engaged in tool work. A number of visual
"footprints" are left behind by unskilled

digital retouching (Fig. 9-6). They include,
but are not limited to, the following:

1. Tracking, which is a repetitive pattern
 caused by the repeated cloning of a single
 area in a straight line.
2. Hard edges, caused by the inexpert use of
 a brush with a hard edge at full opacity,
 leaving behind a clear edge defining
 exactly where the brushing was done.
3. Blurring, which is caused by using too
 soft of a brush edge within a crisply
 detailed area.
4. Pattern interruption, which is caused by
 cloning detail at an angle that disagrees
 with the angle or curves of edges and
 patterns within the image.
5. Shading problems, again by cloning or
 painting a value whose weight disagrees
 with the surrounding values, resulting in
 clearly lighter or darker brush strokes
 than would look correct.

Prerequisites for Successful Brushwork

I highly recommend the following when
engaging in tool work:
1. Work on a copy of the area requiring tool
 work on a separate layer from the original
 area or in a copy of the file itself. If your

Figure 9-6
In this grouping the center image is the original, a detail from a scratched bench with a worn and tattered decorational sticker. The surrounding images feature: 1-Tracking; 2-Hard Edges; 3-Blurring; 4-Pattern Interruption; 5-Improper Shading; 6-Acceptable Brushwork.

work is less than satisfactory, there is no harm done to the original. If your work looks great, then it is a very easy thing to merge that work into the original.

2. Work in Actual Pixels View, just as you would when applying Unsharp Mask. This is the one zoom that will give you precise feedback on the quality of your work, as every pixel in the image maps to a pixel of monitor resolution. Beware, though, of spending unnecessary time cloning away dust specks too small to be noticed in the image when printed. A generally reliable rule of thumb is that if an artifact can't be noticed at 66.7% zoom on your screen (one keyboard invoked reduction from Actual Pixels View), it probably won't be apparent when printed.

3. For all but the most straightforward work, consider controlling the opacity of your tool tip to allow yourself to build your brushwork through layering several strokes of the brush rather than one stroke. Think of building an onion from the center on out. Each brush stroke is a semi-transparent skin applied to the layers below to incrementally deliver the shape, weight, and color desired. This technique imparts more control and finesse into your brushwork and makes it easier to hide the fact that there was ever brushwork done at all.

The Brush Tip

A painter, whether painting the siding on the garage or a landscape on canvas, controls the application of paint initially through the choice of brush. The tip might be flat, round, or pointed. The brush hairs might be fine, coarse, or bristled. The brush tip might be slender or fat.

Figure 9-7
The control settings for Photoshop's Brush Tool.

A digital brush is designed to mimic the qualities of the real world brush. The color specialist controls the impact of the brush stroke by setting the shape, width, and edge quality of the digital brush (Fig. 9-7). The shape might normally be circular, but it is possible to build (or download from various Web sites) virtually any regular or irregular shape. The width is defined in pixels, which means *the size of the brush is relative to the resolution of the image being brushed*. The higher the image resolution, the smaller the brush tip, based on its pixel width. Referring to Chapter 4, Sharpness and Detail, higher resolution images have smaller pixels. Therefore, a 20-pixel brush width used in a 300 ppi image will be smaller than a 20-pixel brush width used on a 200 ppi image. The edge of the brush can be hard or soft, as the edge can be feathered to blend the color and weight being painted with surrounding pixels.

Because of the power and sophistication of current software such as Photoshop, the "paint" is every bit as flexible as the "brush." The applied paint can be opaque or semi-transparent, and it can even have shape and detail, as when the color specialist is **cloning**, which is exactly copying detail from one part of the image to another part of the image. The paint can be created from scratch or picked up from existing color in the image. We can create any tint or shade of the created or borrowed color with ease. And we can cause that color to interact with existing pixels in a variety of ways, based on the choice of Blending modes.

Color Correction Using Tool Work

Because this book is about digital color correction, the few examples of tool work are confined to this category. There are daily opportunities to practice the more prosaic uses of brush tools for janitorial and cosmetic purposes. I leave you to accomplish this practice on your own. In this section we will look at two approaches for tool-based color correction:

1. Painting a correction
2. Revealing a correction through a layer mask

We're going to work on Theresa Aldridge's digital photo of the street musician. In this image, there are some opportunities for tool-based color correction in the guitarist's face, neck, and fingers. We'll improve the neck and fingers by painting our correction.

Figure 9-8
This original digital photo of the street musician features some opportunities for improvement that don't lend themselves to either overall adjustments or selected adjustments via masking.

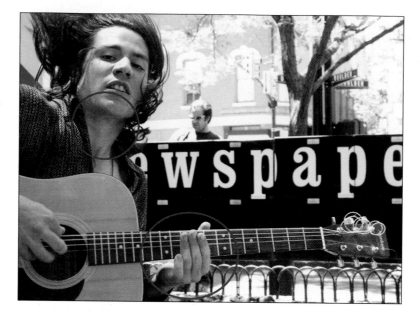

We'll reduce the hot spots on the forehead and nose by revealing a correction through a layer mask.

Painting a Correction

This technique calls for the alteration of color through good, old-fashioned painting. Because the area being treated is not conducive to masking, the correction is controlled through brush strokes.

Option A: A desired color is mixed as the Foreground Color "paint" and is applied in semi-transparent layers by the Brush Tool. As a finishing touch, some very localized sharpening is applied to disguise the work.

1. Open guitarist.tif in Photoshop.
2. Make a Duplicate Layer. Name this layer "Paint Correction."
3. Change to Actual Pixels zoom and center on the guitarist's neck. His neck has a reddish streak crossing his throat with a whiter streak above and below the red one. We are going to paint a more even, pleasing skin tone in this streaked area.
4. Using the Eyedropper Tool, sample the reddish color found in the red streak. This loads the reddish value into Photoshop's

Foreground Color swatch near the bottom of the Tool Bar.

5. Click on the Foreground Color swatch to launch the Color Picker. This window shows us the exact color of the sample, in this case 161R, 83G, 56B.
6. Reduce the red value to 150. Essentially, we are creating a skin tone as our "paint" that has a more pleasing balance to it. Choose OK.
7. Choose the Brush Tool from the Tool Bar. Choose a 15-pixel brush tip with a soft edge (by setting the brush tip Hardness to 75%). This creates a brush tip that is roughly the same width as the reddish streak and will hold the detail of the area being brushed, yet reduces the chances of edges being detected by feathering the brush stroke effects into the surrounding tones.
8. Set the Brush Tool Mode to Normal and the Opacity to 20%. Begin to paint the reddish streak as well as the whiter streaks above and below. Check the results after each stroke. Each stroke should coax a healthier skin tone into the targeted area.

9. Move to the fingers around the guitar neck and repeat the process.

Option B: A desired color is mixed as the Foreground Color "paint" and is applied using the Color Replacement Tool.

1. Open guitarist.tif in Photoshop.
2. Make a Duplicate Layer. Name this layer "Paint Correction."
3. Change to Actual Pixels zoom and center on the guitarist's neck.
4. Using the Eyedropper Tool, sample the reddish color found in the red streak. This loads the reddish value into Photoshop's Foreground Color swatch near the bottom of the Tool Bar.
5. Click on the Foreground Color swatch to launch the Color Picker. This window shows us the exact color of the sample, in this case 161R, 83G, 56B.
6. Reduce the red value to 150.
7. Select the Color Replacement Tool, which is the third option under the Healing Brush Tool (represented by the Band-Aid icon) on the Tool Bar.
8. Set the same brush tip values as the prior exercise. Consult the Photoshop Help pulldown menu for a complete discussion of Color Replacement Tool settings. For this exercise, choose Color as the Blend Mode, Once as the Sampling option, Find Edges to respect Unsharp Mask edge definition, and 30% as a workable Tolerance setting.
9. Paint over the offending reddish streaks in the neck. You should see an immediate blending of the raw neck colors with the more appealing adjacent tones.

You may not be satisfied with your initial results. That is why we work on a duplicate layer. Practice, practice, practice. Alter the size of your brush diameter from time to time and experiment with the edge softness and other brush controls. Brushwork is not easy. Expert brushwork takes practice, patience, and experience.

Revealing a Correction Through a Layer Mask

For the hot spots on the forehead and nose we are going to take a different approach. This second approach is very handy when you need to effect a color

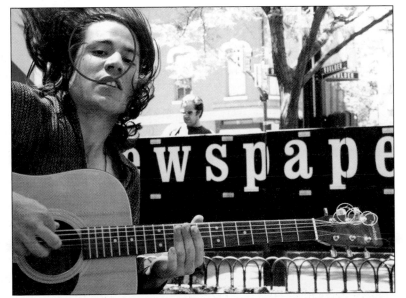

Figure 9-9
This image does not feature opportunities for a defined selection in reducing the highlight areas in the face. However, we can combine brushwork with layer masking and a Curves adjustment to improve these areas without leaving behind any evidence of our work.

correction in a vaguely defined area that does not lend itself to normal masking, where it would be difficult to disguise straightforward brushwork because of lack of image detail or the size of the area needing treatment (Fig. 9-9). Essentially, we copy a selected area to a new layer, apply a Curves adjustment to the entire selection, and then reveal the desired areas of the corrected selection through a layer mask (Fig. 9-10).

One advantage to this technique is that the brush does not impact the detail in the image. Since in this technique it is the mask that we will brush, not the image, there is less chance of evidence of the brushwork being apparent.

1. Open guitarist.tif.
2. Using the Rectangular Marquee Tool, draw a rectangular selection around the musician's head.
3. Edit/Copy the selection.
4. Edit/Paste the selection, creating its own layer.
5. Selecting this new layer, and deactivating the layer below it, choose Image/ Adjustments/Curves and increase the

weight in the highlight area, skewing the balance to a light beige (245R, 240G, 225B).
6. Reactivate the original background layer, keeping the layer with the corrected area selected.
7. Choose Layers/Add Layer Mask/Hide All. This will render your corrected area completely transparent, revealing the original image on the background layer.
8. Select the Eraser Tool, making sure the Background Color swatch is set to White.
9. Set the Eraser opacity to 20%. Set the pixel width to 30, making sure that the brush edge (the Eraser Tool is in fact a "brush" of sorts) is set to a soft value. *Warning*: This technique requires that the Layer Mask icon be selected in the Layers palette, not the icon representing the image on that layer. Simply single clicking the black rectangle representing the Layer Mask before brushing, just to be safe, ensures that this will be the case.
10. Begin to brush the overly light areas of the nose and forehead. As you brush, the layer mask, originally opaque, will begin to feature semi-transparent areas

Figure 9-10
This copied selection receives a Curves move (step 5 from the above procedure) to skew the entire selection to a heavier, beige-casted highlight. We only intend to blend certain parts of this selection with the original image information on the Background Layer.

Figure 9-11
The brushed Layer Mask with the brush tip size is indicated by the circular cursor. Note the small black Layer Mask icon on layer 1 in the Layers palette, showing the whitish, opened area of the mask. Only the parts of the corrected selection revealed by these opened mask areas interact with the original color data on the Background Layer.

wherever the brushwork is done. The upper layer's corrected areas will begin to be revealed. We are, in fact, allowing controlled portions of an overall correction from the upper layer to blend with the uncorrected lower layer (Fig. 9-11). Once we, or our customer, are satisfied, we can merge the two layers together.

The above examples barely scratch the surface of all that is accomplishable through tool work. Every instance of required tool work is a custom job. No two are exactly alike. The more practice and experience with brush tools we compile, the better we get at it. The rule of thumb is never to use tool work when selective correction will do, and never to use selective correction when overall moves will suffice.

Chapter 9 Summary

Tool work is the riskiest, and most time-consuming, of all digital color editing. Any correction is localized to the digital brush tip

and the stroke drawn by the technician. Manual drawing skills are invaluable to the success of tool work. Typically, tool work is reserved for dust and scratch removal, cosmetic improvements, and extremely localized color adjustments not conducive to normal masking techniques. There is no substitute for practice in this area.

Chapter 9 Review

1. Define what is meant by "tool work."
2. Cite three conditions that call for tool work as the correction of choice.
3. Cite an example in which digital "paint" features properties unavailable in conventional paint.
4. Cite four examples of visual evidence that poor tool work leaves behind.
5. Describe two different approaches for color correction using tool work.

10

Special Treatments

Chapter Learning Objectives

- Become familiar with common treatments used in digital photos
- Learn direct and effective methods to produce these treatments

There is no limit to the number of visual effects that can be applied to digital photos. Professional color specialists and hobbyists alike are always discovering cool ways to combine pixel alteration techniques to produce eye-popping results. A half-hour's cruise through sites selected by Google.com will lay out step-by-step methodologies for turning otherwise healthy people into zombies with rotting flesh dripping from their faces or house cats into armored, robotic war-waging machines.

As impressive as a lot of that stuff is, there are few opportunities where you get paid to turn a supermodel into a member of the undead or a house cat into a 25th-century tank. There are certain treatments, however, that are quite common. Because these effects are used so often, it is a requirement for employment as a color specialist that one demonstrate competency in carrying them out.

We're going to look at four such treatments in this chapter.

1. Duotones
2. Sepiatones
3. Euro grays
4. Drop shadows

The first three are all derived from grayscale information and rendered in Cyan Magenta Yellow blacK (CMYK), or custom colors, as they are largely print-based effects. The last effect is used in Web and print applications and can be carried out in Red Green Blue (RGB) or CMYK. In this chapter, we'll begin with one of Joe Esker's photographs and turn the image, successively, into a duotone, sepiatone, and Euro gray version of itself.

Duotones

The duotone is a special treatment that came into its own by taking advantage of the large install base of two-color offset presses in the printing industry. Customers whose budgets aren't equal to four-color press runs can nonetheless add visual interest and even emotion to the design of their print matter by combining a second colored ink with the normal black ink of a single-color press run. Designers and printers work corporate brand colors into printed pieces for headlines, tint boxes, logos, and photos. These second colors tend to contrast well with black ink and offer blending possibilities to create shades of the second color.

The duotone is just such a mix of a custom color, such as a Pantone formulation, with a process black ink, to create a photographic image with more visual impact than a black halftone itself is able to deliver. To follow along with the subsequent procedure, copy Fig10-1.tif from the CD to your desktop, and open it in Photoshop.

1. **Convert the image mode from CMYK to grayscale** (Image/Mode/Grayscale).
2. **Save As** to Fig10-1GS.tif to denote the file is a Grayscale, to follow along with the images in this chapter and to avoid altering the original.
3. **Convert the Grayscale image to a duotone** (Image/Mode/Duotone). The action will launch Photoshop's Duotone Options window. The pulldown menu in the upper left part of the window allows the selection of Monotone, Duotone, Tritone, or Quadtone, which are one- to four-color treatments

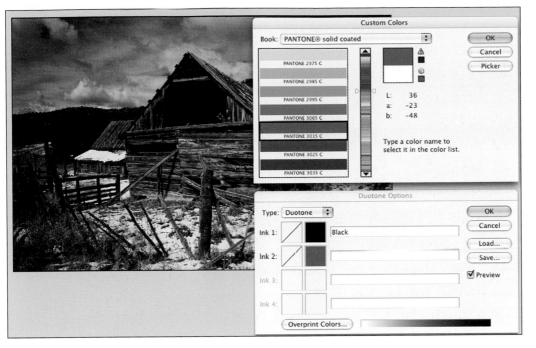

Figure 10-1
The duotone is perhaps
the simplest color image
and has proven quite
useful in adding the
impact of color to
images on basic two-
color press runs.

allowing any mix of up to four different inks. Choose Duotone.

4. Ink 1 will already be designated as Black. **Select the White swatch in the Ink 2 row,** just below the Black ink swatch. (If you or someone else has used the Duotone option previously since the Photoshop application was last launched, it will remember the Ink 2 choice from that last duotone, and the Ink 2 swatch will be colored instead of white.) This will launch the Custom Colors window associated with the Color Picker. We'll pick our color from the Pantone Solid Coated library. Using the slider to the right of the color chips column, cruise down to find Pantone 3015 C. Select this color, loading it in as Ink 2.

5. Our grayscale image has now taken on the appearance of a two-color halftone, or duotone. The trick with duotones is to make sure that the Black separation does not dominate the partner color, rendering the image a casted neutral rather than a presentable duotone. So, we have to shrink the size of the Black ink's dot percentages to allow Ink 2, in our case

Pantone 3015 C, to assert itself. **Select the little Curves graphic in the Ink 1 row to launch the Duotone Curve window.** Typically, I remove the Black ink halftone dot out of the highlight area of the image and have it appear in the quartertone. I do this by simply typing a 1 in the 20% field (reducing the 20% black dot to 1%) as shown in Figure 10-2, and I reduce the maximum value of the Black ink from 100% to 90%. The result is a shorter range black separation

6. **Save As** to Figure 10-1.eps. The EPS, or Encapsulated Postscript mode, is required to preserve the Pantone ink separation, protecting it from being converted to CMYK unintentionally. Our duotone is now complete, ready for placement into a document featuring the same combination of inks. The 3015 C ink gives the image a cold, dark, winter night mood that just is not possible in a grayscale image. Choosing a different secondary color would produce an entirely different effect, which is one of the appeals of the duotone technique.

Figure 10-2
This screen grab shows
the Black ink Curves
adjustment used to
ensure that the black
ink does not mute
the Pantone color.

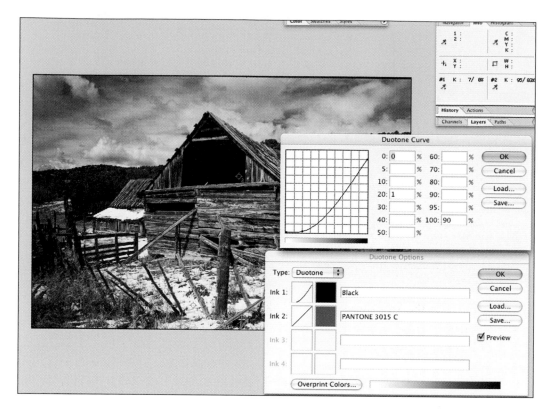

Sepiatones

Originally, sepiatoning was an accepted photographic process using dyes derived from the ink of Sepia cuttlefish, a marine creature related to squid. The result was a monochromatic image rendered in shades of brown, rather than black. The photographic processing related to this technique imbued the sepia prints with archival qualities superior to black and white, which explains why so many surviving photographic images from the 19th century feature this look. People find the sepiatone looks so agreeable on historical photos that, even when an original does not feature it, we are often required to produce it.

Perhaps the easiest way to produce a sepiatone is to create a duotone using Pantone 150C, a light orange color, with black. Unfortunately for us, more often than not the sepiatone look is used in combination with normal four-color process images in a magazine article or perhaps a textbook.

Therefore, it is useful to know how to create a believable sepiatone with some combination of the CMYK ink set, as those are the inks we are forced into using under normal circumstances. To best control the results during the printing process, we are going to use only the Magenta, Yellow, and Black channels for our sepiatone and remove all detail and value from the Cyan channel.

1. **Change your original file to Grayscale** mode. In this case, we'll simply open up Fig10-1GS.tif from our duotone exercise and use that same image.
2. **Select/All** to select the entire image. Then **Edit/Copy** to place a copy of the entire grayscale image on Photoshop's clipboard.
3. **Change the Grayscale file to CMYK** mode (Image/Mode/CMYK).
4. Making sure that your Channels palette is available, **select the Yellow channel and Edit/Paste** the original grayscale

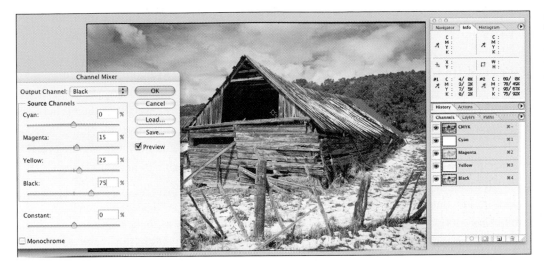

Figure 10-3

The sepiatone technique following details on how to mimic the results of photographic sepiatoning using Photoshop's Channel Mixer.

information into the Yellow channel. **Select/Deselect.**

5. In the Channels palette, select the CMYK combined channel. **Choose Image/Adjustments/Channel Mixer.** Channel Mixer is a very useful feature in Photoshop that allows us to take shape and weight from one channel and copy it into another, the better to restore shape where there is none, or, in our case here, to create the balance of weight and shape we need to produce the sepia effect from the highlight region all the way through to the shadow. This is done by selecting an Output channel, which is the channel receiving the pixel data, and adjusting the sliders of the Source channels, which are delivering the pixel data.

6. **Select Cyan as the Output channel. Slide the Source Cyan slider down to 0%.** This removes all Cyan data from the CMYK image.

7. **Select Magenta as the Output Channel. Slide the Source Magenta slider to 62%.** This reduces the original Magenta data to 62% of its original value and mitigates the pinkish cast to the sepia balance. Don't panic if your image appears orange.

8. **Select Yellow as the Output channel. Slide the Source Yellow slider to 70%.** This reduces the Yellow channel's value to 70% of the original grayscale data that we copied into that channel. Your image should lose its orange cast and begin to appear agreeably brown.

9. **Select Black as the Output Channel. Slide the Source Magenta slider to 15%, the Source Yellow slider to 25%, and the Source Black slider to 75%.** These adjustments takes full advantage of the shape and weight of the Magenta and Yellow channels in supporting the lighter values in the black and in replacing the data from the Black channel itself as that was reduced. The image should now display the sepia effect desired (Fig. 10-3). Depending on your printing methods, the numbers cited above may require tweaking.

Now, you can also use Photoshop's Photo Filter option on your RGB image to achieve this effect, but be aware that when you, or your output device's raster image processor (RIP), convert your RGB file to CMYK, your sepiatone will be rendered to CMYK, not YMK. This may or may not be a big deal in the world of digital printing, but

in analog printing such as offset or flexography, any reduction of variation through simplifying an image will result in more predictable press sheets.

Euro Grays

This technique that came to be called Euro Gray was borrowed from a German fashion magazine. That magazine cover featured a rich, shimmering neutral image with a violently pink banner text. The saturated pink color contrasted wildly with the controlled balanced feel of the image, which just looked too three-dimensional to have been reproduced with black ink only. I bought the magazine to bring home an edgy European fashion rag for my kids and also to put that cover under the magnifying glass and figure that neutral out.

As it turned out, the rich, shimmering neutral was created using standard CMYK inks on a glossy, enamel cover stock. The black separation dominated with a full-range black image from highlight to shadow. Underneath the black was a balanced set of cyan, magenta, and yellow separations that were constrained to less than half the weight of the black separation. The violently pink banner text was 100% magenta only. Clearly the press operators were able to maintain a high density level of magenta ink for the pink text without throwing the image into a pinkish balance, as the constrained magenta percentages in the image were dominated by the neutralizing effect of the dominant black ink and the balancing effect of the cyan and yellow inks. Brilliant!

So, to the Euro gray process itself, you'll recognize that this process is quite similar to the sepiatones process, again using Channel Mixer to build a CMYK combination from an original grayscale file (Fig. 10-4).

Figure 10-4
The Euro gray is created using a full range black separation. The cyan (C), magenta (M), and yellow (Y) separations are all rebuilt by Channel Mixing out all of the original CMY information and replacing that data with reduced copies of the Black channel.

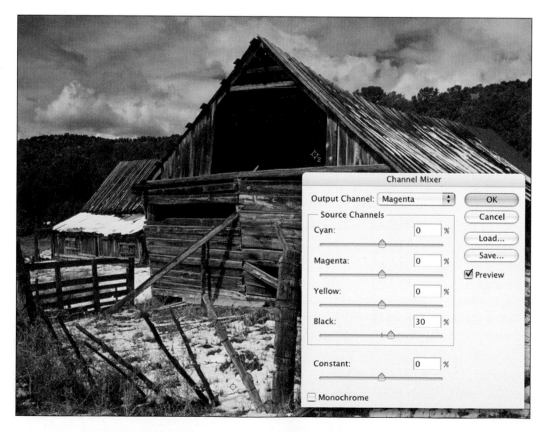

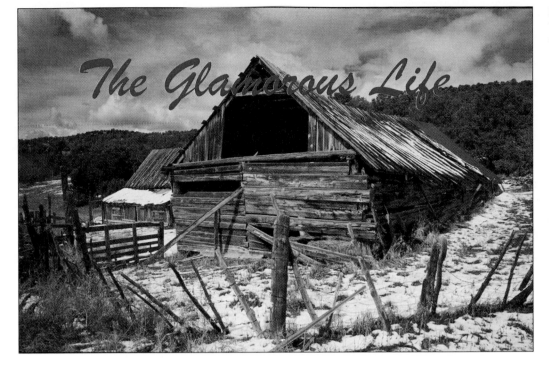

Figure 10-5
The finished Euro gray with accompanying text.

1. Again, we need to **begin the process with a grayscale file.** So we'll use Fig10 1.GS.tif.

2. **Select/All** to select the entire image. **Edit/Copy.**

3. **Image/Mode/CMYK** to convert your file from grayscale to four-color process.

4. **Select the Black channel** in the Channels palette. **Edit/Paste** the original grayscale information into the Black channel. **Select/Deselect.**

5. **Select the CMYK combined channel** from the Channels palette and choose **Image/Adjustments/Channel Mixer.**

6. **Select Cyan as the Output Channel.** Set Source Cyan to 0% and Source Black to 40%.

7. **Select Magenta as the Output Channel.** Set Source Magenta to 0% and Source Black to 30%.

8. **Select Yellow as the Output Channel.** Set Source Yellow to 9% and Source Black to 30%.

9. **Select OK.**

10. **Choose Image/Adjustments/Curves.** Reduce the CMY Quartertone by 5%. Reduce the Black midtone by 10%.

11. Voila! Euro gray. To get the effect of the magazine cover described above, simply set some text in the CMYK file in a large bold typeface and color that text 100% magenta (Fig. 10-5). You can also skew the color balance somewhat by increasing the Source Black number for whichever channel you would care to emphasize. For instance, increasing the value of the Cyan Output channel with the Source Black can help bring a slightly more metallic look to the image.

Drop Shadows

Silhouetting an object, which is removing that object from its surround, and adding a drop shadow to ground the object is an everyday occurrence in the graphics world. Because it is done every day does not mean

Figure 10-6
Notice the difference in weight and shape to the shadows cast by the ceramic vase and the drinking glass. The multiple overlapping shadows suggest multiple light sources.

that everybody does it well. Again, a bit of artistic sensibility and a certain amount of informed judgment is required. Creating a drop shadow for an outlined image in Photoshop is a very quick thing to do and is automated without much difficulty. Creating a *realistic* drop shadow is another thing entirely.

Start noticing shadows as you go about your daily business. Look at their shape, their general weight, and how their edges fall off or gradually fade away. Is there a difference in darkness in the part of the shadow closer to the object than further away? How does a raised area above a surface affect the shadow? How does the angle of the light source or the distance of the light source from the object affect the shadow? Does the size and mass of the object have an effect?

Any object, such as a product or a person, removed from its surround and placed against white paper appears to be floating.

Viewers find the object more believable and interacting in a stronger manner with other graphics such as text and tints if that object is "grounded" with a drop shadow.

The drop shadow implies all of the following:

- A surface that the object is resting or standing on
- A light source
- The angle, strength, and distance of that implied light source
- The mass and even the opacity of the subject

The Implied Surface

A poorly executed drop shadow can have a jarring effect on the viewer and imply other surfaces, such as walls, that don't make visual sense. To "ground" an object is to create a drop shadow that implies a horizontal plane on which the object rests. The shadow, then, needs to be roughly

horizontal, rather than vertical, to suggest the surface on which it is cast.

The Implied Light Source

A shadow is created when an object interferes with light projected toward a surface. The shadow takes on the shape of the interfering object, *from the perspective of the light source*, not the perspective of a viewer. The direction, length, and weight of the shadow all tell us about the light source. The shadow is cast 180° from the light source, or directly opposite to it. The length of the shadow implies the height of the light source above the object. Small, tight drop shadows imply a light source directly above the object. Long shadows suggest a low light angle.

Dark shadows with harder edges suggest an intense beam of light, generally closer to the object. Lighter shadows with soft edges suggest a softer light source, or more distance between the light source and the object.

The Object

Opaque objects throw darker shadows than objects with a transparent quality. An object that permits some light through while blocking other light acts as a filter. Therefore, the drop shadow needs to reflect the characteristics of the object. So, if we are creating a drop shadow for a clear glass bottle of beer, the shadow should take on a casted value of the color of the beer itself. A neutral shadow will not appear to belong to a colored transparent object.

Examine the shadows in Figure 10-6. The two objects in the image cast very different shadows. The ceramic vase is opaque and blocks light; and the drinking glass is mostly transparent, blocking some light and letting other light pass through. The vase is taller and has more mass than the drinking glass.

It makes sense that the character of each shadow is unique.

What are the shadows telling us about the light source or sources? The shadows being cast are to the right and forward of the objects, but are not nearly as long as the objects are tall. We can infer that the light source is above, slightly behind, and to the left of the objects. Because both objects seem to be casting several shadows that differ in direction and overlap each other, we can infer that there are multiple light sources fairly close to each other, as in this photo shoot. A standard three-bulb kitchen chandelier lit the objects in this image.

Look closely at the base of the ceramic vase where it meets the sheet of paper. The thin sliver of dark shadow grounds this vase to the surface on which it rests. Many drop shadow creators miss this little detail. Also, notice that there is really no indication of the neck or the mouth of the vase in the shape of the shadow. Though we can see those details from our perspective, if we were looking at the vase from the perspective of the light source, those details would be centered within the mass of the object, not profiled as we view the scene. The shadow cast in this photo has no residual indication of a thinner neck or mouth. It only reflects the roundness of the vase itself.

A Drop Shadow Exercise

We're going to recreate a drop shadow for the ceramic vase from Figure 10-5. We'll use the shape of the shadow from the original, but create a new shadow from scratch. Let's begin by looking at a couple of unconvincing drop shadows. The first example shows the basic Layer Styles Drop Shadow so often used for product shots in newspaper inserts and catalogues (Fig. 10-7). This shadow is unconvincing because it casts the shadow against an implied wall, rather than a horizontal surface.

Figure 10-7
This shadow is fast and
fairly automated and,
therefore, popular.
However, it fails to
"ground" the object
"casting" it.

The second example shows a shadow cast
in the same direction as the original photo's
shadow (Fig. 10-8). The shape of the object
is evident, too evident actually. The shape of
the shadow is rendered from the outline of
the object from our perspective, not that of
the light source. Also, there is no dark line

Figure 10-8
This shadow is
somewhat improved
on the first, since it
does imply a believable
surface. The object is
still "floating"
somewhat and the
shape is incorrect
from the perspective
of the light source.

where the vase rests on the implied surface,
so the vase is still "floating" to some extent.

Follow along, step by step, with the
following exercise, and we should end up
with a drop shadow that brings the
reviewers to their feet, cheering wildly.

1. **Open file Fig10-06.tif.**
2. **Crop the ceramic vase from the entire image,** making sure to include the original shadow as well as the vase.
3. **Save As to Fig10-06crop.tif.** Cropping the original reduces the file size, thus speeding up all subsequent work. Saving As to a new name protects the integrity of the uncropped original.
4. **Create a Duplicate Layer of the Background Layer,** naming this layer Working Layer for organizational purposes. Keep this layer active for now.
5. **Select the Pen Tool.** Make sure the Paths icon is selected in the Pen Tool Control Strip. Cut an outline path around the edge of the ceramic vase, using the control point Bezier handles to create smooth curves to follow the shape of the vase accurately (Fig. 10-9).
6. Go to the Paths palette and, from the Paths palette pop-up menu, **Save your Work Path.** No complex Pen Tool Work Path should go unsaved or it may need to be redone at a later point. Name this path Outline.
7. Again, from the Paths palette pop-up menu, **choose Make Selection.** Set the Feather field to 0, to create a hard edge on your selection. From the Select pulldown menu, choose Save Selection. Name this selection Outline, to mentally link it with the path of the same name.
8. From the Select pulldown menu choose **Inverse.** Making sure your Background Color is set to White, hit the Delete key on your keyboard. You should not

see any apparent change. Return to the Layers palette and turn off the Background Layer view. You'll now see that the vase's surround has been rendered transparent, but only on the Working Layer. Select/Deselect, to turn off the Outline selection.

9. From the bottom row of icons on the Layer palette, choose **Create New Layer.** This will create Layer 1 on the top of the layer stack. This layer will be blank and fully transparent. **Rename this layer Shadow Layer.** Hold down your cursor on the Shadow Layer and pull it in between the Background Layer and the Working Layer.

10. Turn off the Working Layer View. Select the Shadow Layer. **Choose the Pen tool and cut a smooth work path around the shape of the original shadow** (Fig. 10-10). Save this path as Shadow. From the Paths palette pop-up menu, choose Make Selection. Feather this selection 5 pixels.

11. Set Foreground color to 80% Black only via the Color Picker. **Choose Edit/Fill and fill the Shadow selection with the Foreground color.**

12. **Activate the Working Layer view,** which shows the silhouetted vase in relation to our Shadow selection (Fig. 10-11). **Deactivate the Background layer.**

13. What we want to do now is create a layer that serves visually as the "paper" on which our silhouetted vase with Shadow will print. This will aid us in judging the weight and fall off of our shadow as we further adjust it. **Select the Create New Layer icon again, name this layer "paper" and move this layer so that it sits above the Background layer but below the Shadow layer in the layer stack.** Making sure this Paper layer is active, **Select/All and Edit/Fill with White** (Fig. 10-12).

Figure 10-9
Our cropped vase showing the Outline selection marquee.

Figure 10-10
The selection tracing the original shadow from the photo.

Select/Deselect to make the marquee go away.

14. Choose the Shadow layer. Click the Add Layer Mask icon at the bottom of the Layers palette. Making sure that the

Figure 10-11
The Working Layer and Shadow Layer only is visible. Our drop shadow in progress is the filled selection.

Foreground/Background colors are set to the Black/White default, choose the Gradient tool. Drag your cursor from the very bottom of the image to slightly above the top of the drop shadow. You will notice that now your shadow has a

graduated weight to it that is darkest near the vase and lightest in the foreground.

15. **Click on the Layer Thumbnail on the Shadow Layer. Choose Filter/Blur/ Gaussian Blur and set the Radius value**

Figure 10-12
The work in progress with the paper layer inserted into the Layer stacking order. As the number of layers increases in any Photoshop file, the color specialist is required to pay close attention to make sure that she is not trying to edit information on one layer while a different layer is actually selected.

Figure 10-13
Your finished piece
should look like this.

to 8 pixels. This further blurs the edge of our shadow, rendering it more realistic.

16. Now comes the coup de grace, the thin additional shadow immediately where the vase rests on the implied surface. This is the most challenging part of the exercise, as some manual brushwork is required. **Choose Select/Load Selection and choose the Outline selection previously saved in this procedure. Select/Inverse. Choose the Brush tool.**

17. **Set the Foreground/Background swatches at the bottom of the Tool**

palette to Default. Set the Brush Mode to Darken and the Opacity to 30%. Set the Brush width to 50 pixels and the Hardness to 0.

18. **Begin to brush along the bottom of the vase.** Use a single continuous brush stroke the entire width of the bottom of the vase, *keeping most of your brush tip above the selection marquee.* This technique blocks most of the brush stroke, except for a fine line along the vase bottom.

19. **Make a shorter second stroke, inset a bit on both ends from the original**

stroke. Again, make a single continuous stroke with most of the tip above the selection marquee.

20. **Make a third, shorter stroke, inset on both ends from the second.** What we are doing is building the thin shadow where the vase rests on the surface using three consecutively shorter strokes, creating a believable, gradual, fine dark line below the object. If you aren't happy with any of your strokes, just back up one History State on the History palette and try it again. Once this is completed choose Select/Deselect to close the selection marquee.

21. At this point, you may well be satisfied with your shadow. In that case, you're done (Fig. 10-13). If the shadow is close, but just needs a little tweak, choose the Shadow layer, click on the Shadow layer thumbnail, and launch the Curves palette. A simple midtone increase or decrease can do wonders in terms of perfecting your work.

Choosing the Working layer and brightening the vase via a Curves adjustment might be in order as well.

Chapter 10 Summary

Certain visual effects are so common in print advertising that it becomes a requirement for employment to master these effects. They include, but are not necessarily limited to, duotones, sepiatones, and drop shadows. Automated drop shadow techniques rarely satisfy. It is incumbent that the drop shadow look natural and properly ground the image to an inferred surface.

Chapter 10 Review

1. What is the single biggest reason for the popularity of the duotone technique?
2. What characteristics do people associate with a sepiatoned image?
3. Which channel carries the most information in a Euro gray?
4. Cite three characteristics of a light source that a drop shadow implies.

Color Correction vs. Color Management

Chapter Learning Objectives

- Recognize the difference between the terms "color correction" and "color management"
- See how each term has its place in the color reproduction process
- Learn how color-managed contract proofing best predicts the printed result of the corrected image

11

This book goes to some lengths to describe various attributes of a successful color image and details evaluation and correction strategies to achieve that optimized state. For the most part, we studied correcting images in their original Red Green Blue (RGB) mode. The hobbyist and home photographer never needs to reprocess the image out of its RGB state to successfully print it to a desktop color printer. The desktop printer's software transforms the image from RGB to the printer's Cyan Magenta Yellow blacK (CMYK) space, and most people never even think about it.

The professional color specialist, however, is called on to process the file from its RGB state to a CMYK state for a variety of different printing conditions. All the hard work involved in polishing these images digitally can be for naught if the translation from RGB to CMYK is not accomplished in a controlled, informed manner (Fig. 11-1).

Perhaps the biggest challenge in all of color reproduction is the transformation of the RGB digital file into the CMYK printing color space. The elephant in the room is simply this: we can view millions of different colors on a digital display, which expresses color in the red, green, blue additive color space. We can print only five to six thousand of those colors in the subtractive CMYK space under the most controlled conditions on a sheet fed offset press using a very white, coated stock and quality inks. As soon as we switch the technology to digital toner printing or flexography, we lose even more colors. The wide format inkjet device is probably the widest of the color gamuts, and even that does not approximate RGB capability. So, most photographic images show colors in RGB than we can't reproduce in CMYK. It just isn't in the CMYK capability.

What is a color technician to do? The best answer is to fully understand the process. With a full understanding of the color reproduction process, you can best direct the sacrificial transformation from RGB to CMYK. We must accept that we lose color variation from RGB to CMYK. Knowing what is possible, as

Figure 11-1
This comparison shows the different size of three color gamuts, the largest being the Adobe RGB space and the smallest being a generic SWOP CMYK print space. The center space is the Epson 10600 inkjet space on premium glossy paper.

opposed to what is wishful, is our starting point.

Color Management 101

The topic of color management is not fully explainable in one chapter. In fact, I recommend Abhay Sharma's *Understanding Color Management* as a comprehensive examination of the entire topic. It is no longer possible to fully understand the workings of any of the Adobe applications without a basic understanding of color management. The most glaring weakness of the GNU Image Manipulation Program (GIMP) software is its lack of color management capability. For the sake of this book it's important to review how the color-managed process ensures the best reproduction of the corrected color image.

Color correction is the informed adjustment of images to bring them into a state of visual optimization. **Color management** is the informed control of the entire color reproduction process, from input through output, using specialized measurement devices, software, control elements, and practices. It's meat-and-potatoes process control. One of the strongest features of color management for the color technician is that it is *the* method of bringing the visually optimized image into a printable, optimized condition. And by that we mean the best representation of the image possible within the constraints of the process.

The management of any color process requires:

- **Identifying** all devices involved in a given process
- **Calibrating,** or putting all identified devices into an optimized running condition
- **Characterizing,** or collecting data on all devices in that calibrated state

- **Converting,** or using that characterized data to shape color images and documents to best conform to the given process

Let's expand on each one of these four points.

Identifying Devices

Even the home hobbyist who prints his own pictures engages in a color process that uses three different devices: camera, computer, and printer. Each of these devices needs to behave in a repeatable fashion for there to be any hope of controlled, predictable results. The beginning of any color management process is to identify which devices will be used in a given workflow because all of the subsequent work in color management is based on specificity. You can't create a color management system for any series of devices or exchange any one of those for a different brand or make of device and expect the reliability of your results to remain unchanged.

Calibrating Devices

Once all devices are identified, each single device needs to be put into a calibrated condition. Specifically, a calibrated condition is a known, achievable, recorded, and verifiable state where the device itself and the types of materials used in conjunction with that device are adjusted to run within either industry- or shop-specific tolerances.

Let's examine a desktop printer and a multicolor analog printing press. The desktop printer is pretty much a self-contained device equipped to deliver reliable color images when:

- One of a variety of acceptable papers is used.
- The ink cartridges are dispensing the correct amount of ink.

Figure 11-2
The initial instructions for calibrating an HP PSC 1200 desktop color printer.

Figure 11-3
The HP PSC 1200 prints this calibration sheet which the user then scans back into HP's All-In-One software for a registration check.

- The ink nozzles are aligned to print in register.

The desktop printer runs a calibration routine when new ink cartridges are loaded or when the user invokes the calibration routine (Figs. 11-2 and 11-4). This automated routine corrects any out-of-calibration issues using test forms and sometimes scanned data from a printed sheet (Fig. 11-3).

The analog multicolor printing press is a different animal. Just getting substrate in the form of precut sheets or a continuous roll (known as a web) through a large press takes a certain amount of skill. In addition to the press and the stock, there are:

- The inks themselves
- The ink delivery and metering systems
- The plates
- The impression settings for all the various rollers
- The dryers
- The running speed of the press
- Any inline finishing systems

When we refer to a certain printing condition, we are referring to the press and all the collateral components that make up the entire complex process. Nonetheless, any and every printing condition is measurable, recordable, controllable, and reasonably repeatable. In fact, it has to be that way, or color management would not be possible. No matter the complexity of the process, it needs to be understood, repeatable, and verifiable from day to day and week to week and by different operators working different shifts.

A common misconception is the thought that calibrating a given device means aligning that device to all other calibrated color devices. This is not the case. Calibrating a device means securing that device into its own optimized condition, its sweet spot, which may or may not align closely with the sweet spot of other devices.

Characterizing Devices

Once a device has been calibrated, the next step in the color management process is to characterize it. This process is accomplished on different devices by different means. Input devices such as cameras and scanners capture an industry standard color chart and then rely on color management software to evaluate the captured image. A monitor characterization routine uses a colorimeter attached to the monitor screen to record a series of different colors flashed into its

optics (Fig. 11-5). Printers and proofing devices print an industry standard chart such as the IT8, which is measured using a spectrophotometer (Fig. 11-6). All these characterization routines order measured color data into tables. These tables are converted to equivalent CIELAB (LAB) values for each color analyzed, and those LAB values are mapped against the original LAB values of the standardized chart data.

The result is an International Color Consortium (ICC) profile. This ICC profile is a data file describing the particular device's ability to express color. This ICC profile can be graphed as a three-dimensional color gamut using Apple's Colorsync Utility or just about anybody else's color management software. The ICC profile is then distributed to all users and copied into system level folders for software, such as the Adobe Creative Suite or a particular color raster image processor (RIP), to access them.

ICC profiles are embedded into color images as part of the normal color management workflow. The annoying Profile Mismatch window that pops up when opening certain color images in Photoshop is Adobe's way of telling you that the file's embedded profile disagrees with whatever Working Space profile you have invoked through the Color Settings menu, and that you have a decision to make. You can keep the embedded profile as is, change it to agree with your Color Settings, or disable the color management process. The best advice for those with little color management training is to respect the embedded profile and convert from there to the specific output device's color space.

Converting Color Data

Every device, from the original digital camera, slide, or color negative to the final print mechanism, has its own specific color space. As a color-managed image moves through the color process from device to device, it is transformed and altered to best take advantage of the capabilities of the specific color devices. In a normal commercial or even packaging print process, the original RGB camera and computer display image ends up as a CMYK version.

Figure 11-5
A colorimeter is positioned to analyze RGB data emitted from the computer display to build an ICC profile for that particular display.

The conversion process in a color-managed workflow takes full advantage of the device profiles of the RGB camera (or computer working space) and the CMYK press. Because ICC compliant software is able to compare two different profiles, it can compute the most accurate transition from any given color in the original, or source, space, to the intended or destination space. Using LAB space as the central hub, software on the color technician's workstation or an output device RIP transforms the RGB data to LAB data and then to CMYK in a controlled, optimized fashion, using the data in the pertinent ICC profiles. This method assures that the CMYK device will print the closest color of which it is capable to reproduce for any given original RGB color.

UCR and GCR

The conversion of any digital image from RGB to CMYK creates a new channel, or separation, namely the black. How much of the original image's data needs to be in this black separation has been a hotly

debated topic in the printing world for decades. Traditionally, the job of the black separation in a CMYK set has been to support detail and shadow weight in the image. Because black ink is significantly less expensive than colored inks, people have looked for ways to save money in the press run by extending the amount of black ink in the image and decreasing cyan, magenta, and yellow. The trick has been to do so with no damage to the visual impact of the image.

At the same time, with CMYK's four separations, each separation featuring a dot percentage range from 0%–100%, it is theoretically possible for the darkest shadow portion of the image to feature as much as 400% Total Ink Coverage (TIC), or 100% of all four inks overprinting each other. This has proved to be undesirable because of a variety of print quality problems that an overabundance of overprinted inks creates. These problems include ink drying issues, loss of shadow detail, and offsetting (or ink from one sheet transferring to the back of a subsequent press sheet). Test forms used for

Figure 11-6
This photo composite shows a color gamut comparison superimposed on the IT8 chart from which the smaller of the two profiles was made. The IT8 chart was printed on an offset press in a calibrated condition complying with SWOP guidelines. The printed chart was then measured by a spectrophotometer and the results analyzed by color profiling software. The resulting ICC profile can be displayed as a 3-D model, commonly referred to as a color gamut. The larger white space within which is contained the SWOP profile is the Adobe RGB color gamut.

Figure 11-7
This Maximum Black/Total Ink Coverage control element is a useful component of a press fingerprinting layout. A magnifier and a densitometer are required to analyze the printed outcome of this control element. Values for Maximum Black and Total Ink Coverage are required data for the creation of a successful press profile.

the press calibration process will contain a control element for determining the optimal TIC number, which changes based on the type of press and the quality of the stock. For instance, newsprint color uses a TIC between 240% and 260%. Commercial offset printing uses TIC between 280% and 320%. The CD included with this book includes one such Total Ink Control Element and instructions for its use.

There are two general strategies for controlling the creation of a black separation and the TIC value: UCR and GCR. The acronym UCR stands for under color removal. A UCR black separation is short range, meaning that the presence of black ink is limited between the quartertone and the shadow, with the black constrained to shoring up the darker neutrals and darker colors.

GCR, or gray component replacement, creates a full-range black from highlight to shadow with the black not only dominating the neutrals but also supporting shape and detail in all colors as well, not just darker colors.

Creating an ICC profile during the Characterization step of the color management process requires a decision on whether to use UCR or GCR as the conversion strategy of choice. In addition to this decision, the profile creation software also needs to know what TIC value is required *and* what the Maximum Black portion of that TIC value will be (Fig. 11-7). Maximum Black is the highest percentage value of black ink that is wanted as the absolute shadow limit. We've discussed earlier in this book how 100% black ink is undesirable for the shadow detail in a printed image. Part of the Total Ink Control Element Evaluation is the identification of the proper Maximum Black, and is included in that element's instructions on the CD.

Which strategy should one use: UCR or GCR? Again, that is one of those questions with the answer, "It depends." I have devised a mnemonic for my students, which is useful in making the UCR/GCR decision, based on my own experience regarding the strengths of each. The mnemonic is based on the query, GCR: True or False? If the subject matter of the images can be categorized in any one of several classifications starting with the letter T, standing for True, than we go with GCR. If the subject matter of the images can be categorized in classifications beginning with the letter F, for False, then we use UCR.

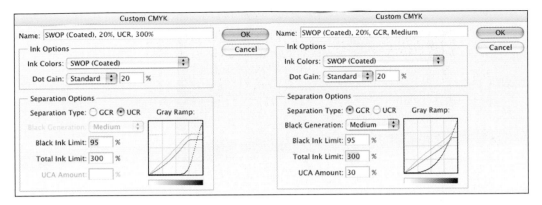

Figure 11-8
A comparison of normal Photoshop settings for custom UCR and GCR CMYK profiles. Note the graphs in the lower right of each window. The GCR graph shows a fuller black curve with reduced, flattened values of cyan, magenta, and yellow.

The following are some subject categories agreeable to GCR treatment (Fig. 11-9):

- Tools
- Technical
- Toys

The following are some subject categories agreeable to UCR treatment:

- Fashion
- Flesh
- Food
- Fine Art
- Fabrics

I stated earlier that the GCR black separation is full range affecting everything from highlight to shadow, including all neutrals, where the black ink dominates the other inks, to shape in colors, where black ink actually replaces the third, or unwanted, channel in the color mix. My experience with

Figure 11-9
A collection of objects that respond agreeably to GCR treatment.

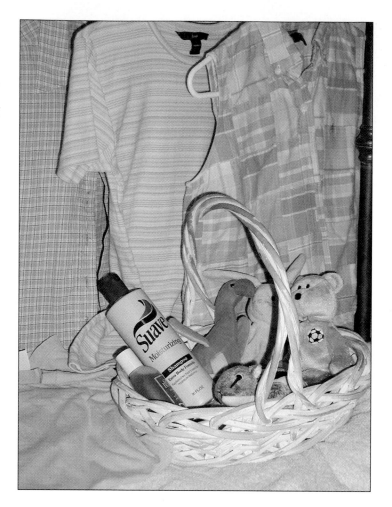

Figure 11-10
An example of the type of subject matter at an elevated risk with GCR treatment, because of an unavoidable graying of the softer pastel colors if the black unit on press features any untoward dot gain.

tool or toy catalogs and technical product matter (computers, circuit boards, etc.) is that the abundance of metallic items have the common occurrence of dark black elements (toy wagon or car wheels, hammer heads, etc.), and the saturated primary colors of these categories are agreeable to GCR treatment. These are hard items as a rule, with little subtlety required for color transitions.

The UCR categories feature noticeably softer subject matter. Pastel colors are difficult to control with a high percentage of black ink in the mix such that can tend to tip those colors toward a gray, rather than whatever softer hues are required (Fig. 11-10). Very dark shades of color can also blacken and lose their color cast because

of the dominance of the GCR black separation. GCR skin tones on press can take on the "raccoon-eye" look or the "Fred Flintstone 5 o'clock shadow" if the black ink gains more than is desirable, again because detail and shading in GCR separations is dominated by black (Fig. 11-11).

Color Management in Practice

We use color management practices to shape the color data in the original image through the scanning or digital camera process. We use color management practices to best display the image on our computer monitors. We use color management practices to proof our corrected work. Finally, we use color management practices in sending our color images directly to a

Figure 11-11
I shaved the morning this picture was taken, but you wouldn't know it from the GCR black separation on the right. Since most image detail is carried in the black channel in a GCR CMYK treatment, skin tones can be at risk of any black inking issues on press. The black separation on the left is a UCR black. Note the absolute absence of black information in the lighter areas of the image.

digital press or printer, or in creating the plates that are required for an offset or flexographic press run.

There are many out there who think that this process takes care of any flaws in the original color image intended for reproduction. Somehow, they assume, color-managed processes automatically evaluate all images and correct all shortcomings along the line somewhere. This idea is unsubstantiated by any real experience with color-managed workflow. The control of the color process results in the integrity of the original color data being reproduced *as faithfully as is possible* from one end of the process to the other. So, if a flat, pinkish, soft image goes into one end of a properly color-managed process, a flat, pinkish, soft image is what will come out the other end. Every time.

Note the emphasis on the phrase, "as faithfully as is possible." That phrase is not worded, "as a perfect match," for a reason. If I had a dollar for every minute in any given year that color reproduction professionals

struggle to make novice color buyers, sales staff, and others understand how large portions of the RGB space contain colors out of reach of the CMYK space, and that the reason these colors are out of reach has nothing to do with malice, incompetence, or laziness on the part of prepress or press operators, I could comfortably retire.

In addition to device gamut size differences, the color reproduction process, like any process, features variation. There is variation among devices and technologies and there is variation within a single device. There is a maxim well known to those who study the entire color process: a press can't even match itself. Within an entire press run, no two impressions (press sheets) pulled randomly from two different times in the run will perfectly match each other. There are just too many variables involved, not just within the mechanism of the press itself, but in ambient influences such as temperature and humidity.

A healthy working relationship between those who produce color images and those

who buy them begins with the understanding that exact visual matches between original photos and the press sheet are impossible. From that starting point an agreement can be reached as to how much variation is acceptable. The processes of color measurement and color management allow us to put numbers to allowable variation and to measure whether we are indeed within that agreed upon range.

The Contract Proof

In the commercial printing industry, and the flexographic and gravure industries as well, the cost of running a press dictates that the client approve all design, layout, and color correction work before plates are made and mounted and the press is fired up. The **contract proof** is the client approval mechanism in such a process. Just like any other contract, the signatures of both parties, customer and printer, have a certain meaning. The signature of each party signals a certain promise.

The printer (or prepress house in certain cases) is signifying:

- The proof was created from the current version of the document; the same document from which plates will be made.
- The proof is an accurate prediction of the press condition.

The customer is signifying:

- Satisfaction with the proofed image in every respect.
- A promise to buy all press sheets that look like the contract proof.

The definition of a contract proof differs depending on who is doing the defining. The bottom line definition of a contract proof is that it is whatever the client is comfortable living with. We work in an industry where proofing device or proofing material manufacturers believe it is their job to define the contract proof. In some cases,

the printer believes it is his responsibility to define the contract proof. The manufacturers and printers debate whether the contract proof needs to feature the same halftone dots or stochastic screening that the plates will feature, or even whether the proof needs to be imaged on the same device that will image the plates. If the client, who would be the person paying the bill, is comfortable with an inkjet proof over a more expensive laser ablation proof, then the case is closed.

In the digital print world, a contract proof is simply a press run of one on the digital presses that will run the job. Nothing could be simpler or more accurate. Did the client sign off on the proof? Hooray! Now go back to the digital press and run 2,000 more of the same.

In all workflows where an off-press proof needs to accurately predict an on-press outcome, a proof that has the following four characteristics will be a strong contender for the client's definition of a contract proof:

1. Substrate agreement
2. Colorant agreement
3. Dot gain agreement
4. Color gamut agreement

Let's look at each of these characteristics individually.

Substrate Agreement

Substrate agreement is a strong visual similarity, in substrate color, brightness, and finish (reflectivity) between the contract proof's substrate and that of the press run. Some proofing devices simplify this process by imaging the digital file to a transfer sheet that is then laminated to a single sheet of the actual stock reserved for the press run (Fig. 11-12). This method is highly flexible as the transfer sheets can be laminated to board stock, film, or foil with a preprinted opaque white ink as well as more common coated and uncoated papers.

Figure 11-12
The Latran Prediction Proof is a laser ablation contract proofing system that can image to a transfer sheet which is laminated to the actual press stock for perfect substrate agreement. Laser ablation technology explodes colorant from an ink sheet to the transfer sheet by superheating a thin aluminum layer sandwiched between the ink sheet's ink layer and its carrier layer.

When this transfer method is not an option, some proofing devices are available that can print directly on the same press stock as the press. Often, this pertains to uncoated stocks only. For instance, an inkjet device can be calibrated to proof on an uncoated offset stock (Fig. 11-13). However, the clay used in the coating process renders coated offset stocks unusable in an inkjet device. There is an interaction between the offset coating and the inkjet ink that is ruinous for the image. You can watch test inkjet proofs on coated offset stocks brown up and desaturate before your very eyes.

Finally, there is the combination of certain stocks manufactured strictly for proofing purposes, in conjunction with finishing options, such as matte or deglossing finishes, that are designed to very closely resemble an intended press substrate. In this instance, the substrate agreement is between two different substrates: one for the proof and one for the press. Substrate agreement is measurable with a spectrophotometer, which can compare the measured LAB values of the proofing stock to the LAB values of the press sheet and compute the DeltaE, or straight-line difference, between the two.

Colorant Agreement

Unless we create the contract proof on a press, the chances are high that we will print with a certain type of colorant, namely ink, and proof with a completely different colorant, such as an ink sheet, colored laminate, inkjet ink, or even toner. For the proof to act as a contract proof, the colorants of the proof need to very closely emulate the colorants of the press run.

Proofing system manufacturers go to great lengths to match their ink sheet and laminate colorants to printing industry standards and guidelines such as Specifications for Web Offset Production (SWOP), Specifications for Newsprint Advertising Production (SNAP), and General Requirements for Applications in Commercial Offset Lithography (GraCOL). Typically, inkjet devices feature CMYK inks that are purer in hue and capable of greater saturation than pressroom inks. In addition, inkjet devices will feature light cyan and light magenta, and sometimes even a second black for a total of seven distinct inks. In these cases, we "match" the pressroom inks by using software to constrain the inkjet devices and introduce a level of hue impurity through

mixing small amounts of secondary ink into the primary.

Any single value patch of a given pressroom ink needs to be able to be accurately mimicked by either a patch of a single value of the corresponding proofing colorant or by some mix of proof colorants. For instance, the 100% value of the press sheet's cyan ink may require an 80% intensity of an inkjet cyan with a 5% yellow mixed in to achieve the same visual impact. As in any other comparative instance, the two patches can be verified by a spectrophotometer DeltaE calculation.

Dot Gain Agreement

All conventional printing presses feature a certain amount of dot gain as a normal byproduct of the process. **Dot gain** is the growth of any given halftone dot from the original screened dot size on imaged film or plates to the final printed dot on the press. Ink is a liquid and naturally tends to spread on contact with a substrate. Uncoated stocks absorb more ink than coated stocks and exacerbate dot gain. In addition, the printing process features pressure (which is why it is called a press, after all). Ink is applied to any substrate by impressing the inked image

either directly from the plate in the case of flexography, from an engraved cylinder in the case of gravure, or "offset" from the plate to a rubber blanket, in offset printing. It makes sense that the impression process spreads a halftone dot.

The knee-jerk reaction to dot gain is to think of it as an evil that needs to be eradicated. In fact, a certain amount of dot gain is desirable. Controlled dot gain contributes heavily to the success or failure of the printed image. Too little dot gain results in washed out images every bit as disappointing as those with too much dot gain (Fig. 11-14). In fact, any given calibrated printing condition will feature a normal "gain curve" which can be measured and graphed. If this gain curve is judged to be greater than (or in some cases, less than) optimal, adjustments can be made to either the press condition or to the digital file itself, which is then re-imaged to film or plates.

Dot gain is measured using a densitometer, or by the densitometric options on a spectrodensitometer. Since densitometers compute dot gain by actually reading density and converting density to dot gain, the proof does not actually need halftone dots for a valid "dot gain" computation. A

stepped scale with anywhere from five to twenty patches of increasing density or dot percentage increments of a single ink is read, patch by patch (Fig. 11-15). The densitometer reads the density of each patch by emitting a known quantity of neutral light at the patch and then reading the amount of light that is reflected back into the densitometer's optic. That light passes through a series of RGB filters to determine the color of the ink as well as the density. The less light that is returned through the optic, the higher the density value. That density reading is then run through a calculation known as the Murray-Davies Formula (which would be a great name for a blues band) and either the Dot Area or Dot Gain is displayed. Dot Area is simply the measured total dot size of a given patch. Subtracting the original dot size of a given patch from the final Dot Area reading gives us the Dot Gain. Dot gain curves can be plotted by hand, or in most color measurement and color management software, viewed as two-dimensional line graphs on an XY chart.

The contract proofing system needs to be calibrated so the dot gain profile of the contract proof agrees with the dot gain profile of the intended press condition. A side-by-side visual comparison of a stepped scale from the proof and the same from the press sheet should show very little difference in the perceived weight of each patch and the

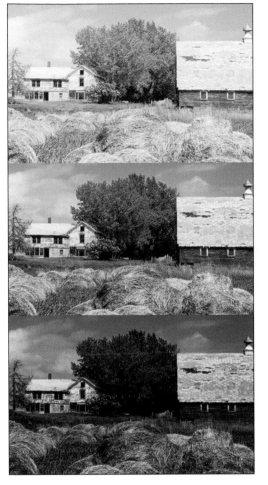

Figure 11-14
Three possible press outcomes from the same four-color plates. The top image shows the result of too little dot gain; the center shows the result of expected, normal gain; the bottom example shows the results of too much dot gain.

differentiation on each scale from patch to patch.

Color Gamut Agreement

Color gamut agreement is the similarity in shape of the three-dimensional color gamut models of the proofing device and the

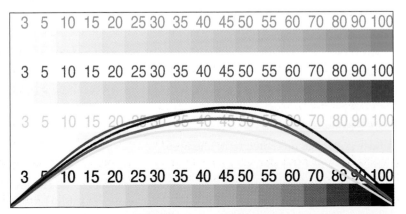

Figure 11-15
In this illustration are stepped single ink scales from which dot gain curves are computed, with the subsequent curves superimposed. The difference between the indicated, original dot values and the actual printed dot area values results in the computed dot gain.

printing press rendered from data stored in their respective ICC profiles. As discussed earlier in this chapter, ICC profiles can be compared using color management-compliant software, including Photoshop. Software is used in the color-managed process to constrain the larger gamut devices to print only those colors that are possible on the smaller gamut devices. Since proofing devices feature larger gamuts than printing presses, as a rule, the contract proof can be constrained to reproduce only those colors that are achievable on press.

Typically, creating any contract proof condition requires initial help from the proofing manufacturer as well as the pressroom in tweaking the proofing system to best emulate the printing condition. Constant monitoring of the process and correcting egregious variation is the task of the production floor personnel. Color management is a perfect example of the type of process control that W. Edwards Deming, the late and revered father of statistical process control would recognize in a heartbeat. It was Deming who maintained that quality can't be inspected into a process; it needs to be built into the process, measurable and verifiable.

Chapter 11 Summary

All the informed color correction in the world can be for naught if your image is reproduced in an uncontrolled print process. Converting the image from RGB to CMYK requires that the image's RGB data be transformed to the particular CMYK space of the print device, whether that device is a desktop printer or a production press. That desktop printer or production press needs to be in a calibrated condition to properly render the image presented to it, and even then we must expect to sacrifice the number and purity of reproducible colors.

An RGB file rendered to CMYK mode for a certain type of print condition is completely unsuitable for a different print condition. For instance, an image that is converted to a SNAP color space for newspaper color reproduction would look washed out and faint if printed on a nice enamel stock on a sheet fed press. That same original RGB image, if initially converted to the sheet fed press's GraCOL color space, would appear muddy, dark, and devoid of detail if printed in the newspaper. For this reason, we now do most of our color corrections and adjustments in RGB color space, which gives us the flexibility to reproduce a source image in the most controlled manner to a variety of print conditions and even on the Web.

Despite the challenges and limitations of the printing press, every one of us is surrounded by impressive examples of color printing every day. When we examine any printed sample, the question we must ask is not whether the printed piece exactly matches the original photo, but whether the printed image features contrast, balance, sharpness and detail, and believable colors. If it does, then all have done their job.

Chapter Review

1. Explain the difference between the terms color correction and color management.

2. What are the basic steps of the color-managed process?

3. What color measurement device is key to the collection of color data required to create an ICC profile?

4. What subject matters best lend themselves to GCR treatment?

5. What does the term Total Ink Coverage refer to?

6. Why is a contract proof called a "contract"?

7. Name the four characteristics the author claims are required for a contract proof.

Glossary

A

additive color—The primary components of white light, which are red, green, and blue. The color space of computer displays, TVs, and digital cameras.

adjacency—Also known as simultaneous contrast, the phenomenon of two identical color values appearing different due to different surrounding color values.

ambient light—The room light surrounding another viewing condition, such as a monitor or a light box.

analog—Any condition of being driven by a continuous, though varying signal, as opposed to the on/off basic condition of digital.

ANSI—American National Standards Institute, which administers U.S. voluntary consensus standards and conformity assessments; including CGATS, the Committee for Graphic Arts Technology Standards.

anti-alias—The creation of intermediary value pixels between adjacent, strongly contrasting pixels, to create an appearance of smooth contours and diagonals.

B

balance—The equalized value of primary components to create neutrals, or grays, and represent hues accurately.

bicubic—The most accurate, and time-consuming, method of computing color values of new pixels created for file enlargement through a pair of cubic analyses of color values of neighboring pixels.

bitmap—An image composed entirely of black or white pixels, generally associated with the on/off signals driving the expose mechanism of an output device.

blown out—A highlight area where tonal values have been erased to the value of the uninked substrate.

brightness—The axis representing the continuum of white to black values in a three-dimensional color space. Grayscale files feature brightness and nothing else. Color files use brightness in combination with hue and saturation to define a particular color.

C

calibration—The adjustment of a device to a repeatable and predictable state. All color reproduction process control practices depend on color devices being in a calibrated state.

CCD—Charge-coupled device. A semiconductor chip used in scanners and digital cameras to convert light into digital signals. A CCD chip is the "film" of many digital cameras.

channel—In Photoshop, all data related to a given primary, or ink, making up an image. Would mean the same as a printing plate were it not for the fact that a channel can contain a nonprinting mask, or that more than one ink can coexist in a single channel, as in the case of duotones and tritones.

characterization—The act of compiling color data on a given device in order to construct a color profile, or gamut model, which describes the given device's ability to express color.

CMOS—Complementary metal oxide semiconductor. The competitive chip to CCD chips used in certain digital cameras to convert light into digital signals.

CMYK—The four-color process primary inks, which are cyan, magenta, yellow, and black, used as a reproduction standard in the printing industry.

color circle—A method of graphing the relationship of additive RGB and subtractive CMY primary colors in a way that makes sense to professionals in the graphics industry.

color gamut—A three-dimensional model displaying a device's ability to express color. Color management relies on the ability to compare two different gamuts to each other and constrain larger gamuts to smaller gamut behaviors.

color management—The use of certain hardware, software, measuring devices, and practices to reproduce color in a consistent manner across a variety of devices.

colorant—Any ink, toner, ink sheet, wax or colored laminate used to produce color images.

colorimeter—A color measurement device using tristimulus methodology to analyze received light in a manner agreeable to how humans perceive light.

contrast—In this context, the combination of dynamic range and tone distribution supporting the perceived difference between lighter and darker areas of an image.

control element—Any color bar, registration target, slur target, step wedge, or other element placed outside of trim on a printed sheet which is used to evaluate and inform the adjustments of the proofing or printing process.

conversion—The remapping of an image's mode from one color space to another, using the data captured during the characterization step of the color management process.

CTP—Computer to plate. A filmless digital technology of exposing images to printing plates using a platesetter driven by a RIP.

curve—A corrective adjustment applied to an image which is graphically represented by a linear XY diagram.

D

DeltaE—The straight line difference between any two measured colors, computed in LAB space. A DeltaE of 1.0 or less is considered to be an identical visual match between two colors. DeltaE readings greater than 4.0 represent out of tolerance conditions requiring attention.

densitometer—A device which computes the difference between the device's transmitted light and that which is unabsorbed by either a substrate or other material and is received into its optics, expressing that difference as a numeric value known as density. There are two categories of densitometer: transmission (which analyzes film positives or negatives) and reflection (which analyzes proofs, prints, and press sheets).

density—The weight, or visual intensity, of printed matter, or the relative darkness of exposed and processed regions of film. In printing, density is a numeric measurement of ink film thickness, which absorbs some light and reflects the rest. The higher the density value, the darker, or more intense, is that particular laydown of colorant.

digital—Any technology using the basic on/off signal, or a combination of on/off signals, in order to construct data or to transmit data.

digital camera—A filmless photographic technology which captures images using either a CCD or CMOS chip and then stores those captured images on memory sticks until they are uploaded to a computer. Digital photography has largely replaced scanning as the dominant image capture technology.

dot area—The inked coverage of a sampled area as read by a densitometer and then translated to halftone dot percentage values.

dot gain—The difference between measured dot area of a printed sample and the original halftone dot size in the same area on the printing plate.

DPI—Dots per inch. The resolution, in machine pixels, of an output device. Often confused with pixels per inch (ppi), the resolution of digital images.

drop shadow—A shadow added to a silhouetted subject to give that subject the appearance of being grounded on a surface.

DTP—Desktop publishing. The technology that revolutionized color reproduction using affordable personal computers, page layout, illustration and photo retouching applications, digital typesetting, and Postscript printing devices. Generally recognized for decentralizing color separation and film output capabilities from the few (professional trade houses) to the many (service bureaus).

duotone—A color image constructed from a custom color ink and a black ink, taking advantage of two-color printing presses.

dynamic range—The computed difference between an image's white point, or highlight, and its black point, or shadow. Dynamic range is one of two components that form contrast in an image.

E

edge definition—Digitally enhanced difference between light and dark sides of a line along two bordering color values in an image. Proper edge definition gives digital images the appearance of sharper detail.

EPS—Encapsulated Postscript file. A file format containing both the Postscript information for an image or single page and the bitmapped screen information for display purposes.

Euro gray—A quadtone, or four-color image, comprised of CMYK inks dominated by the black separation, giving the impression of a richer grayscale treatment.

expanded gamut—The addition of nonprocess inks to the CMYK set to expand the reproducible colors of an original image. Pantone's Hexachrome, which adds green and orange, and Opaltone, which adds red, green, and blue to the normal CMYK are two popular expanded gamut solutions.

F

Farnsworth-Munsell 100 Hue Test—The industry standard vision test for evaluating a subject's ability to discriminate difference between like hues.

file compression—Reducing an image's size for storage or transfer purposes through processing that reduces pixel bit depth or replaces pixel information with small scripts.

fingerprinting—A printing press evaluation procedure intended to determine an optimal running condition and gather data for film and plate compensation.

FIRST—The Flexographic Image Reproduction Specifications and Tolerances, which is the flexographic industry's equivalent to SWOP or SNAP.

flexography—A printing process dominating most packaging market segments, known for its use of raised image photopolymer plates and an engraved cylinder ink delivery system called an anilox roll.

fluorescence—The property of a material to appear to reflect more light than it absorbs, caused by the excitement of electrons in the material by the received light.

G

GCR—Gray component replacement. A four-color process which reduces CMY in both grays and the unwanted component in colors and replaces those reduced inks with black ink.

GIF—Graphics interchange format. A compressed file format which color indexes, or reduces the colors that define an image to 256 or fewer, and was developed by Compuserve for computer display purposes.

GIMP—GNU Image Manipulation Program. A free and versatile photographic image editing software distributed worldwide for Macintosh, Windows, and UNIX platforms.

GRACoL—General Requirements for Applications in Commercial Offset Lithography. The color reproduction recommendations for sheet fed offset printing.

gradation—A term synonymous with Curves image adjustments.

gradient—A continuous transition of a color from a light shade to a darker one of the same color, or from one color to another, typically used as a design element.

grain—The granules in a photographic film emulsion that support detail, but can be distracting when digitized if enlarged or sharpened in appearance.

gravure—A printing process which uses an engraved cylinder in place of a plate for each ink. Known for its use in longer run printing and for its high-quality images.

grayscale—An image printed using shades of black ink only.

H

halftone—The process of screening an image to represent various shades of color with varying sized dots of ink.

Hexachrome—Pantone's expanded gamut color reproduction system using CMYK, green, and orange inks in conjunction with a six-color press.

hexadecimal—A system of defining colors, predominantly for Web design purposes, using base-16 math, wherein any RGB channel can be defined by pairs of single character values ranging from 0–15, using one digit numbers in conjunction with the letters A through F.

highlight—The lightest region of a grayscale or color image.

histogram—A chart showing the distribution of tonal values in an image.

HSV—Hue saturation value. The method used to define colors by three attributes: hue, which plots a color around the 360° of a circle; saturation, which plots the richness of a color on an axis ranging from the circle's center to its rim; and value, which plots the tint or shade of the color along an axis perpendicular to the hue.

HTML—HyperText Markup Language. The coding language used to describe how displayed graphics are to appear on a computer screen, and to create links from one displayed page to another.

hue—The purest attribute of a color, without shade or saturation, defined by its wavelength, and usually modeled as a position on a circle.

hue error—The contamination of a process color ink with color other than its intended hue, found in varying extents in all process inks as a byproduct of the ink formulation process.

I

imagesetter—Either a film or plate exposing device which produces separated film or printing plates from instructions sent to it by a RIP.

indexed color—The process of reducing an image to 256 or fewer representative colors for quick display on computer screens.

ink rotation—The succession of color ink laydowns in a multicolor press run.

inkjet—A color printing technology using ink sprayed from nozzles directly onto a substrate. Wide format inkjet printing is a growing segment of the point of purchase, poster, vehicle wrap, and banner industries.

interpolation—The process used during file resizing to create new pixels with values computed from weighted averages of surrounding pixels.

J

JPEG—Joint Photographic Experts Group. A file format using lossy compression standards set by an ISO committee of the same name.

L

LAB—Short for CIELAB. A three-dimensional color space which mimics the way humans perceive color, and within which any color can be plotted and is used as a transitional space for color mode transformations.

LPI—Lines per inch. The number of rows of halftone dots in a linear inch in a screened separation.

luminosity—A term used to describe the brightness of a color, synonymous with brightness or value.

M

machine pixel—The smallest artifact exposable by an output device. Rasterized images are essentially rows of machine pixels which are either exposed or not. Machine pixels can be organized to create halftone dots.

mask—A protective digital overlay used to control which areas of an image are to respond to an edit and which are to remain as is.

maximum black—The highest black ink value allowed in a four-color process image, serving to protect shadow areas from plugging, or going solid, and serving as the base component of Total Ink Coverage.

micron—One millionth of a meter, or one ten-thousandth of a millimeter. Output device exposure spots (machine pixels) are measured in microns.

midtone—The gradation pivot point located halfway between highlight and shadow, the adjustment of which effects contrast, balance, and color hue.

N

neutral—Any gray value in an image devoid of hue. Neutrals are useful in determining whether an image is printing in balance. Three-dimensional color models position neutrals in the center and grow colors out from this center.

O

offset—The dominant lithographic printing technology which transfers, or offsets, the inked image from a plate to a rubber blanket and then to the substrate.

Opaltone—An Australian expanded gamut solution featuring red, green, and blue touchplates in addition to CMYK to extend the number of reproducible colors in a graphic. The Opaltone method replaces the need for the majority of Pantone custom inks through various combinations of process and Opaltone RGB inks.

overall—Any edit with the potential to affect every pixel in an image. Overall edits are typically all that most images require for visual optimization, and have the best chance of being invisible, or not obvious.

P

Pantone—A registered trademark ink formulation system using sixteen base inks to formulate thousands of identified colors. Pantone's solid coated, solid uncoated, and process libraries are found in all desktop publishing systems. Pantone's Hexachrome is its expanded gamut solution.

pastels—Those colors closest to gray in terms of saturation.

PDF—Portable document format. Adobe's cross-platform electronic document format which has become the de facto standard for electronic publishing.

pixel—The smallest component of a digital picture. A pixel is square, uniform in value, and composed of however many channels making up the file. Millions of pixels of differing values are needed to form a photographic printable image.

plate—A substrate such as a metal, plastic, or photopolymer coated with a light sensitive emulsion, on which a single separation of the image is exposed and processed and which is fastened to a plate cylinder on press in order to receive and transfer ink.

platesetter—Any imagesetter which directly exposes printing plates.

plugged—The condition where darker tonal values in a printed image suffer enough dot gain to reproduce as a solid (or 100% coverage) sacrificing shadow detail and differentiation.

PNG—Portable network graphics. A lossless compression file format developed to improve on and replace GIF.

posterization—Exceedingly harsh color transitions created from severe contrast increases.

PPI—Pixels per inch. The resolution measurement of captured images. Typically, images destined for print are captured at a ppi factor of twice the intended lpi.

prepress—Any working system of technicians, hardware, and software bridging the gap between design and press.

primary colors—Any combination of root colors from which an array of other colors are created. RGB are the additive primaries, CMYK the subtractive.

profile—In color management, a software file describing a device's ability to express color, and which is used during color transformation processes to control outcomes in a predictable and repeatable fashion.

proof—An agreeably accurate representation, or prediction, intended to show how an image will appear when printed.

Q

quartertone—The gradation pivot point located halfway between highlight and midtone, controlling weight and detail in lighter values and brightness in colors.

R

raster—A single row of output, or machine, pixels. Loosely used to mean any file composed of pixels. The pixelized representation of an image as arranged into bitmapped rows and columns.

RAW—The original, unprocessed data format of digital cameras, captured by the CCD or CMOS chip. Most consumer-level cameras process RAW data into JPEG format for economy of storage and ease of use.

RGB—The additive color space of Red Green Blue primaries. The major components of white light. The color space of scanners, digital cameras, computer displays, TVs, and video.

RIP—Raster image processor. Any combination of hardware and software that serves as a front end for a marking engine, or output device. The RIP converts Postscript, PDF, EPS, and TIFF files to 1-bit TIFFs for exposure purposes.

S

saturation—One of the three components of any color, saturation is the level of richness of a color, 0% saturation being gray and 100% fully saturated.

scanner—Any device that scans an original and converts the measured data into digital information. Color scanners are divided into two main categories: flatbed and drum, with virtual drum and camera back scanners also in use.

selection—A localized area of a digital image created for the purpose of causing certain pixels to be editable and others to be protected, or left as is.

separation—Any channel in an image that will eventually result in a printing plate.

sepiatone—An image that is produced with sepia ink. The term is now used to mean any image that looks like a sepiatone, and is associated with archival, historical themes.

server—An unattended computer which carries out automated tasks from remote clients.

shadow—The dark regions in an image. The extreme dark end point of an image.

shape—Any detail that gives a color the appearance of three-dimensionality. Usually supplied by a combination of unwanted color component and black.

sharpness—The enhancement of edge definition in an image to give the illusion of greater detail and sharper focus than the image actually features.

silhouette—To remove a photographic subject from its original surround, generally for design or photomontage purposes.

SNAP—Specifications for Newsprint Advertising Production. Color separation and production guidelines for newspaper printing.

spectrophotometer—Any device which measures color using tristimulus methods and is capable of translating those XYZ readings into LAB coordinates for the purposes of plotting ICC profiles and DeltaE computations.

substrate—Any surface onto which ink is applied in the printing process. Paper, paperboard, adhesive labels, film, foils, metallized papers, canvas, polypropylene, and plastics are all commonly used substrates.

subtractive—The CMYK color space used extensively in the printing process.

swatch—Any square of uniform color stored in desktop applications for easy retrieval and usage.

SWOP—Specifications for Web Offset Production. The ANSI standard for color separations and production methodologies for publication printing.

T

three-quartertone—The gradation pivot point located halfway between the shadow and the midtone.

TIC—Total ink coverage. Also known as total area coverage (TAC). The maximum allowable overprint of combined CMYK percentages in the darkest area of an image. TIC is determined by certain control targets during the press fingerprinting process.

TIFF—Tagged image file format. An image file format originally developed by Apple, Adobe, and Aldus that supports large, photographic images in grayscale, RGB, and CMYK tone distribution.

tone distribution—The distribution of shades or values of data between the highlight and shadow end points.

tool work—Any image editing carried out within the controlled tip of the cursor.

U

UCR—Under color removal. The reduction of CMY inks and their replacement with black ink in neutral values between the midtone and the shadow.

unsharp mask—Also shortened to USM. The software filter associated with an old process camera technique of enhancing contrast along image edges to produce the effect of increased detail and focus.

unwanted component—The third color, or least primary in a color blend. Called unwanted due to its effect of dirtying up colors, it is actually essential for detail and shape in colors.

V

value—Synonymous with brightness, lightness, and luminosity as a component of color. Also an increment of tone, or weight, of a color.

vector—A line segment whose length and direction are determined by control points at each end. Vector files are resolution independent, meaning that they can be resized with no loss of crispness or detail. Illustration programs are primarily vector based, as are page layout programs.

vignette—The soft and gradual fall off of an image to its unprinted substrate, creating an undefined edge associated with nostalgic or romantic themes.

W

wanted component—The two leading channels or separations defining any color. For instance, cyan and magenta are wanted components in a navy blue.

workflow—A sequential series of steps, tasks, and devices in a working process resulting in an accomplished goal.

workstation—Any computer requiring a technician interacting with it to accomplish work.

Z

ZIP—A lossless compression routine used to compress an item or items into a single transferrable folder whose contents require extraction on the receiver's end.

Index

Page numbers followed by *f* indicate figures.

A

Additive color, 174
Adjacency, 174
Ambient light, 92, 174
Analog, 174
Anti-alias, 54–55, 54*f*, 174
Aurelon ICISS, 82

B

Balance, 33–46
 CMYK, 39–41, 40*f*
 definition, 34–36, 35*f*, 174
 gray, 41–46, 41*f*, 42*f*, 43*f*, 44*f*
 intentional cast, 45–46, 45*f*
 LAB, 38–39
 repair, 104–106
 RGB, 38
Bicubic, 174
Bit-depth, 63
Bitmap, 174
Black
 ink patch, 23*f*, 164*f*
 maximum, 178
Blown out, 174
Brightness, 174

C

Calibration, 174
Camera
 digital, 19*f*, 176
 horizontal, 56*f*
CCD (charge-coupled device), 49, 174
Channel, 174
Characterization, 174
Charge-coupled device (CCD), 49, 174
CIELAB (LAB), 20, 20*f*, 178
 balance, 38–39
CMOS (complementary metal oxide semiconductor), 49, 174
CMYK (cyan, magenta, yellow, and black), 19, 19*f*, 67*f*, 174
 balance, 39–41, 40*f*

Collage, 18*f*
Color, 65–83
 additive, 174
 alterations and corrections, 68–69, 68*f*
 attributes, 69–71, 69*f*, 70*f*
 communicating, 76–77
 correcting, 122–126, 123*f*, 124*f*, 125*f*, 126*f*
 versus management, 157–172
 using tool work, 137–141, 138*f*–141*f*
 description, 71–76, 72*f*, 73*f*, 74*f*, 75*f*
 determination of location, 98
 expanded gamut, 80–83, 81*f*, 82*f*
 linking contrast to, 70–71
 management, 159–166
 contract proof, 168–172
 versus correcting, 157–172
 in practice, 166–168, 167*f*
 measurement and record, 98–99
 primary, 179
 realistic, 107
 sample readings, 99–100
 skin tones, 78–80, 79*f*
 snappy, 7
 spaces, 18–20, 19*f*, 20*f*
 specialist, 4*f*, 5–7, 7*f*
 subjectivity, 8
 tool work and, 134
 wanted/unwanted components, 77–78, 77*f*
Colorant, 175
Colorant agreement, 169–170
Color cast, causes, 36–37, 37*f*
Color circle, 35*f*, 116*f*, 175
Color gamut, 158*f*
 comparison, 163*f*
 definition, 175
Color gamut agreement, 171–172, 171*f*
Colorimeter, 21, 175
Color management, 175
Color Picker, 74*f*
Complementary metal oxide semiconductor (CMOS), 49, 174
Computer to plate (CTP), 175

Contrast, 7, 15–32, 16f, 17f, 18f, 175
 color spaces, 18–20, 19f, 20f
 controls, 20–21
 correction, 106, 106f
 end points, 26–28, 26f, 27f, 28f
 light measurement, 21–32
 linking color to, 70–71
 settings, 29–32, 31f
Control element, 175
Conversion, 175
Creo EverSmart scanner, 26f, 50f, 59f,
 68f
CTP (computer to plate), 175
Curves, 28–29, 29f, 30f, 175
 adjustments, 31f

D
DeltaE, 175
Densitometer, 21, 175
Density, 175
Desktop publishing (DTP), 176
Detail. *See* Sharpness
Digital, 175
Digital camera, 19f, 176
Dot area, 176
Dot gain, 176
 agreement, 170–171, 171f
Dots per inch (DPI), 62, 176
DPI (dots per inch), 62, 176
Drop shadow, 149–156, 150f, 152f,
 153f, 154f, 155f, 176
 implied light source, 151
 implied surface, 150–151
 object and, 151
Drum scanning, 55f
DTP (desktop publishing), 176
Duotone, 144–145, 145f, 176
Dust and scratches, 106–107, 107f
 tool work and, 132–134, 134f
Dynamic range, 20–21, 24f, 176

E
Edge definition, 55, 176
Encapsulated postscript file (EPS), 176
EPS (encapsulated postscript file), 176

Epson 10000, 62f
Epson 10600, 158
Epson 10000CF, 170f
Euro gray, 148–149, 148f, 149f, 176
Expanded gamut, 176

F
Farnsworth–Munsell 100 Hue Test, 8,
 12–14, 13f, 176
File compression, 52–53, 53f, 176
Fingerprinting, 176
FIRST (Flexographic Image Reproduction
 Specifications and Tolerances), 177
Flexographic Image Reproduction
 Specifications and Tolerances (FIRST),
 177
Flexography, 177
Fluorescence, 177

G
GCR (gray component replacement),
 163–166, 165f, 166f, 177
General Requirements for Applications in
 Commercial Offset Lithography
 (GRACoL), 177
GIF (graphics interchange format), 52–53,
 177
GIMP (GNU Image Manipulation
 Program), 4f, 69f, 70f, 177
Glossary, 173–182
GNU Image Manipulation Program
 (GIMP), 4f, 69f, 70f, 177
GRACoL (General Requirements for
 Applications in Commercial Offset
 Lithography), 177
Gradation, 177
Gradient, 177
Gradient wedge, 54–55
Grain, 55–56, 177
Graphics interchange format (GIF),
 52–53, 177
Gravure, 177
Gray component replacement (GCR),
 163–166, 165f, 166f, 177
 balance, 41–46, 41f, 42f, 43f, 44f

Grayscale, 177
GretagMacbeth Spectroscan, 22*f*

H
Halftone, 177
 screen resolutions/rulings, 51–52, 51*f*
Hexachrome, 81–82, 177
Hexadecimal, 177
Highlight, 93, 95*f*, 177
 measurement and record, 94
 repair, 103–104
Histogram, 177
HP PSC 1200, 160*f*, 161*f*
HSV (hue saturation value), 177
HTML (HyperText markup Language), 178
Hue, 178
 error, 74
Hue error, 178
Hue saturation value (HSV), 177
HyperText Markup Language (HTML), 178

I
Images, 1–14. *See also* Photoshop
 adjustments, 9, 9*f*
 correction of poor, 107–112,
 108*f*–112*f*
 evaluation, 85–100
 checklist, 88–90, 89*f*
 review, 103–107
 optimal, 7–8
 characteristics, 10–12
 definition, 10
Imagesetter, 178
Indexed color, 178
Info Palette, 40*f*
Inkjet, 178
Ink rotation, 178
Interpolation, 178

J
Joint Photographic Experts Group (JPEG),
 52, 178
JPEG (Joint Photographic Experts Group),
 52, 178

L
LAB (CIELAB), 20, 20*f*, 178
 balance, 38–39
Light
 ambient, 92, 174
 measurement, 21–32
Lines per inch (LPI), 62, 178
LPI (lines per inch), 62, 178
Luminosity, 178

M
Machine pixel, 178
Mask, 113–127, 178
 categories, 117–121, 118*f*, 119*f*
 color correcting the greens, 122–126,
 123*f*, 124*f*, 125*f*, 126*f*
 functions, 113–117, 115*f*, 116*f*
 geometric selection, 119
 gradient, 121, 121*f*
 pixel value, 120, 120*f*
 unsharp, 181
Maximum black, 178
Micron, 178
Midtone (MT), 25, 178
Monochrome, 4*f*
MT (midtone), 25

N
Negatives, 35 mm, 6
Neutral, 179

O
Offset, 179
Opaltone, 81–82, 82*f*, 179
Overall, 179

P
Pantone, 72*f*, 73*f*, 179
Paper, grades, 23*f*
Pastels, 179
PDF (portable document format), 179
Photoshop, 28*f*, 43*f*, 49*f*, 53*f*, 57*f*, 73*f*,
 90–99, 90*f*, 91*f*, 93*f*, 107*f*, 116*f*, 120*f*,
 137*f*, 147*f*, 165*f*, 174

Pixel, 48
 creation, 49–52
 definition, 179
 image clean-up, 98
 machine, 178
 resampling, 54
 view options, 96
Pixels per inch (PPI), 62, 179
 magnified view, 3f
Plate, 179
Platesetter, 179
Plugged, 179
PNG (portable network graphics), 53,
 179
Portable document format (PDF), 179
Portable network graphics (PNG), 53,
 179
Posterization, 179
PPI (pixels per inch), 62, 179
Prepress, 179
Primary colors, 179
profile, 180
Proof, 180
 contract, 168–172
 Latran Prediction, 169f

Q
Quartertone, 180

R
Raster, 48, 180
Raster image processer (RIP), 48–49,
 49f, 180
RAW, 180
Resampling, 54
Resolution, 62, 62f
RGB, 18f, 180
 balance, 38
RIP (raster image processor), 48–49, 49f,
 180
Rivard's pyramid, 9, 9f, 66f, 102, 102f,
 114, 130, 130f
Rule of 16, 63, 63f

S
Saturation, 180
Scanner, 180
Selection, 180
Separation, 180
Sepiatone, 146–148, 147f, 180
Server, 180
Shadow, 93–94, 180. *See also* Drop
 shadow
 measurement and record, 94
 repair, 104
Shape, 180
Sharpness, 48–64, 180
 bit-depth, 63
 improvement, 106–107, 106f
 Rule of 16, 63
 visual problems and, 97
Silhouette, 180
Skin tones, 78–80, 79f
 digital cosmetic surgery, 134–135,
 135f
 neutral areas and, 96
SNAP (Specifications for Newsprint
 Advertising Production), 181
Specifications for Newsprint Advertising
 Production (SNAP), 181
Specifications for Web Offset Production
 (SWOP), 74, 181
Spectrodensitometer, 21–22, 22f
Spectrophotometer, 21–22, 181
Stylus, 131f
Substrate, 181
Substrate agreement, 168–169
Subtractive, 181
Swatch, 181
SWOP (Specifications for Web Offset
 Production), 74, 181

T
TAC (total area coverage), 181
Tagged image file format (TIFF), 181
Three-quartertone, 181
TIC (total ink coverage), 181
TIFF (tagged image file format), 181
Tone distribution, 20, 24–26, 25f, 181

Tool work, 129–141, 181
 adding object or effect, 135
 considerations, 135
 prerequisites for successful brushwork,
 135–136
 recognizing a need, 132–135
 Rivard's Pyramid and, 130, 130*f*
 work habits, 133
Total area coverage (TAC), 181
Total ink coverage (TIC), 181
Touchplating, 81

U
UCR (under color removal), 163–166,
 181
Under color removal (UCR), 163–166,
 181
Unsharp mask (USM), 11, 11*f*, 56–61,
 57*f*, 58*f*, 181
 advanced sharpening techniques, 50*f*,
 59–61, 61*f*
 optimal results, 58–59
Unwanted component, 181
USM. *See* Unsharp mask

V
Value, 181
Vector, 181
Vignette, 181

W
Wacom tablet, 131*f*
Wanted component, 182
Workflow, 5–7, 182
 complex, 6*f*
 simple, 5*f*
Work habits, 133
Workstation, 182

X
X-Rite DTP41, 22*f*
X-Rite DTP92, 22*f*
X-Rite 528 Spectrodensitometer, 22*f*
X-Rite 361T, 22*f*

Z
ZIP, 53, 182